CLASSIC GLAMOUR
PHOTOGRAPHY

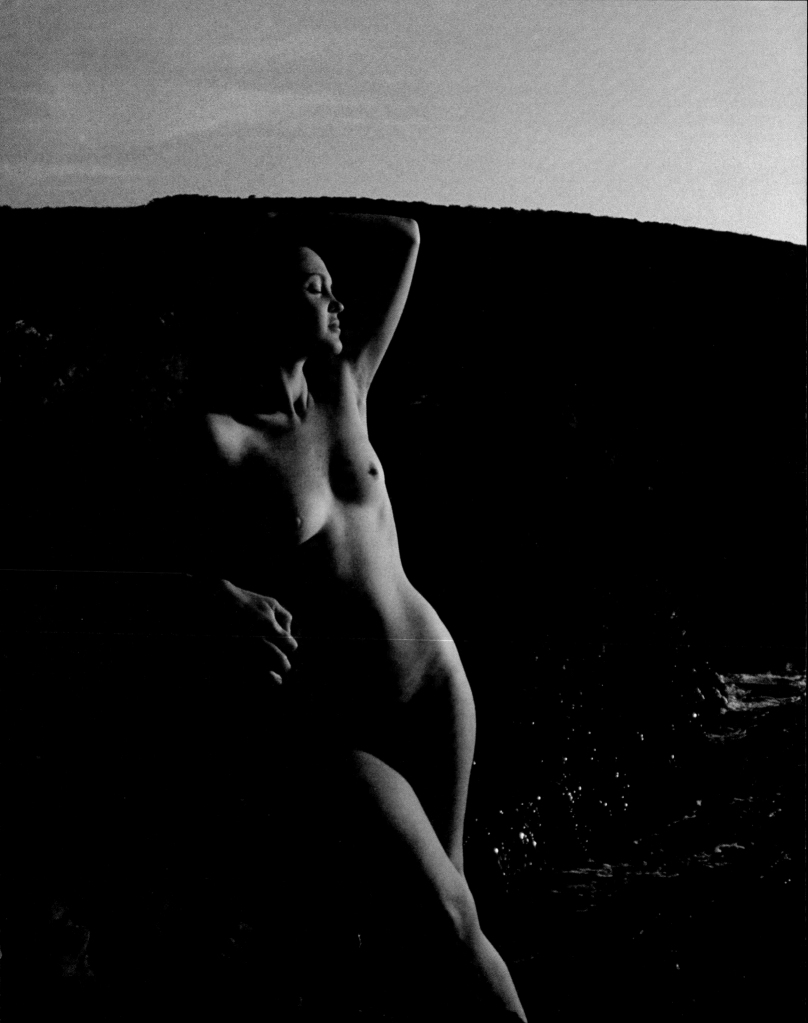

CLASSIC GLAMOUR
PHOTOGRAPHY

IAIN BANKS

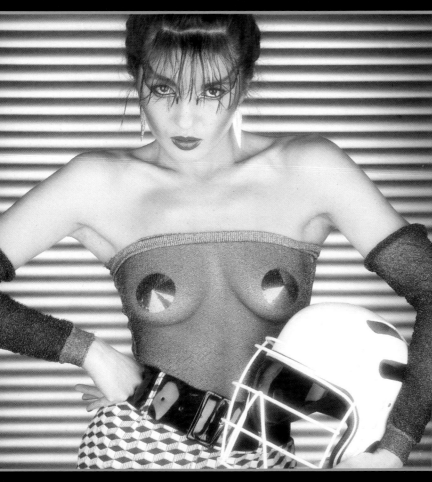

Amphoto Books
American Photographic Book Publishing
An imprint of Watson-Guptill Publications
New York

A Quarto Book

Copyright © 1987 by Quarto Publishing plc

First published in New York by AMPHOTO,
an imprint of Watson-Guptill Publications,
a division of Billboard Publications, Inc.,
1515 Broadway, New York, NY 10036

Library of Congress Cataloging in Publication Data
Bank, Iain.
Classic glamor photography.
Includes index.
1. Glamour photography. I. Title.
TR678.B36 1989 778.9′24 88-35107
ISBN 0-8174-3672-3

Printed in Hong Kong

2 3 4 5 6 7 8 / 93 92 91 90

CONTENTS

FOREWORD

THERE ARE TWO APPROACHES to glamour photography which can be clearly distinguished. The first arises from the traditions of fine art where its exponents have adapted the techniques of painters and sculptors. Their primary objective is to present the female form in a way that is aesthetically pleasing yet still evokes a human response in the viewer. The second has its roots in commercialism. Those who adhere to this approach tend to employ the techniques of graphic design. They do not invite the viewer to identify with the image. They strive to depersonalize the picture, preferring to rely on colour and shape to produce an image that is attractive. There are also those photographers who do not fit neatly into either category. They may produce pictures which are artistic rather than graphic, but have a wide appeal and are therefore ultimately commercial. Alternatively, others may employ a commercial approach but still come up with a result which is a work of art.

This book includes a wide range of pictures from the artistic creations of Lucien Clergue to the purely commercial shots of Beverley Goodway and John Kelly. Of all the photographers whose work appears here, Lucien Clergue owes most to pure 'artistic' tradition. Many would not consider him a 'glamour' photographer at all; he is a photographer of the female nude. 150 years ago he would have been a painter, but today he uses the camera instead of a brush. Michael Boys, too, has a similar approach although he is more flexible than Clergue, and is quite prepared to be commercial if he thinks that the occasion demands it. However both Clergue and Boys stress the importance of establishing a rapport with the model, which suggests that they are concerned with putting a human being as opposed to an object on to film.

David Hamilton, Byron Newman and Patrick Lichfield all use the artistic tradition to produce images that are commercially successful. Hamilton uses grain the same way the Impressionists used brush strokes, to blur the edges of reality. Newman and Lichfield both place a great deal of emphasis on styling, constructing their scenes with care and precision. They often build a pseudo-narrative element into their images.

If Hamilton, Lichfield and Newman are using 'artistic' techniques to induce an emotional response, then Chris Thomson, Jan Cobb, John Mason and Uwe Ommer are all employing aspects of graphic design to produce aesthetically satisfying images. The power of their pictures lies in their cleanliness of line and form and in their bold use of primary, rather than pastel colours. Their models are ultimately little more than props, chosen for the shape and colour of their bodies rather than their ability to come across as personalities.

John Kelly and Beverley Goodway are both commercial photographers, who make no pretence to artistic aspirations. Kelly's straightforward approach to the subject is guided primarily by the demands of the market for which he works. His

6

use of gold reflectors and tungsten lighting gives his models a tanned and healthy look. He presents his girls in such a way that they look friendly and warm. Beverley Goodway, likewise, makes his models seem approachable, They personify the 'girl next door', young, smiling and happy.

Glamour photography is concerned with fantasy. The beautiful woman is simply a two-dimensional image on film, but the photographer's skill is employed in building up the fantasy around her. Three photographers, whose work appears in this book, have accepted that their work is primarily based on the fantastic element and by taking this a stage further, have produce pictures with a surreal and bizarre quality. Cheyco Leidmann has created a world where weird landscapes are peopled by creatures bearing little or no relation to human experience. Bob Carlos Clarke's models also live in a world that is entirely illusory. James Wedge's hand-tinting techniques serve to distance the image from the accepted idea of everyday life.

In selecting the photographers for inclusion in the book, we have inevitably had to leave out many whose pictures place them at the forefront of glamour photography. But those that we have chosen represent a healthy cross-section and demonstrate the diverse approaches to the subject that are being practised by professionals today.

The idea of the second section of this book is to show how professional glamour photographers set about their task and how they achieve their effects. It is a fallacy to think that you must be able to buy expensive equipment and hire top models if you want to take good glamour pictures. The working practice of professionals show this is simply not true. Many of the photographers in this book use very basic equipment and prefer to work with girls who are new to modelling, because they feel that the freshness is reflected in the photographs.

However, to produce fine photographs rather more is required than the basic equipment. What distinguishes a great photographer from a merely adequate one is his vision and imagination. These qualities can be developed by looking at other photographers' work and trying to understand what makes their pictures effective. It is a question of cultivating a critical sense to discover how the photographer has marshalled the elements at his command to produce a single successful image.

Throughout the text we have referred to the photographer in the masculine gender. I would like to make it perfectly clear that no disrespect is intended to female photographers. It is simply that everyday use of English has failed to keep pace with the demands made upon it by an ever-changing society.

SECTION ONE
THE CLASSIC PHOTOGRAPHERS

Some pictures are not provided with shutter speed details; this is because professional photographers tend to leave the shutter speed out of their calculations when exposing pictures by studio flash with a leaf shutter camera. The reason for this is that leaf shutter cameras can be synchronized with the flash at any speed; it therefore makes sense to work by aperture size alone.

"I want the images in my pictures to be the result of trust — trust on my part that the girls will not waste my time and trust on their part that I will produce pictures that show them off to their best advantage."

MICHAEL BOYS

P hotography is rather like music,' says Michael Boys. 'To be technically perfect, you must practise hard. To be a solo performer you must not only practise, you must also be gifted.' Boys is in a good position to speak authoritatively on the subject of photography in general, because in his time he has covered virtually every branch of the business. He has worked for newspapers, done theatrical photography, has supplied pictures to women's magazines, and has undertaken a great deal of glamour photography.

Although glamour photography forms only a fraction of his total output, it is nevertheless an important part of his work and one to which he invariably looks forward.

He enjoys working with girls who are not professional nude models. The professionals, he finds, tend to be too blasé, too slick, and look as though they have seen it all before. 'That is not what I am looking for in my pictures', says Boys. 'I want the images to be the result of trust — trust on my part that the girls will not waste my time and trust on their part that I will produce

pictures that show them off to their best advantage. Generally speaking it is an approach that has worked remarkably well.'

Boys's intention is not to create wildly erotic photographs. He likes to portray his models in a witty, slightly sexy way and produce relaxed, informal pictures. This style of photography does not really suit the cold flood of electronic studio flash, so not surprisingly, Boys chooses to illuminate his own studios by daylight, finding that natural light best compliments his natural approach. Given the choice though, he prefers to shoot glamour on location.

'When you go on location with a girl, it is something of an adventure for both of you,' says Boys. 'That shared feeling of excitement helps you to build up a rapport with the model. By the time the shooting starts, you have already spent some time together and you know each other better. A certain amount of trust will have been built up, and that makes it a great deal easier when the model takes her clothes off.'

When Boys is searching for a suitable location he likes to wake up at dawn, and check the

This picture was taken at the beginning of the session on a dull wet autumn day. The model was apprehensive about the shoot, so Boys decided to photograph her in silhouette against a window, using her long hair to mask her face. Boys set up a tungsten lamp beside and to the right of the camera, to provide fill-in light on the girl's front. A shaft of sunlight fell through the window and produced highlights on the pink flower the model is holding. Boys had already mounted a 10 magenta filter on the front of his lens and this helped to give the picture an overall pink glow.
150mm lens, Ektachrome 64, 1/125th sec, f4

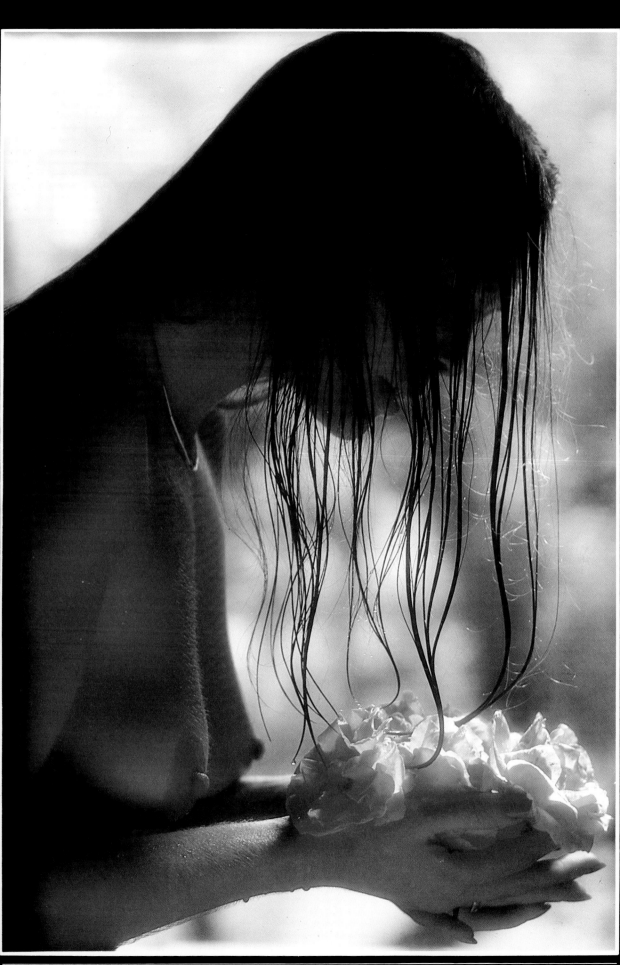

weather; if it is good, he sets off on a hunt for the right spot. When he finds a promising place, he wanders around assessing the photographic possibilities, so that when he returns with the model he already has a fairly clear idea of what he wants to do.

According to Boys, the importance of the location cannot be underestimated, and a good setting can add a great deal to an otherwise straightforward picture. Imaginative styling is also important. He points out, for example, that a scantily clothed girl is often more appealing than one who is not wearing a stitch. Make-up and hair also play a large part in making the final picture successful. Boys therefore takes care to make sure that every minute detail, however tangential, is attended to. Very often he finds it is the little things that make the difference between a picture that sells and one that just rests in the files for ever.

On location Boys likes to experiment with new ideas. He thinks it is important to keep shooting, regardless of whether the ideas are good or indifferent. This means that when he returns home with all the film, he does not feel as if he has missed opportunities. He usually finds that he has ensured some good shots, using this method. Boys also believes that a photographer should never go off duty. At all times, between takes, during lunch, in fact whenever there is a break, the photographer should watch out for scenes that might make pleasing pictures.

He keeps his equipment to the barest minimum, choosing not to carry lights around, making sure instead that the locations he picks are adequately served by sunlight; he then uses white bed-sheets as reflectors. Beyond this, the only equipment he needs is a camera, a couple of lenses, a few filters and a tripod. He uses both 35mm and 6 x 4.5cm cameras. He prefers 35mm, but employs the larger format camera whenever the shot is technically difficult. With the bigger camera he can fit a Polaroid back, which allows him to use the instant print as an exposure guide. With 35mm he relies on the camera's built-in meter and double-checks by

Boys is keen on collecting period French stoves and the one on which the model is sitting (LEFT) is part of his collection. The picture is intended as a witty play on the eye. The glow in the stove was produced by an ordinary bulb on the end of an electric cable fed down the chimney. Boys covered the holes in the side of the stove with red gel to produce the effect. A quartz light with a half-blue gel over it, which cooled the lamp sufficiently for use with daylight film, was placed to the left of the camera. Exposure was tricky, because the level of daylight coming through the window was high. Boys metered the window and then reduced the exposure by three stops to produce a correct exposure for the skin tones.
150mm lens, Ektachrome 64, 1/125th sec, f4
The shot (RIGHT) was taken on the French island of Porquerolles, one of Boys's favourite locations. He went out early in the morning and found a deserted beach which looked as though it might be promising. The idea of the plastic bag shower came to him then. When he returned with the model later, the sun was strong and the contrast high, so he rigged up three white double bed sheets to reflect back onto the model's body.
105mm lens, Kodachrome 25, 1/125th sec, f4

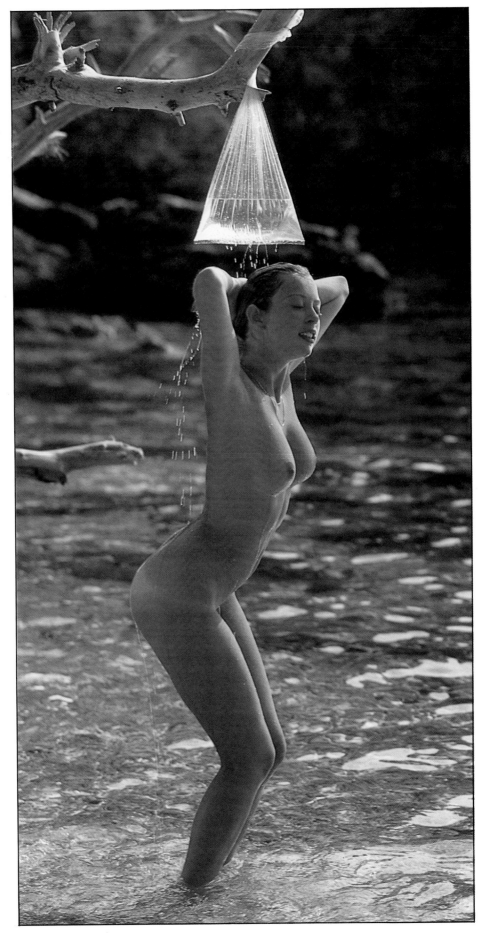

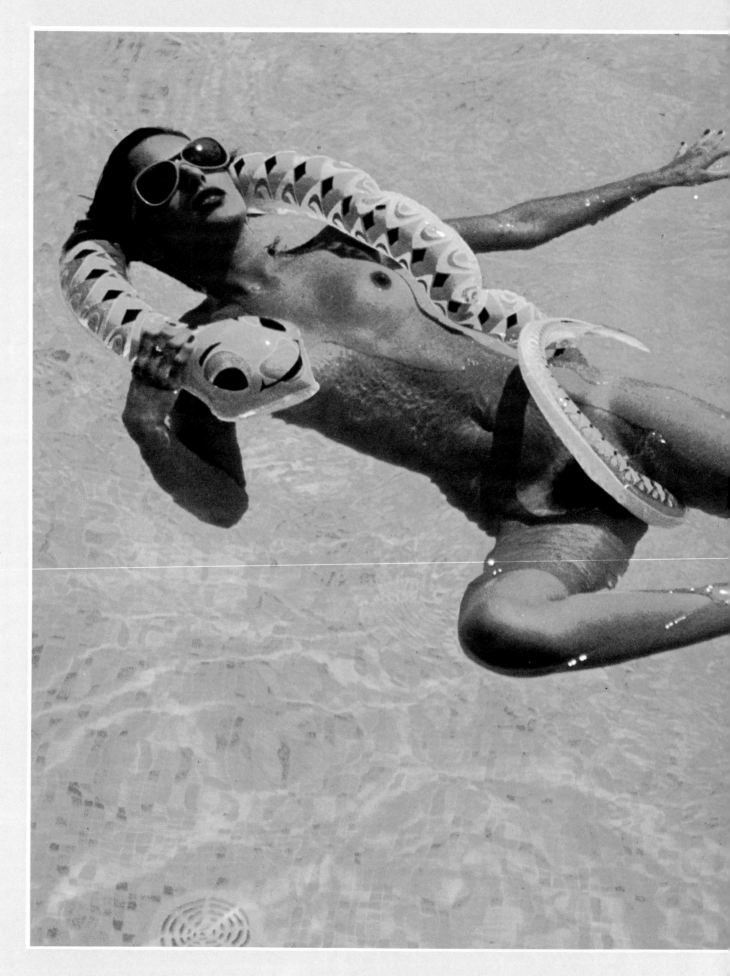

'You have to keep your eyes peeled for likely looking props if you are a professional photographer,' says Boys. He bought the inflatable serpent off a market stall in East London in the vague hope that he would be able to use it in a shot at some later date. The moment came when he found himself shooting a set of pictures in a private swimming pool. By standing on a step ladder and shooting down into the pool, Boys was able to frame the picture so that the sides of the pool did not appear, leaving the figure of the model to contrast with the even blue tone of the pool. *24mm lens, Kodachrome 25, 1/125th, f5.6*

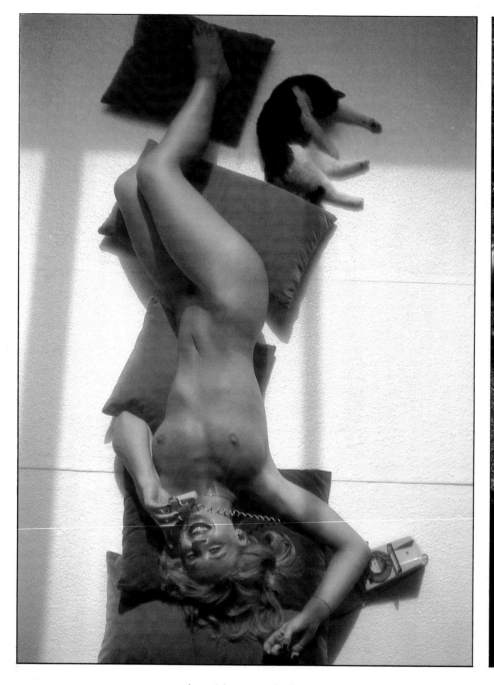

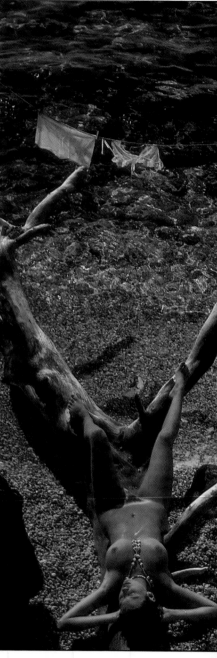

using his own judgment and experience. He uses the tripod nearly all the time, pointing out that on location he can never tell what the light is going to do. He finds that even if the light is quite bright, it is always safer on a tripod. As far as lenses are concerned, Boys uses anything between 24mm and 300mm, although a 105mm lens is probably the one he uses most.

Boys is a successful commercial photographer who has managed to avoid being 'pigeon-holed'. He still gets a tremendous enjoyment out of photography, despite the fact that he has been practising it for thirty odd years. As far as his glamour work is concerned, this enjoyment is clearly evident in his pictures, as is the rapport which he establishes with his models during the shoot.

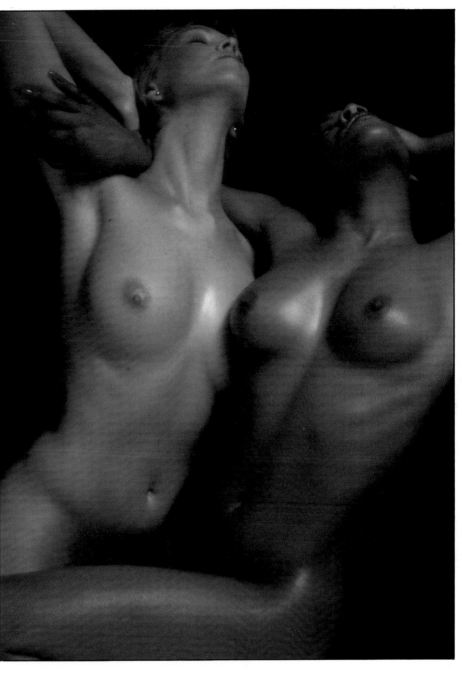

Boys took this picture (FAR LEFT) from a step ladder. He carefully arranged the model's legs to make them appear slimmer and to lengthen them. Boys wanted the picture to look particularly natural and relaxed, and he achieved this by placing a cat in the frame and getting the model to hold the telephone.
50mm lens, Kodachrome 25, 1/125th sec, f8
While on a location survey, Boys noticed the dead tree (CENTRE LEFT) and marked it out for possible use. Later he returned with the model and posed her in such a way that the shape of her body echoed the shape of the tree's branches. He used a polarizing filter to give the

model's body a richer tone and to improve the textural qualities of the picture.
24mm lens, Kodachrome 25, 1/250th sec, f5.6
Boys rarely shoots his glamour shots in the studio, preferring to capitalize on the advantages of location work. However he had a very specific image in mind when he planned this particular shot (ABOVE), and so he borrowed a black studio for the session in order to create this idea. Boys used electronic flash to achieve a statue-like effect, and he directed the models carefully to adopt very specific poses.
150mm lens, Ektachrome 64. f16

> *"My pictures are supposed to be strong. If they weren't I wouldn't be succeeding on my own terms. Looking back, I realize that much of my earlier work had a sentimental, nostalgic quality about it, despite the immediacy of the actual subject matter. Now I seem to be treating my images in a far more modern way."*

BOB CARLOS CLARKE

Bob Carlos Clarke's style of photography is so individualistic that his work is instantly recognizable. He learned his trade at college, and made his living afterwards by shooting editorial pictures, mostly for car, motorcycle and men's magazines. His work from that era is filled with images of sex, violence and consumerism. He has been criticized for his portrayal of women as fantastic creatures rather than real people. His use of props such as guns and cars, has also come under fire from various quarters.

But Carlos Clarke remains unrepentant. 'My pictures are supposed to be strong. If they weren't, I wouldn't be succeeding on my own terms.' He denies that the images amount to an expression of his own philosophy of life, but qualifies this by saying '40 per cent is me, but 60 per cent is simply what the market wants at the time.'

Most of Carlos Clarke's work relies on hand-tinting for its colour content, although recently he has started to shoot more straight colour. This change is due to pressure of time rather than a conscious decision on his part to abandon the techniques that took him to the top.

He discovers the inspiration for his images in all sorts of places and things. 'It may be some object that I find lying around in a junk shop. The shape attracts my visual attention,' he explains. He finds it useful to wander around London, simply observing. He likes to keep in touch with visual trends and certain influences inevitably find expression in his work. Looking back,

Clarke finds that much of his early work had a sentimental, nostalgic quality about it despite the immediacy of the actual subject matter. Now he feels that he is treating his images in a more modern way.

His approach to photography has changed as well. In the early days he relied heavily on chance to provide the elements in his pictures. He rarely had a clear and detailed idea of what he was trying to achieve from a particular session. This did not matter greatly at the time for a number of reasons. Firstly, he was shooting in black and white and could manipulate the image during printing; secondly, most of the work was hand-tinted and so the colour in the picture was entirely up to him, and thirdly, many of his early pictures were montaged. This meant that the image was really put together after the shooting was over.

Now however Carlos Clarke makes sketches before he reaches for his camera. Only when he has a clear idea of what he is trying to achieve does he actually expose film.

He is very choosy about what he includes in the frame, saying that he always limits himself and takes out everything that does not contribute to the final image. He stresses that each element must complement the others as it only takes one false note to make the entire picture suffer.

Although Carlos Clarke's pictures rely heavily on graphic arts techniques, he is insistent that the techniques are merely a means to an end. He is also aware that unless he concentrates on how

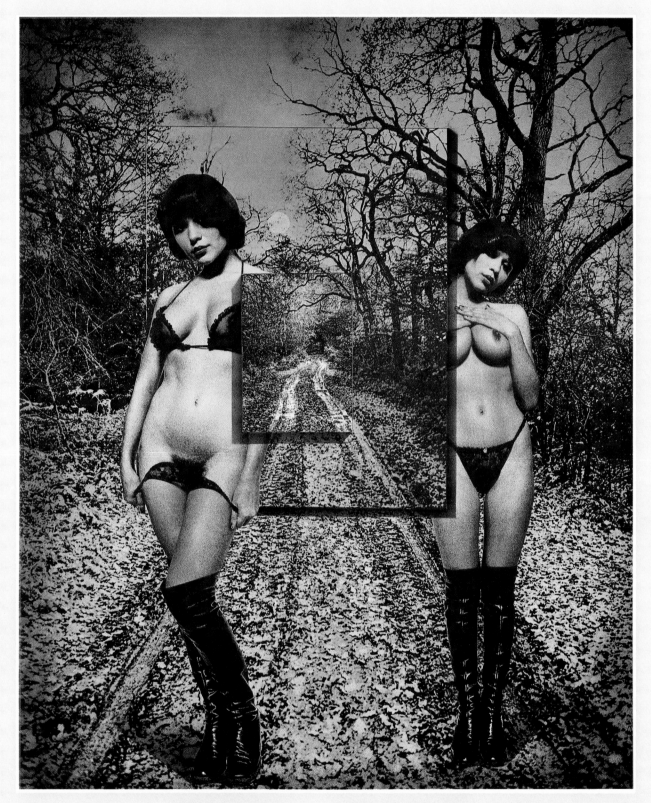

This shot started life as a single black and white photograph of a muddy track through the woods. Carlos Clarke then printed up two smaller sections of the negative. He hired a model and photographed her twice in the studio, producing blue-toned prints of her in two separate positions. The four images were then montaged onto the original print and hand-tinted with water colours and photo dyes. The shadows around the edges of the centre sections were air brushed onto the print later.

Carlos Clarke was commissioned by a men's magazine to produce an illustration for use with a satirical article about women. Carlos Clarke posed the two models on a roof top in West London on a cold winter's day. The rather threatening aspect of the picture stems as much from the models' domination of the landscape as it does from their guns. The black and white print that Carlos Clarke produced did not live up to his expectations. So he printed the negative onto Kodalith paper — hence the warm brown tone — and induced reticulation by subjecting the print to extremes of temperature.

a certain technique will affect the final result, there is a danger that the technique itself will start to dominate the picture and will reduce the impact of the image.

The models in Carlos Clarke's pictures are simply images, rather than people. He uses them to inject an extra element into the picture, that element being sex. In the same way that he might put in a car, to represent machismo, he uses his models to add a degree of sexual danger.

The unreal quality of Carlos Clarke's pictures stems essentially from his marked choice of model, prop, location, and technique. They all contribute to the pervasive atmosphere of menacing fantasy. Carlos Clarke tries to find models who have 'a slightly bizarre beauty', rather than opting for the stereotyped good looks of many glamour models. He increasingly uses professional models finding that they are more likely to be able to play a part, to understand the mood of the session and are able to react instinctively, rather than waiting for direction. The photographic reputation that precedes him also plays a part in making his rapport with models smoother.

Carlos Clarke deplores the obsession with equipment that preoccupies so many amateur photographers. Photography, he says, is about imagination, and having the skill to put a piece of imaginative thinking on to film. The equipment is about as important as the sculptor's chisel.

He refutes the idea that he is an artist, claiming that photography is simple a record of what appeared in front of the lens at a given moment. He refuses to move from this position even when it is pointed out that it is he who decides what should appear in front of the lens at any given moment, and chooses in what way the images should be presented.

His success as an advertising photographer shows that he has a strong grasp of the economics of the business, but he finds that he can detach himself from much of his commissioned work. 'If I identified with my advertising photography, I'd have a broken heart every day,' he says.

He takes his personal work very seriously and maintains a rigidly perfectionist stance regarding its quality. He produces at most about 20 pictures for himself a year. Each one takes days and sometimes weeks to produce. 'When I look back at those shots I'm lucky if there are still four that I can honestly say I'm proud of,' he asserts.

Carlos Clarke's work manges to successfully straddle the line between reality and fantasy. Many photographers have attempted to do this and few have succeeded. One main reason for Carlos Clarke's success is that his technical skill is sufficiently broad to allow free rein to his imagination.

'Domestic Pet' is Carlos Clarke's title for this image which was taken for the cover of a German women's magazine. 'They wanted a picture which illustrated the modern woman's dilemma — sex siren versus house cleaner.' Carlos Clarke shot a black and white photograph of the model's legs, and then made a separate exposure of the vacuum cleaner. He montaged the two images together and burned-in the shape of the snake. The composite image was by this time on a 20 x 16 in print. The colour was added by hand, using water colours and photo-dyes.

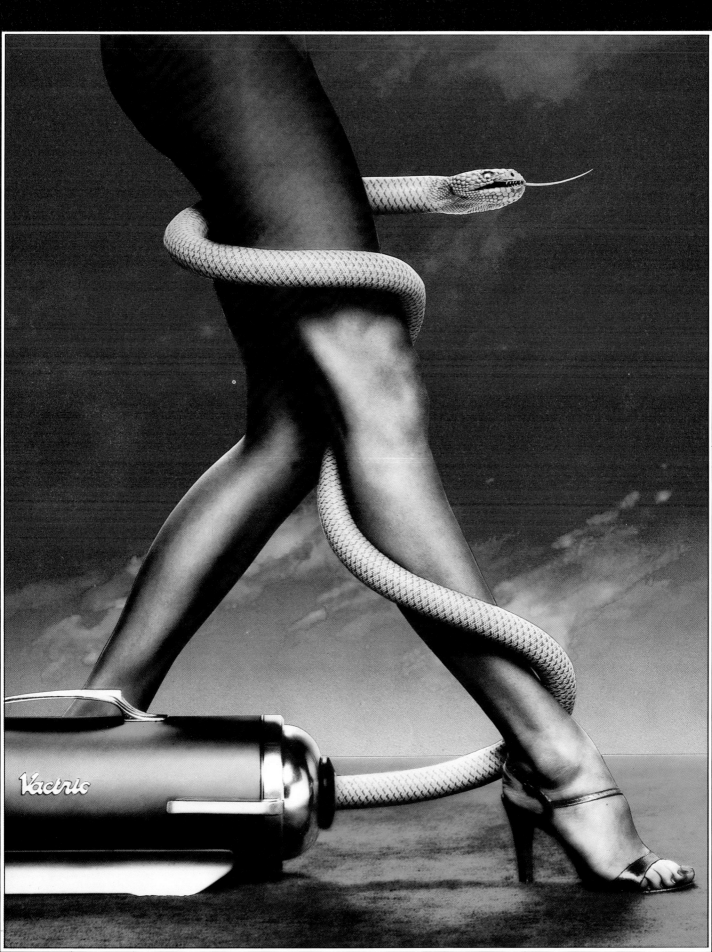

"The sea brings dynamism to my photographs. The movement of the water, the sun's reflections and shadows, the texture of the sand, play with the woman's body and transform or redefine it."

LUCIEN CLERGUE

Lucien Clergue's fascination with photography in general and the nude in particular has led him to set up a photographic meeting place in his home town of Arles, where aspiring photographers can congregate to discuss and practise their art. Clergue himself runs workshops and seminars which concentrate on the purely visual aspects of the medium.

His interest in the nude form is similar to that of a painter or a sculptor. He recalls visiting the museums in Arles and measuring the figures of the sculptures there, calculating the proportions which were judged 'perfect' in their day.

Through his photographs he has put into practice all he has learnt about form and has gone further in exploring the relationship between the nude and its surroundings. His quest has taken him to locations all over the world.

He rarely uses professional models, because he finds that they invariably add glamour and glossy sophistication to a picture. He prefers the spontaneity and lack of artifice that comes from using amateur girls as models.

The relationship between the model and the photographer is very important to Clergue. He says that there must always be respect for the model, and that the photographer should try to involve her in the picture-making process, otherwise the photographer cannot hope for any success. Clergue maintains that the natural shyness which occurs when a photographer undertakes his first nude session should not be extinguished, since it helps to bring the two participants emotionally closer.

He always shoots by daylight, finding that it compliments the spirit of his photography. He thinks that artificial light, whether it is flash or tungsten, is alien to his pictures, and he finds anyway that there is really no need for it, as a good tripod will compensate for inadequate light.

Locations play a tremendously important part in Clergue's photographs. Arles itself is an ancient town, full of the remains of Roman

The shot (RIGHT) from Clergue's collection of 'Urban Nudes' was taken in New York in winter. It reflects the fascination which Clergue shares with his friend Andre Kertesz, for contrasting the private vulnerability with the relative brutality of the outside world. The plants and the glass table are components of a domestic scene, whereas the view from the window shows only the bleakness of skyscrapers and freeways. The snow on the ground is also in strong contrast to the warmth of the interior of the room.
17mm lens, Kodachrome 64, 1/60th sec, f5..6

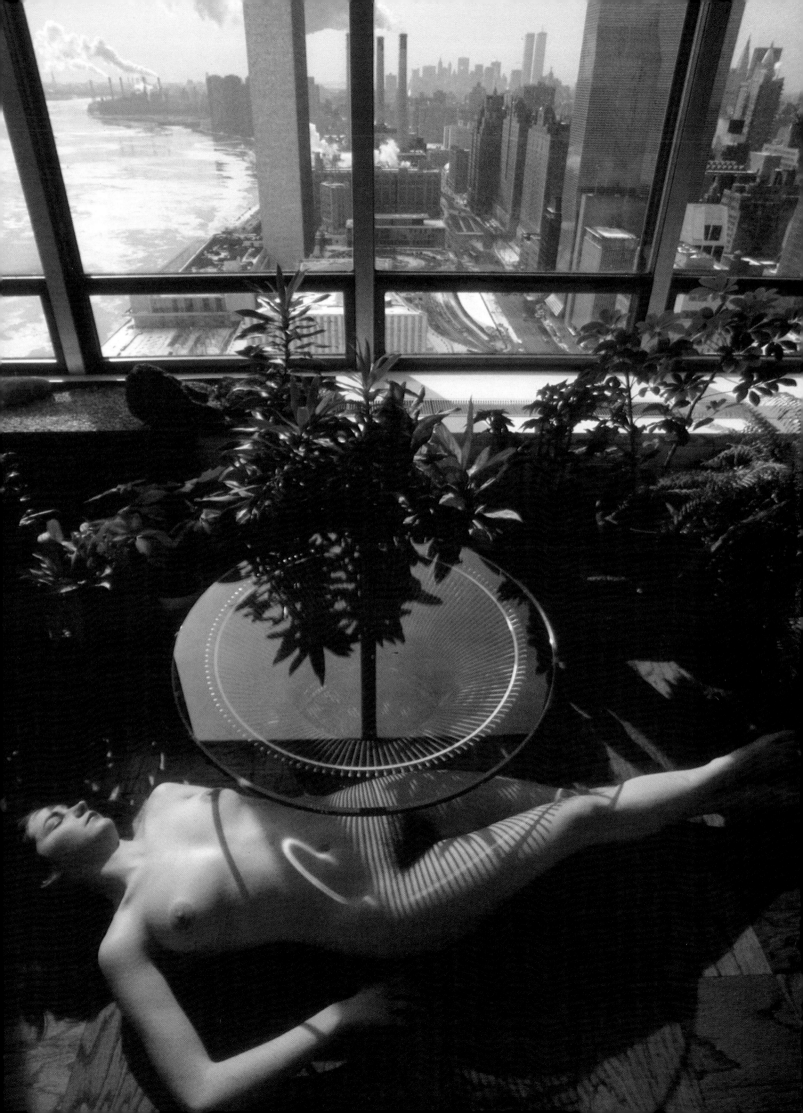

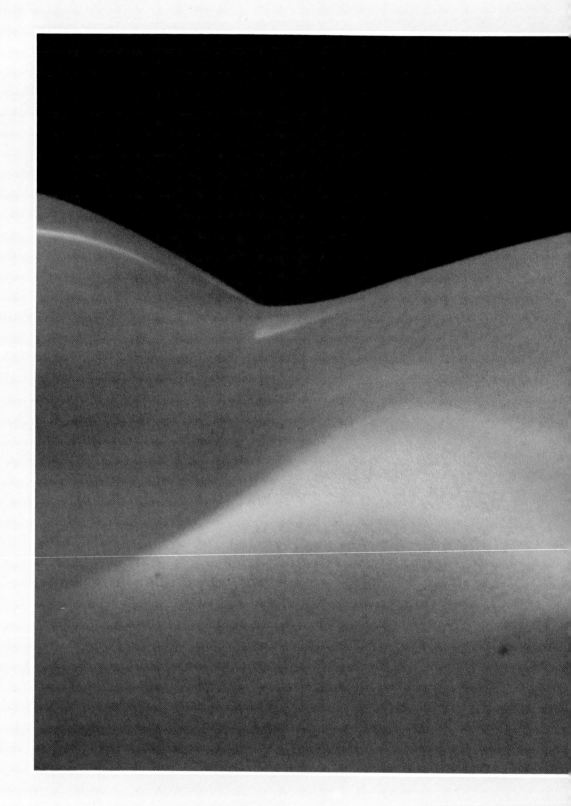

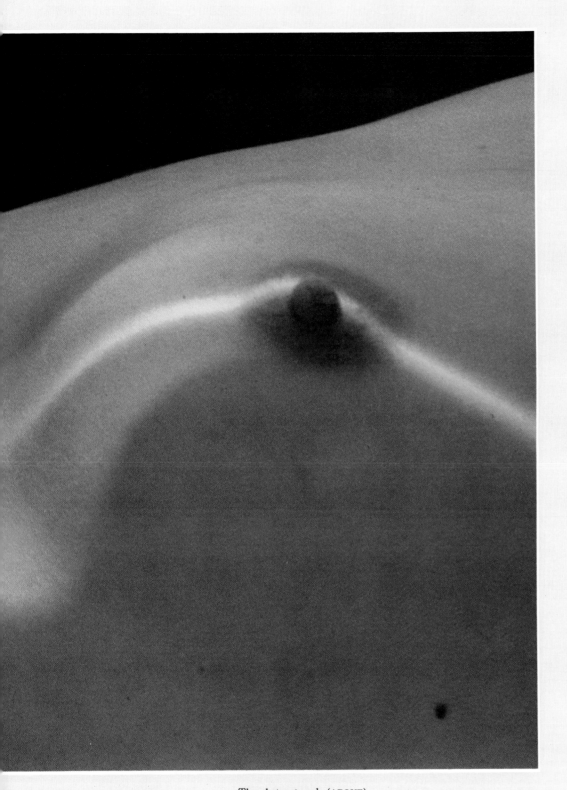

The abstract nude (ABOVE) was photographed in a lighthouse on the Mediterranean coast of France. Clergue posed the model so that the beam of light split by the giant fresnel lens of the lighthouse fell across her breast. The curves of her body have altered the shape of the shaft of light. *50mm lens, Ektachrome 64, 1/8th sec, f2*

One of Clergue's favourite ways of portraying the nude is to reduce the image to an abstract. In this shot he has carefully arranged the models so that they produce a composition which the viewer cannot immediately make out. Each of the elements in the picture has been carefully arranged to show ordinary parts of the body in a new and visually stimulating way. *85mm lens, Ektachrome 64, 1/60th sec, f8*

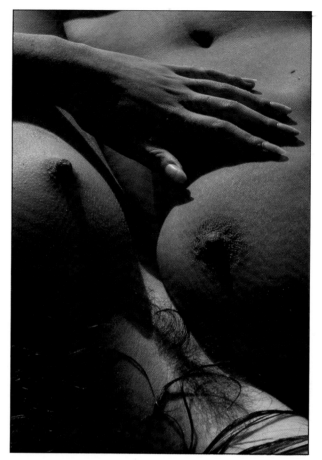

The sea has always been a great provider of inspiration to Clergue (RIGHT). It adds a dynamism to what would otherwise be a straightforward portrayal of the female nude. His habit of 'beheading' his models allows him to represent their shapes as exercises in designs rather than characters in their own right. The shadow which appears at the top of the frame is another example of Clergue's method of reducing the female body to pure form. *17mm lens, Ektachrome 64, 1/30th sec, f16*

buildings which have fired Clergue with an enthusiasm for architecture. This has found expression in his collection of pictures entitled 'Urban Nudes'. 'Each time I photograph a nude in a room', he says, 'I think very carefully about the model's relationship to the shape of the room.' If a window is to be included within the frame Clergue is careful to make sure that what is seen through it bears some relation to the foreground part of the picture.

Clergue has also produced memorable studies set in forests and in deserts, but out of all locations, he loves the sea best. 'The sea brings dynamism to my photographs. The movement of the water, the sun's reflections and shadows, the texture of the sand, play with the woman's body and transform or redefine it.'

Clergue maintains that the photographer cannot plan in advance what he is going to do during a session. 'You must leave yourself open to what might happen. And even if you find yourself in an environment that is not everything you had hoped it would be, you must try it. This is where your imagination is really in demand.'

A distinguishing feature of Clergue's pictures is his penchant for 'beheading' his models. This started when censorship in France was much tighter; it meant that many of his friends, who posed as models for these pictures could ensure that they would not be recognized as their heads were excluded from the frame. But there is

another reason why Clergue continues to behead his models. Without a face, a woman becomes less of a 'character' and more emphasis is thrown on to her form, and it is to this that Clergue wishes to draw the viewer's attention.

Clergue's chosen format is 35mm, for its ease and portability, as well as for the rectangular frame which is well suited to the shape of the human form, lying or standing. He shoots both in colour and black and white, although his black and white work is perhaps the most important part of his output. For colour, he uses Ektachrome 200 reversal film in France and Kodachrome 25 and 64 for work carried out in America.

Many of his pictures, particularly those taken indoors, bear traces of distortion. This is usually due to his use of the 17mm lens. He feels that such distortion often reveals the human shape to greater advantage than simple straightforward photographs. He does in fact use all sorts of lenses. 35mm is another favourite focal length, and he will sometimes shoot on lenses as long as 400mm. Clergue finds that the barrel distortion which occurs occasionally in long zoom lenses can throw new life into a nude photograph.

Clergue's approach to the subject of nude photography is much closer to that of a painter or sculptor than to that of the glossy studio photographer. His fascination with the female form is, as he admits, a lifelong passion.

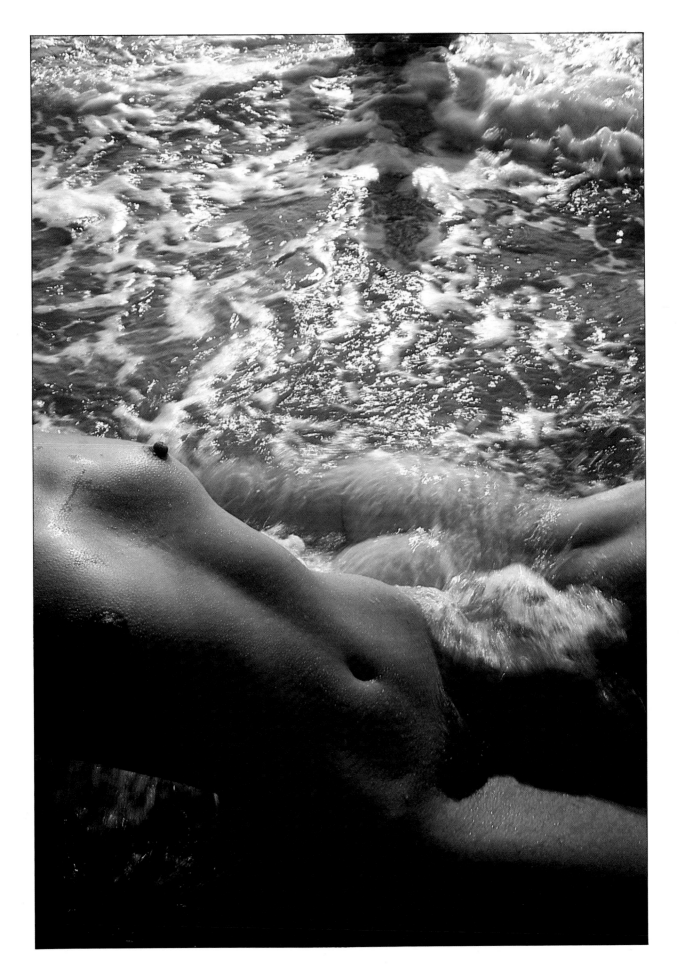

"I have a very exacting attitude to my photography. I like to have complete control over all the elements that make up my pictures. As far as possible, I leave nothing to chance."

JAN COBB

Jan Cobb's cleanly executed, classically composed pictures, marked by a bold use of colour, have made him one of America's best photographers of the female form.

He works almost exclusively in the studio, using electronic flash for illumination. It means that he can plan exactly what he wants in advance, and can take Polaroids of the sets and the lighting before the model even arrives. When the moment comes to start shooting, he knows that the result is going to be precisely what he had in mind, whereas when he shoots in daylight, he never has that kind of control. He will in fact only shoot by daylight if he is trying to capture some particularly exotic effect, such as a sunset, that would be very hard to recreate in the studio.

Cobb makes it clear he is not trying to make any statements in his pictures. 'I am just photographing what I consider to be a particularly attractive form. I don't want my models to come across as 'characters', says Cobb. 'The women I photograph are beautiful, and I am simply trying to bring that beauty to a wider public. I put women on a pedestal, because I think their appeal is worthy of that treatment.'

He is very choosy about models, preferring professional girls to amateurs. A model's pro-portions are very important to his work, and he does not find it easy to discover a girl with exactly the right shape. Skin quality is another aspect to which he pays particular attention, as he frequently lights the model from an oblique angle, and any blemishes show up badly.

Cobb trained for a period as a still life photographer, which gave him a clear understanding of the importance of lighting and colour. Many of his pictures of women are, to all intents and purposes, still life shots.

Cobb maintains that he did not realise that he had a particular 'style' until he saw several of his pictures in a magazine portfolio. He then noticed that all the shots were horizontal, and either had a strong shape on the left side and a weak one on the right or vice versa. But he denies that he developed a style consciously.

He uses 35mm cameras for his work, because he prefers the rectangular format. It also allows him to use Kodachrome film, which is good for reproducing the strong primary colours that he loves to have in his pictures. His favourite lenses are the 85mm and 105mm optics.

Cobb's work demonstrates how the techniques of the still life photographer can be successfully applied to glamour photography. The final produce is a beautifully crafted image that relies on natural beauty for its appeal.

This studio shot (RIGHT) was taken as part of a series to advertise swimwear. The idea was to make the girl look as if she was underwater. Cobb posed the model against a grey painted background. He put a blue filter over the front element of the lens before shooting so that the whole shot would be suffused with a blue tinge, giving the appearance that the model had been photographed in the sea. The diver's mask was an obvious accessory and allowed him to depersonalize the image and concentrate the viewer's attention on the model's body in the swimsuit. *85mm lens, Kodachrome 64, f11*

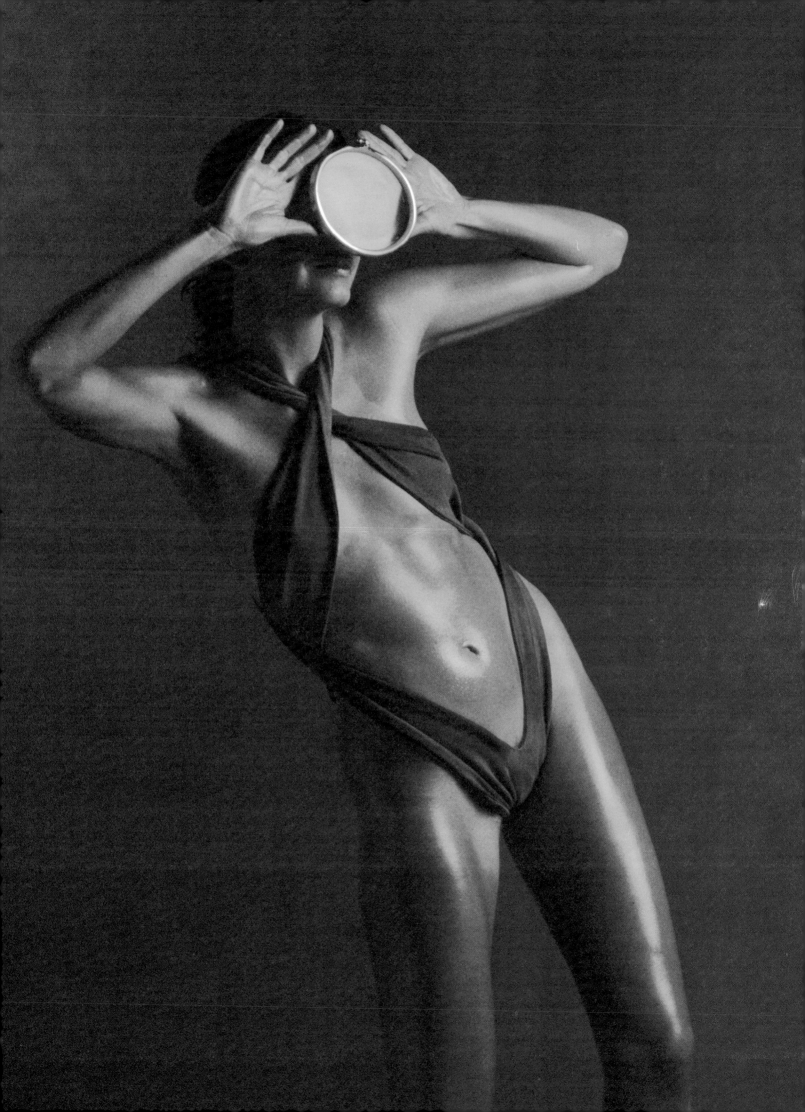

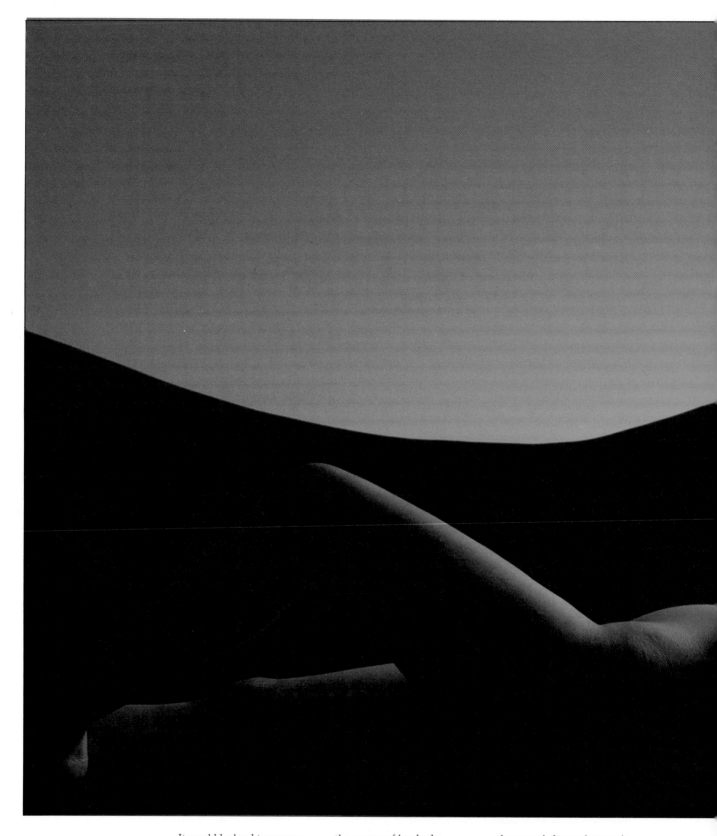

It would be hard to come up with a simpler idea for a photograph (ABOVE), and perhaps harder still to improve the technique. Cobb simply made a large cut-out from a sheet of plywood to create a backlit landscape. The model was stretched out full-length in front of it so that the curves of her body roughly matched the undulations of the mock landscape. For lighting, Cobb placed a long linear strip flash unit behind the plywood sheet and fired it backwards on to a painted backdrop. The model was lit separately from above. Cobb then took the photograph from a low angle and the effect was complete. *35mm lens, Kodachrome 64, 1/30th sec, f4*

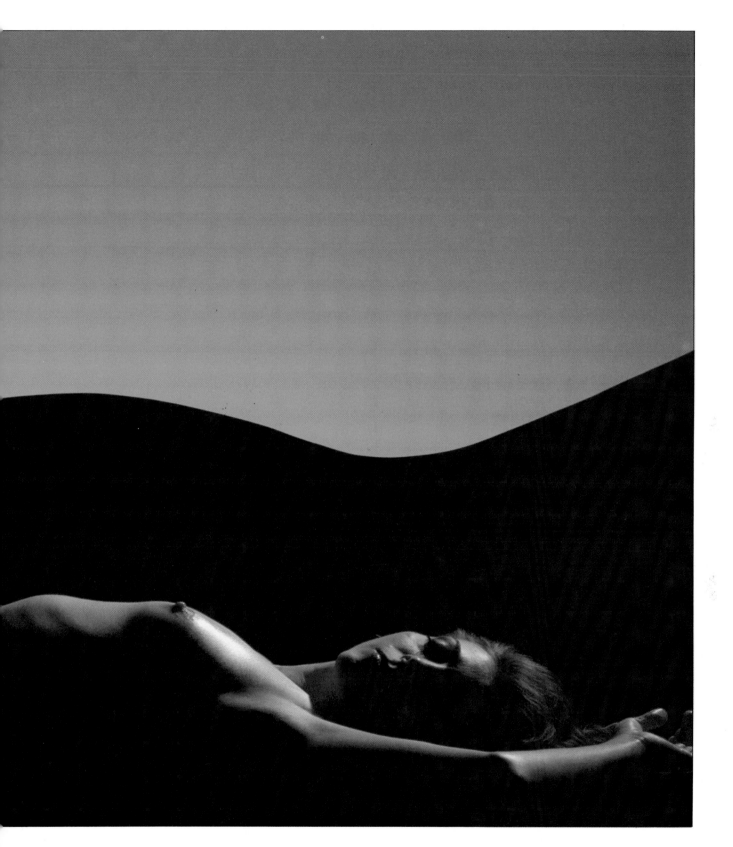

"The aim in my pictures is to make the models look pretty rather than sexy, although they are almost always topless. In this respect I tread a tightrope. If the girl looks too raunchy, the image represents a threat to the viewer; if she is fully clothed the image becomes too tame to be worth a second look."

BEVERLEY GOODWAY

Beverley Goodway has always been a newspaper photographer. He started out on hard news, moved over to editorial fashion and now he produces the pin-up pictures that have boosted sales of tabloid papers during the past decade. He works to deadlines and is constantly at the beck and call of editors. His output is far higher than most other glamour photographers. However, despite the pressure he must turn in results that are technically satisfactory and present the kind of image the paper is trying to project.

His aim is to make his models look pretty rather than sexy, although the girls are almost always topless. In this respect he treads a tightrope. If the girl looks too raunchy, the image represents a threat to the paper's readers; if she is fully clothed the image becomes too tame to be worth a second look and the paper risks losing circulation.

The outcome of these restrictions is that Goodway has developed a formula which he knows will keep him on that tightrope. Since the speed of the production process makes it very difficult to experiment, and since his formula is successful, Goodway sees little point in changing it.

In one respect Goodway is very fortunate. He never has to look far to find his models; they turn up constantly at his studio, hoping for work because they know that he can put their image in front of four and a quarter million people overnight. Goodway prefers to use professional models in their late teens. There are several reasons for this. He finds them experienced enough to be perfectly at home in front of a camera and they do not need much in the way of direction. They know about details such as make-up and hair and, if they are good, they can turn on a 'performance' at will. Yet they also have the advantage of being young, with superb figures and a freshness that shines through even on cold newsprint.

In comparison, girls who are new to modell-

Goodway posed the model (RIGHT) in front of a dark background, so that light from his battery of strobe units would fall off to darkness and leave the girl strongly illuminated with no real visible background. A large soft light was positioned above the model's head to give her hair the rim-lighting effect. Frontal light came from a flash head placed either side of the camera position. The model's lacy coat avoided giving the impression of too much naked flesh, and her smile made the picture look wholesome. Goodway specifically asked the model to put her hands in the positions shown to stop her worrying about what she should do with them.
150mm lens, Ektachrome 64, f11

ing require more careful handling and far more direction — all of which takes time. Occasionally, a new girl takes to the job extraordinarily quickly, and that, Goodway finds, very exciting.

The ingredients of a Goodway shot are fairly straightforward. The girl always occupies the centre of the image area. She looks directly at the camera. The background is generally a single tone, and there is never more than one prop. The clothing that covers the model's lower half is carefully chosen to add either colour or balance to the picture. In almost every shot the girl will be smiling innocently. The lighting is bright and is concentrated entirely on the model.

When he is working in black and white Goodway prefers to shoot against a pure white background as this sets the model forward and makes no demand on the viewer. With both colour and black and white he finds it important not to let the background distract the viewer's attention from the main area of interest. He has experimented with various things — plain coloured paper, painted canvases, venetian blinds — and has come to the conclusion that the best effect is achieved when the background is as unobtrusive as possible.

Goodway is wary of props. They can help tremendously, particularly if the model is nervous, but if they are too interesting they have a

High key lighting nearly always suits blond girls. It lifts their natural colouring and adds to their allure. The background and the model's jacket (ABOVE) have been chosen with care so that they match and provide an element of colour harmony within the picture, the darkness of the blue showing up the model's blondeness to good effect. The pose, although blatantly artificial, has advantages for the photographer; it allows him to make a geometrical pattern with the girl's arms and to show her figure to good advantage. A large soft light throws its beam down onto the back of the model's neck, rim-lighting her hair. Several smaller flash heads either side of the camera position illuminate her front. *150mm, Ektachrome 64, f16*

'If you're going to use a prop,' says Goodway, 'keep it simple.' In the picture (ABOVE) he has used a table, but it is covered so completely with material that it is really no more than a colour element within the picture. The material closely matches the tone of the backdrop and thus lends harmony to the overall picture. The model's blue bathing costume also adds to the effect. The main light for the shot comes from a soft light to the right of the model. The light patch of the backdrop is caused by a single flash head firing straight at it from behind the table. White reflectors have been used to throw a fraction of the fill back onto the model's chest and legs.
150mm lens, Ektachrome 64, f11

The model's pose (LEFT) gently emphasizes her proportions, but at the same time makes a neat shape within the camera's over-square format. This time Goodway has opted for an overall white look — background, necklace, earrings and bikini bottoms. Her dark hair stands out well from the background and so there is no need to set up any kind of backlight arrangement. The model is looking directly into the camera — a typical Goodway technique guaranteed to arrest the viewer's attention. *150mm lens, Ektachrome 64, f11*

Goodway's eye for colour seldom lets him down, and he counts it as one of his important assets. In the picture (LEFT), the model's clothes, her lipstick and her necklace are all blended, and the overall result is pleasing to the eye. Light from this shot came from a main flash unit to the right of the camera while a small spot was used to throw light on to the backdrop directly behind the model. The lightening of tone makes the model stand away from the background, rather than merge into it (a constant danger with matching clothes and backgrounds). *150mm lens, Ektachrome 64, f16*

tendency to steal the picture for themselves. That is why he limits himself to a single prop.

As far as colour is concerned, Goodway attempts to make everything harmonize — the background, the girl's clothes and any fashion accessories she is wearing. He prefers soft pastel colours, finding them more feminine and therefore more suited to the sort of image he is trying to present. Again, he looks for a colour scheme that is undemanding and yet pleasing.

Goodway uses studio flash for his lighting, but claims that he is constantly trying to emulate the effects of daylight. To achieve this he uses several flash heads grouped around the camera. When fired they are reflected off polystyrene sheeting. The idea is to create the spread of frontal light approximating to overcast but bright daylight. However he nearly always places one flash head behind the model's head to light her hair. He also makes sure that there is always a catch-light in the model's eye.

The focal point of nearly all Goodway's pictures is the model's eyes and it is vital that eye contact is established between the model and the viewer. This means that although the lens does in one sense represent the eyes of four and a quarter million people, for the shot to be

successful the impact must be felt by the viewer as one to one. In a session Goodway will wait until the model's eyes light up. Only then does he start exposing film.

Goodway used to shoot most of his material on 2¼ sq in. He now uses 6 x 7cm. He really notices the lack of the last two frames on a 120 roll with the new system. He does, however, enjoy the challenge of having to concentrate extra hard in order to make sure that he gets the same results from less frames.

He also shoots Polaroids, technically to make sure the colour balance is good and the composition is correct, but also to make the model feel more relaxed. 'If you show a girl a Polaroid of how she looks it usually makes her feel more confident,' he says.

Goodway admits to a nagging desire to shoot on location, if only for the scenery and the natural light. But he is a pragmatist, realizing that the weather in this country makes it too risky to set up a tightly budgeted, rigidly scheduled shoot outside. He admits that if he did try some location work, he suspects that the uncontrollable elements involved in outdoor work would soon send him rushing back to the reliable confines of his studio.

"I seize a moment when the girl is brushing her hair, or taking off her clothes and I will take a picture if her position is natural rather than a pose. That's why I don't like professional models — they always rely on stock poses, and that's not what I want."

DAVID HAMILTON

David Hamilton, a former art director, is an English photographer, who has scored a tremendous commercial success with his muted, voyeuristic pictures of young girls. This is thanks to the style he has developed, a style which is instantly recognizable, and which relies on photographic techniques available to anyone. As Hamilton himself admits, 'neither knowing nor caring very much about technical things is something that works to my advantage.'

It is true that the Hamilton style is relatively easy to define, and theoretically easy to copy but his choice of girl manages to set his pictures apart. He scouts the northern countries of Europe a couple of times a year to find girls who are young enough to have a schoolgirl's aura of innocence, and yet whose parents are prepared to let him use them as nude models. He says that he would like to use girls from the United States, where there are plenty who have the same sort of Nordic beauty as the ones he finds in Europe, but he has found the Americans uncooperative.

Hamilton likes to use locations in the South of France, because the weather and the light there are so good. He is able to choose where he shoots as he works for himself and there are no clients demanding that a particular picture should be shot, say, in Barbados.

The fact that he is his own boss has other implications. He can, for example, take as long as he likes shooting his pictures. A typical shoot would begin with Hamilton inviting the models down to the South of France. During their time there, Hamilton observes and occasionally photographs moments that capture his romantic, erotic view of a young girl's life. 'I seize a moment when the girl is brushing her hair, or taking off her clothes — the deciding factor is whether her position is natural, rather than a pose. That's why I don't like professional models — they always rely on stock poses, and that's not what I want.'

The leisurely framework in which Hamilton works belies his speed as a photographer. His training as an art director has given him a clear idea of what he wants, so he never overshoots, 'A session seldom lasts more than half an hour during which time I shoot half a roll or perhaps a roll of film,' says Hamilton.

Hamilton always seeks to photograph his young models looking natural, rather than asking them to 'pose' for the camera. The result is that the viewer attends the picture as an invisible voyeur, catching the girl while she is locked up in her own thoughts. In the picture (RIGHT) his model sits against a bright window covered with a layer of diffusing material. Hamilton has exposed solely for her body and allowed the window area to overexpose, silhouetting the top half of her body. The russet bedspread reflects a tawny light onto the parts of her body which are not illuminated by direct light from the window.
50mm lens, Ektachrome 200, 1/30th sec, f5.6

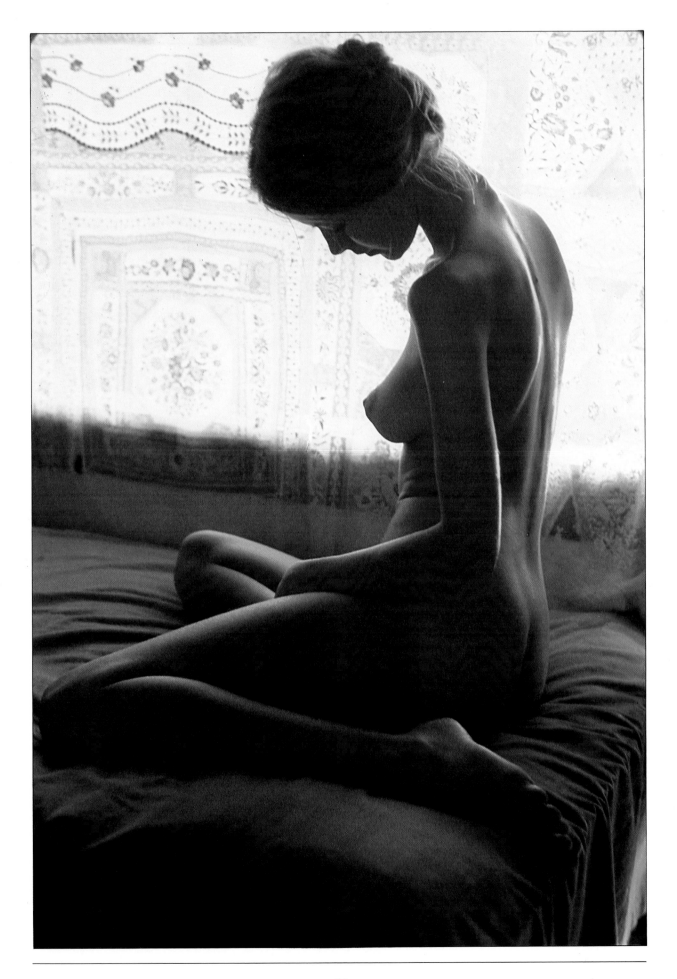

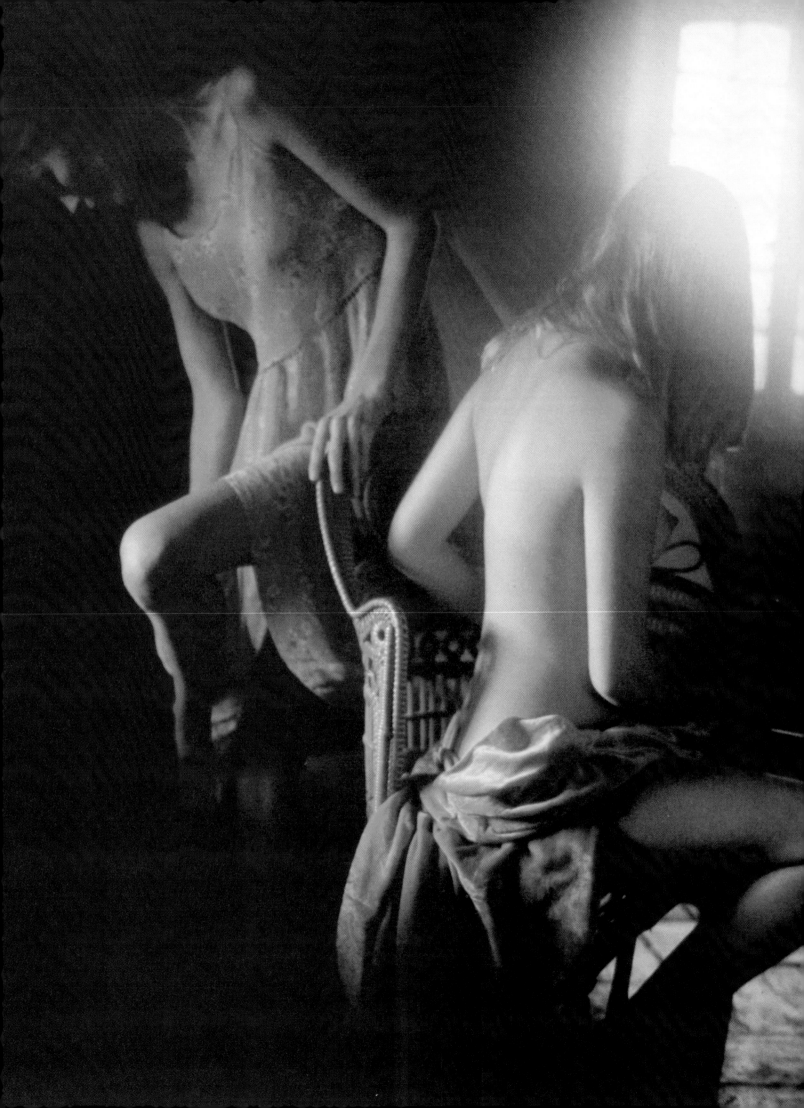

Hamilton photographed these two young girls (LEFT) in a room with windows on either side. The main light came from a window to the left of the camera, and the window in shot provided the photographer with an opportunity to demonstrate his skill at using flare. He gave the models a task to perform, and then waited until they were in a position that suited him, both for light and composition.
50mm lens, Ektachrome 200, 1/60th sec, f1.8

The setting for his pictures is very important. Each element is selected carefully for its colour and its sense of period. Lacy shawls, rattan furniture and potted plants abound in the world of Hamilton's young girls. The colours are always soft muted pastels, making his pictures reminiscent of an earlier, more innocent period.

He claims that he has been influenced by the gum bichromate pictures of Robert Demachy, and that his work has also been inspired by painters like Degas and Bonnard. Certainly the influences are there, in the pastel shades, the abandoned attitudes of the girls and the soft diffusion of light.

Hamilton will not work with artificial light, preferring to rely solely on daylight. This fact, combined with the type of film he uses, largely dictates his shooting techniques.

He always uses 35mm cameras, because they allow him to move around unhindered looking for better angles. He appreciates the camera's built-in meter, which allows him to assess the light levels without taking his eye from the viewfinder. The TTL meter also facilitates bracketing, a technique that he regularly practises.

The front elements of his lenses are almost always capped by a 5 magenta filter. He finds he has to use it because of the coldness of high speed Ektachrome. The magenta filter induces a deepening of the tones, which in turn effectively slows the speed of the film. This, added to the fact that the available light level is frequently low, explains why movement in Hamilton's shots is so often blurred. He uses slow shutter speeds, and wide apertures.

His colour pictures are often grainy, which enhances their period atmosphere. Even taking into account his use of high speed film it looks as if the film has been 'push-processed', but Hamilton denies this.

The diffusion effect for which he is so famous is not created by any one single technique. It is partly caused by the wide apertures, the fast film, and the slow shutter speeds, and Hamilton also uses all the soft focus tricks — vaseline on the lens, shooting into the light to induce spill, and mesh covering the lens.

For most of his work he uses a standard lens, because it offers him the possibility of an extra stop or two over longer optics. He also uses an 80-220mm zoom. He usually carries two cameras so that he does not have to worry about changing lenses at critical moments.

Hamilton is master of a particular set of photographic techniques. The resulting pictures have recieved wide acclaim, and he sees no reason to experiment or move on from his chosen field.

He is continually on the look out for girls whose images on film can conjure up that dream-like 'Hamilton' world of innocence and simple beauty.

"Some girls can just turn on a performance, which is fine for a quick session. But when I go on location with a model I always try to get behind the make-up and record something of the girl's character."

JOHN KELLY

John Kelly has been called the 'Calendar King', and certainly his track record seems to qualify him for the title. He started out originally in the sixties as a reportage photographer working for a London magazine covering fashion, music and gossip. It was an exciting time and Kelly documented everything from the activities of the Beatles, to homelessness. Kelly's work led him to meet and photograph many models, actresses and society girls. Almost inevitably he discovered the market's potential for glamour pictures.

Kelly admits frankly that one of the most appealing aspects about photographing women is that the shots are easy to sell. He qualifies this by asserting that women in general are the most difficult subject to work with. 'Some girls are a dream. It's almost as if they know what you want before you tell them. But there's another side to the coin. If you work with people there are always unforeseeable problems.'

Recently Kelly has been using some amateur models, and although there is no doubt that they need more direction, the rewards are evident in the freshness of the resulting pictures. 'It's always a delight to find someone new. It revitalizes my input.'

Kelly likes to work with girls who are naturally exuberant and extroverted, mainly because he finds it easier to play the calming influence during the session, rather than persistently trying to draw them out. He admits that he does occasionally enjoy working with a shy, retiring girl, but points out that they demand a different setting, a different feel, which is in itself a challenge.

John Kelly finds it essential to establish rapport with the model. 'Some girls can put on a good performance at a moment's notice, which is fine for a quick session,' he explains, 'but when I go on location with a model I always try to get behind the make-up and record something of the girl's character.'

He is not interested in simply recording an image. 'Without the personality, the image looks flat and dull', Kelly says, 'and the imposi-

Although Kelly is widely known as the Calendar King, this particular shot (RIGHT) was taken for the cover of a European magazine. It was photographed in Sri Lanka, on a bright morning at around 9a.m. Kelly organized the models on the beach, choosing their towels carefully for the colour. He made a point of roughing up the sand, because the magazine's readers would not expect to find themselves on holiday in a place so exotic that they would have an undisturbed beach. Kelly then climbed on to a diving board in the middle of a lagoon and fixed a 80-200mm zoom lens to his camera. The setting for this shot was 200mm and even then the frame was not quite tight enough to exclude the gold reflector which Kelly set up by the models' feet to throw light onto their bodies. He also used a polarizing filter to enrich the models' tans.
200mm lens, Kodachrome 25, 1/30th sec, f8

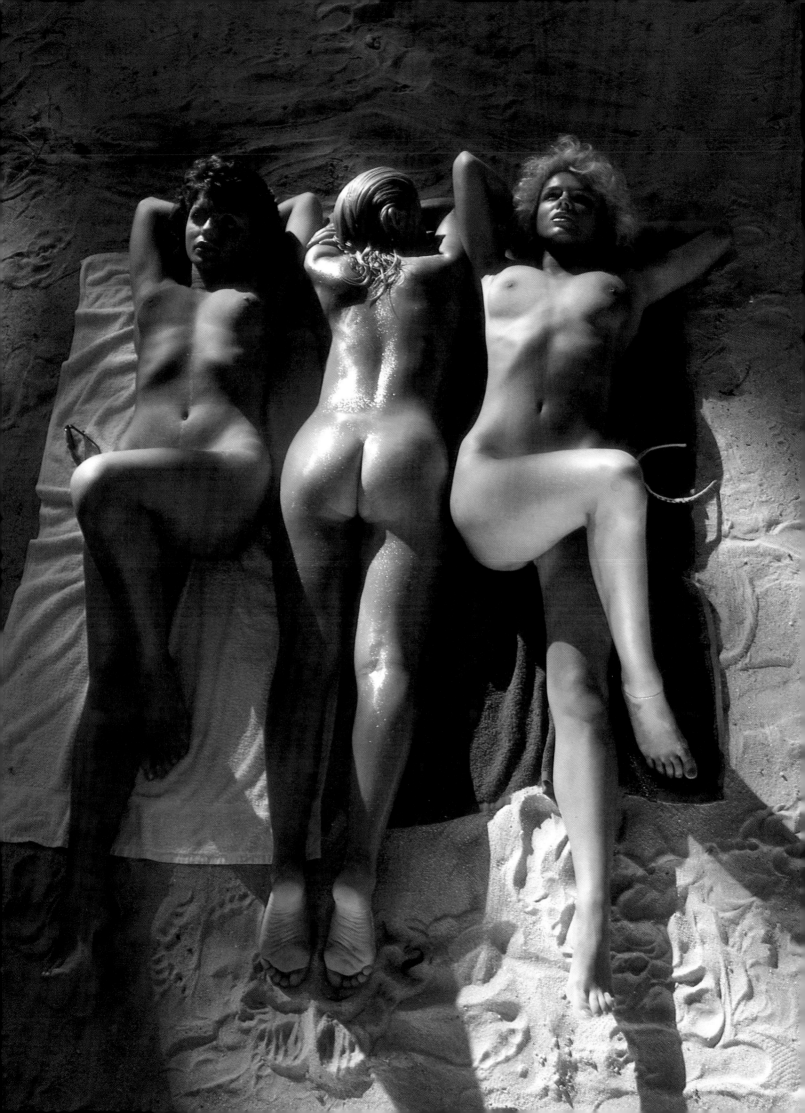

tion of style can only help a little. It is therefore essential that there is some effort from the model, otherwise you will never get a decent result'.

Like most professionals, Kelly has a few favourite models, who are reliable and whom he trusts on important foreign trips. He expects both commitment and hardwork from his models and is not prepared to pander to unprofessional whims.

Kelly works on his own as much as possible. Even on big foreign trips he keeps the numbers down to a minimum, not even taking an assistant, just his agent.

On a typical trip abroad, Kelly loads up his shabby, beaten-up leather camera bag with three Nikon FM bodies, a 50-300mm zoom, a 24-50mm zoom, an 80-210mm zoom, and a fast

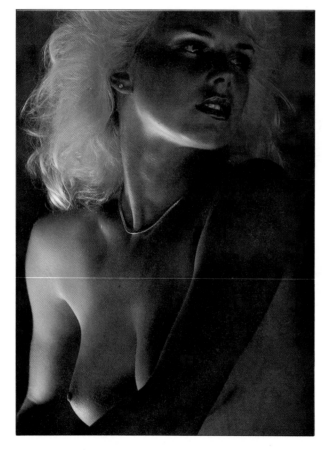

85mm, in case the light is low. He prefers 35mm as a format as he finds it easy to carry, the equipment relatively cheap, and the quality perfectly acceptable.

A large number of photographers are still wary of zoom lenses, but Kelly does not count as one of them. He praises the 25-50mm describing it as a real reportage lens, which allows him to work fast, either close in or from a respectable distance. He likes to keep each of the bodies fitted with a different zoom, so that he can swap from one to the other quickly and play around with the framing.

Kelly's preferred method of working it to get the model to perform; he then prowls around with his cameras, looking for promising angles and useful contrasts and shapes. He does not like having to shoot from a tripod, finding this restricts his freedom to search for the best compositions.

For outdoor pictures he uses Kodachrome 25 and for mixed lighting situations indoors he switches to Kodachrome 64. Occasionally he uses high speed Ektachrome, but only when he he cannot raise the existing light levels to accommodate the slower Kodachrome.

He usually raises the light levels by powering up one or two of the tungsten 'redheads' that he takes with him virtually wherever he is shooting. He prefers tungsten to electronic flash, mainly because of the warm tone it adds to

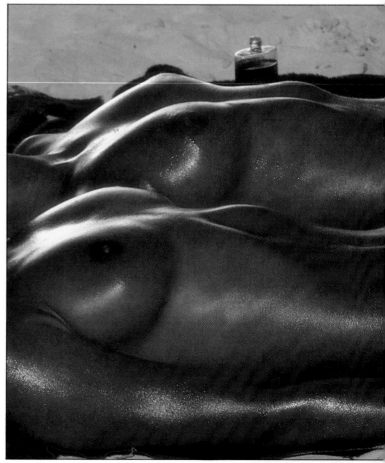

This picture (ABOVE) has only two elements — the model and the light. It proves that it is quite possible to take good glamour pictures without travelling halfway across the globe. The model was lit by a single tungsten lamp placed beside the chair on which she was sitting. Its beam was narrowed down by barn doors so that it did not spill over onto the background. The model was asked to hold a very exact position while the shot was taken, because otherwise the highlights beneath her breasts, along her jawbone and her eyebrow

would have been lost.
85mm lens, Kodachrome 64, 1/30th sec, f4
This picture (RIGHT) illustrates the essence of glamour photography — topless girls baking in the sun. Kelly was trying to capture the symmetry of the girls' bodies by photographing them from a low angle, and using a 150mm focal length on his 80-200mm zoom. The compression of perspective helps to make the two forms look almost like one.
150mm lens, Kodachrome 25, 1/60th sec, f8

46

Wide-eyed innocent-looking blondes often benefit from being posed amid natural surroundings. The model (RIGHT) seems to take her character from the environment. The girl was actually standing under a tree which reduced the light level sufficiently to make Kelly use a gold reflector (which is just out of shot at the bottom of the frame). Had he not bothered to use it the brightness of the daylight behind would have prevented the front of the model's body from being exposed properly. Kelly had to use a fairly slow shutter speed because he did not want the shot to be sharp from front to back, and he therefore needed to use a wide aperture.
85mm lens, Kodachrome 64, 1/125th sec, f3.5

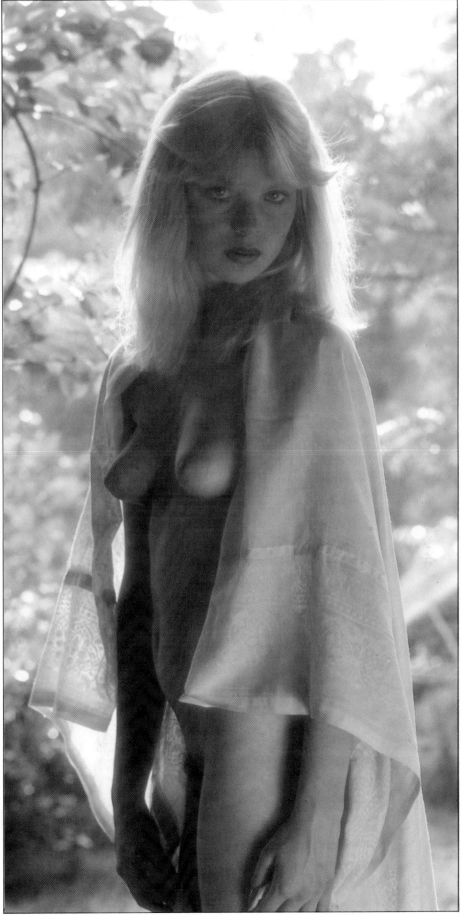

47

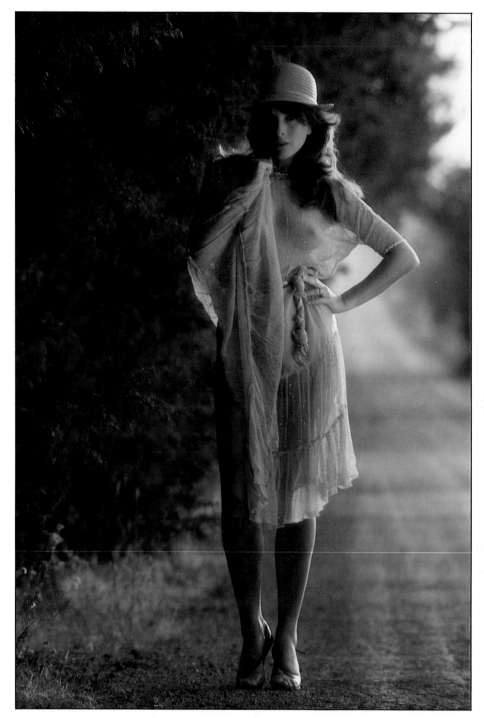

The shot (ABOVE) was exposed by evening light on a small road in Portugal. The strong sunlight filtering through from the right of the frame has effectively rim-lighted the model's hair and made the outline of her body visible through the flimsy dress. Kelly used a long lens — 300mm — to improve the perspective of the road behind, and a wide aperture to reduce the depth of field so that the road apparently disappears into an opaque haze.
30mm lens, Kodachrome 64, 1/15th sec, f8

a shot taken on film that is balanced for daylight, such as Kodachrome. 'The skin tones look warm and therefore more comfortable'. says Kelly. However in the studio Kelly is perfectly happy to use normal strobe flash. One of his favourite techniques is to have the model stand on a large perspex sheet. He places flash heads under the sheet and when he presses the shutter the heads fire and light the model from below. He finds he has to use a large soft front light as well, otherwise the girl ends up looking like something out of a horror movie.

Equipment is relatively unimportant to Kelly, and he certainly does not spend a fortune buying

Low evening light spread softly across a golf course in Portugal (ABOVE). Kelly planned the shot beforehand, ear-marking the location precisely. He wanted the girl to sit in a sandy-coloured chair and wear a straw hat so that the colour scheme matched her blonde hair. The shadows falling across her came from the trees on the other side of the fairway. There was no wind, but the girl was holding her hat because her uplifted arm gave a better shape to her breasts.
85mm lens, Kodachrome 64, 1/30th sec, f8

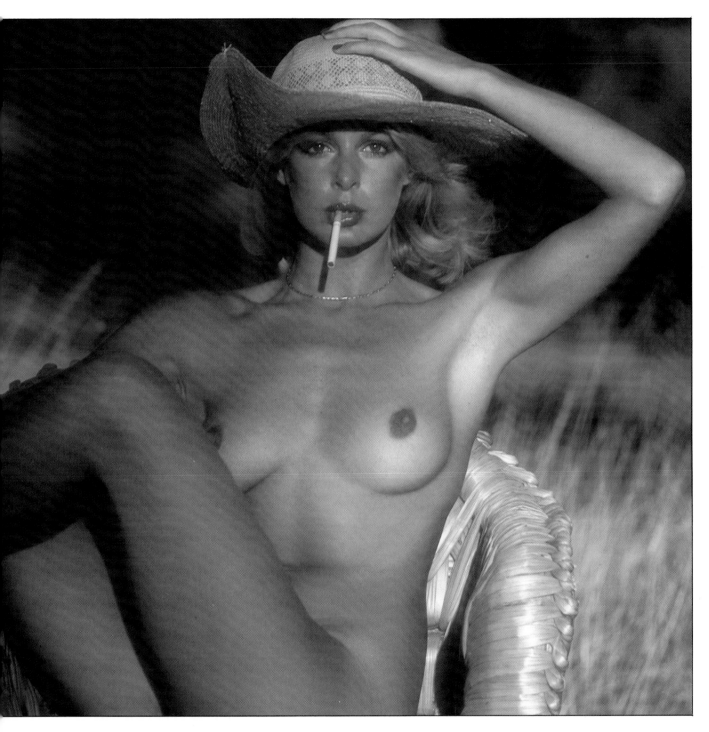

the latest lenses or cameras. He readily admits that he takes no care of his gear, saying that if it cannot stand the strain and breaks, he simply buys a replacement.

But his relative lack of interest in equipment is matched by an enthusiasm for light. 'That's what I'm looking for all the time. Natural light comes in so many forms, from so many directions, that I could never get bored with its variations. It's always a challenge, and as a photographer I respond to it,' says Kelly. 'Even when the light is problematical — there's not enough, or it's so strong that the contrast is practially unrecordable — there's always a picture to be

taken. I enjoy capitalizing on such difficulties. I suppose that's what professional photography is all about.'

Although over the years, Kelly has shot hundreds of thousands of pictures, mostly of beautiful women, the element of repetition does not seem to blunt his ability to produce top quality pictures. Nor does he feel the need to see other photographers' work to gain inspiration. Kelly says he still finds every shoot different. The conditions alter and the demand changes. Perhaps, as he says in his own words, 'it's because I have always had an eye for detail, and details can always be changed.'

"No object can be defined. It becomes what it is in the setting, in the hidden drama in which the isolated woman takes her position. In unfamiliar settings, the trivial objects of everyday life establish an emotional tension."

CHEYCO LEIDMANN

The art of photography depends on capturing a new visualization of objects, of people in a universe of objects.' Cheyco Leidmann's statement makes sense only when one sees his pictures. The objects in themselves have little interest but Leidmann's style of photography manages to make them take on a new significance, particularly when he includes a model in the shot. By juxtaposing the two elements he makes visual statements that are both challenging and direct.

Born and raised in south west Germany, Leidmann moved to Paris to start his career as a professional photographer. He has since established himself as one of the most innovative talents in advertising photography.

'I am a visual person, and I prefer to communicate without words,' says Leidmann. 'I want to transmit a feeling without explaining anything. I want people to understand me without imposing on them a concept of the world.' Although his work resists classification, he has nevertheless acquired a visible style, which can be broken down to a number of constituent elements.

His colours are extraordinary and are probably the most immediately fascinating aspect of his technique. He manges to attain a particularly high level of saturation in his pictures, mainly by the use of slow Kodachrome film, but also by using polarizing filters. 'The psychological impact of colour is tremendous,' says Leidmann. 'It can bring a shock to the consciousness of the onlooker.' Certainly the depth of colours in his pictures does immediately attract the viewer's attention.

'Colour cannot function without light, it is revealed by light,' Leidmann asserts, and indeed the interplay of light and shadow is critical in his beautifully crafted images. Leidmann manages to guide the viewer's eye around the frame, emphasizing an object here, a model there, by varying the tones of the image. The eye is attracted to the brightest part of the image first, and it starts to pick up more concrete clues about the picture's significance. Gradually, an entire impression is built up and the total effect is achieved.

The objects that play such a large role in Leidmann's visual imagination are all carefully

This picture (RIGHT) contains an overtly sexual and yet playful image which evokes a contradictory response. On the one hand the sexual imagery is threatening, and on the other the playfulness deflates the threat.

The shot demonstrates the assured manner in which Leidmann handles colour. The match between the model's dress and one of the balls of 'ice cream' is perfect, while the dark green background allows even the pale yellow to emerge slowly. The high viewpoint has allowed Leidmann to compose a balanced picture, with the girl's dress outstretched to offset the bulge of the 'ice cream'. Like many of Leidmann's pictures, this one can be turned any way and still have the same impact. *35mm lens, Kodachrome 25, 1/60th sec, f2.8*

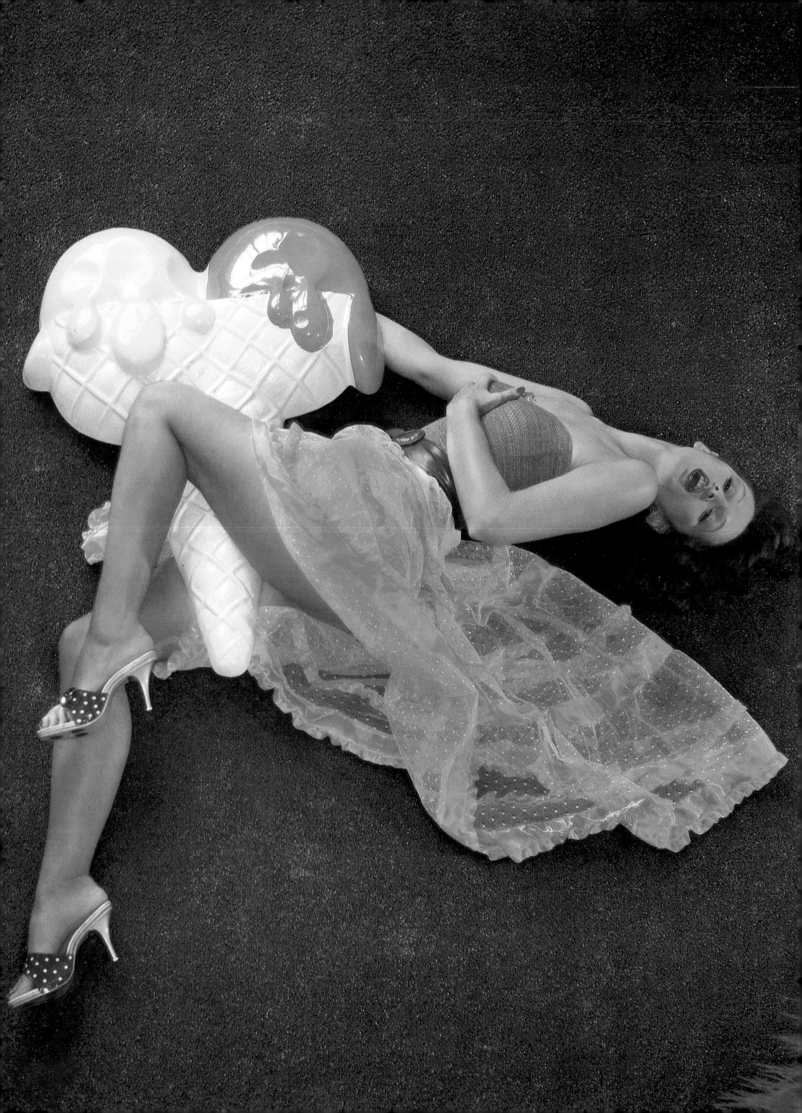

In the picture above Leidmann has managed to include the basic elements of his technique in one simple shot. The 'object', in this case, is the bikini bottom. The 'location' is the model's body. The colour content is provided by the stark contrast between the silver of the bikini and the dark brown of the girl's back. But what is apparently missing is the slightly surreal element that Leidmann nearly always includes in his pictures — until you realise that the whole image has been shot in the studio, where, of course, there is no sun by which the model can tan herself, nor any water in which she can swim. *105mm lens, Kodachrome 25, f11*

52

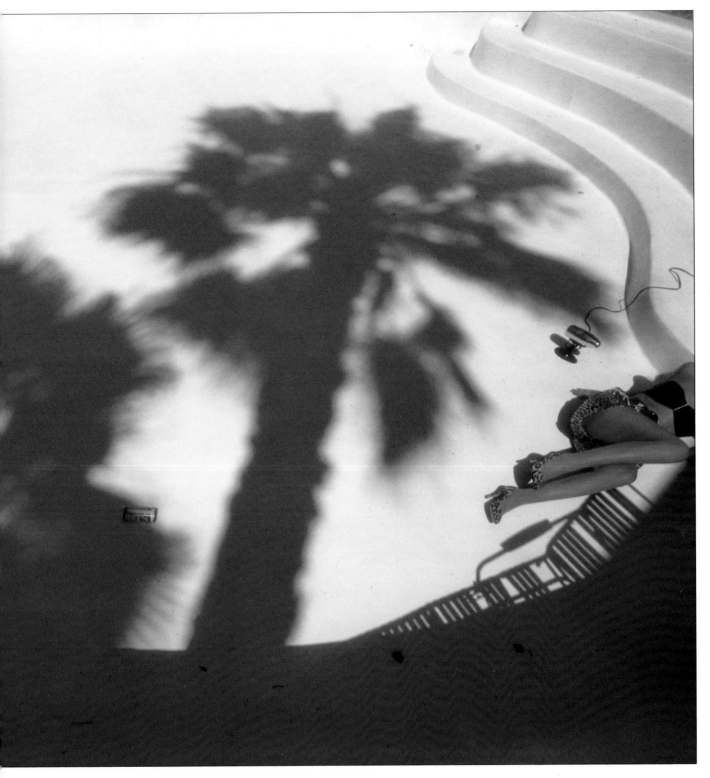

When Leidmann came across an empty swimming pool his imagination was immediately fired (ABOVE). As a location it had the surreal aspect that can turn an ordinary shot into one that is new and stimulating. A model was asked to lie with her head on the bottom step, so that her figure was just beside the shadow of the *chaise longue*. The juxtaposition makes the viewer think that she should be lying on the *chaise longue*, but Leidmann, as in other of his pictures, sets out to exploit accepted notions and unsettle our perceptions. The hair drier also seems unnecessary — the swimming pool is dry so there seems little chance of the model needing to use it. The palm trees growing beside this dry 'oasis' also seem bizarre. The picture poses numerous questions, and Leidmann again succeeds in provoking our attention.
35mm lens, Kodachrome 64, 1/125th sec, f5.6

chosen to add both to the design of the image and also to put across the meaning that each image is intended to convey. Yet the objects rarely exist on their own. There is nearly always a model in the frame, and the relationship between the object and the model is what Leidmann intends to portray. Leidmann describes the way he sees that relationship. 'No object can be defined. It becomes what it is in the setting, in the hidden drama in which the isolated woman takes her position. The objects added to the picture seem to have nothing to do with this woman. Yet they elaborate the drama in which she is the chief character. In unfamiliar settings, the trivial objects of everyday life establish an emotional tension.'

Leidmann prefers to work on location because he enjoys finding bizarre settings for his shots, and also because the settings themselves inspire his creativity. As a result he is quite prepared to travel anywhere in the world to find the right location. He will work in blistering temperatures, or intense cold, if he feels the setting is appropriate for the kind of image he has in mind.

He plans his pictures carefully, to the extent that he knows precisely what effect he is after and what combination of elements is necessary to convey his chosen expression. But he is also prepared to alter his plans, if improvisation seems likely to produce a superior end result. 'I will improvise in the course of shooting, trying anything that comes to me,' Leidmann says. 'On location I feel the need to bring the pictures to life. I let the inspiration of the moment direct me to create the symbolic force that I want to unleash on the viewer.'

Leidmann pours scorn on photographic technique, dismissing it by saying 'I am not interested in photography. I don't even believe in it'. Yet he uses many technical ploys to get his results. His colours are heightened by the use of filters. He is also prepared to strip details into his images at a later date, if he thinks that some extra element is needed to make the picture come to life. The only criterion is the look of the final image.

This eclectic approach applies to his choice of equipment as well. He does not stick to one particular format, swapping easily between 35mm, 2¼sq in and 5 x 4in with equal assurance and success. He has evidently broken through the barrier that distinguishes those who have to think about their technique and those to whom it is second nature.

Leidmann's images are at once disturbing and in a curious way comforting. The disturbing aspect stems from his bizarre use of props and settings, while the comforting part comes from the very ordinariness of the models and the props themselves. Either way, he achieves his expressed intention of catching the viewer's attention, and presenting him with everyday things in a new and stimulating way.

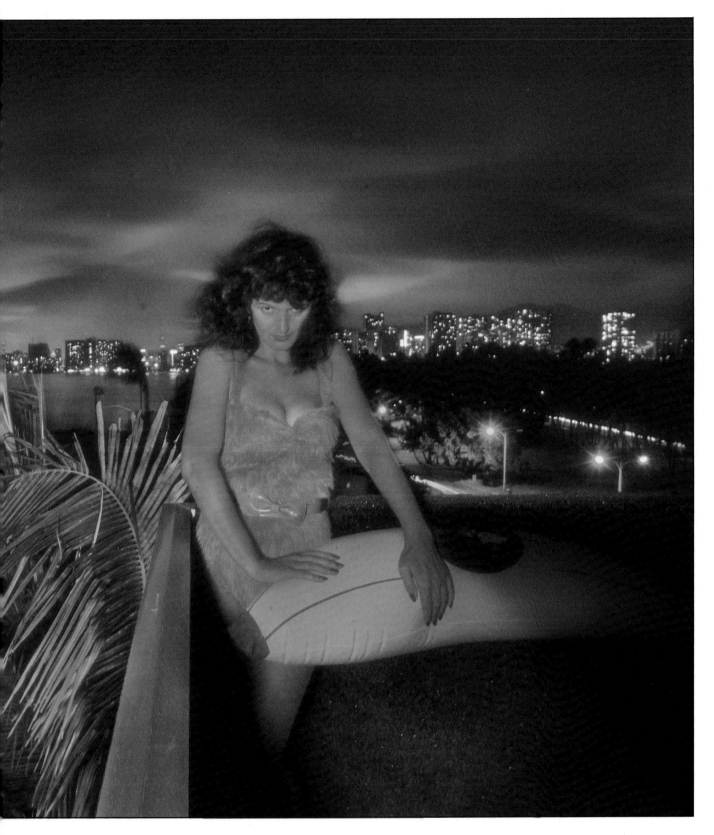

Leidmann used a fill-in flash technique to get this strange image on film. He waited until the daylight was disappearing on the far horizon and the dusk was falling fast and he then had to work very swiftly to complete the shot. Leidmann set the flash deliberately to provide complete saturation on the film of the model's orange dress. Her figure is the first thing that strikes one's attention. The obscene inflatable banana is next on the viewer's list of priorities. It suggest a great deal but remains ultimately mysterious. The viewer's eye is then led to the atmospheric far horizon, lined with buildings and lights. The extraordinarily rich and vivid colours and the existence of the model in her unidentified surroundings combine to make the picture both intriguing and dramatic. *35mm lens, Kodachrome 25, 1/60th sec, f2.8*

"I try to avoid direct frontal lighting as much as possible. It makes the subject look flat. Back or side-lighting seems to lighten the mood, and introduce depth into the shot."

PATRICK LICHFIELD

Patrick Lichfield is mainly a fashion and beauty photographer, but over the past few years his glamour pictures for calendars have received wide acclaim. A calendar shoot, particularly if it is to be conducted in an exotic foreign location, requires a tremendous amount of logistical planning, and that is only half the battle. There also remains the question of the pictures themselves.

Such a project starts with testing models. 'I make a list of about 50 possibles,' says Lichfield. 'A process of initial elimination reduces that figure to 10. When the girls come into the studio, I make video tapes of them going through a sort of routine. Afterwards I get together with the Art Director on the shoot and we can study the girls on video at our leisure. We are particularly looking at their figures and at their faces. At the same time, we are working out what the theme of the shoot should be. Ideally we are attempting to select three girls whose looks suit the mood we are trying to create in the shots.'

Simultaneously, in another part of the globe, a thorough survey is being conducted by Lichfield's location hunter, who documents the possible places and sends photographs of them back to Lichfield.

After a lot of argument and discussion, the Art Director and Lichfield finally settle on a choice of girls and location. His two assistants can then get on with organizing the equipment — the cameras, lenses, film and lighting gear. The models are sent off to a solarium for a bit of pre-tanning in order to minimize the risk of sunburn. The stylist gathers together props and clothes, and the make-up man liaises with the team to make sure he knows what look is aimed at.

During this planning stage, the whole crew are trying to foresee — and therefore minimize — any problems that might arise. Film is clip-tested to establish correct ISO ratings; cameras are serviced, and the small amount of electronic flash equipment is tested, just in case it is required. Lichfield and the Art Director draw up roughs — sketches of ideas they want to try.

By the time the Lichfield crew arrives at the location, they have a very clear idea of what they want. Inevitably, once they get there, things change. The location itself may suggest better ways of achieving an idea originally conceived in a London studio, or the weather may preclude other picture ideas. However even if one idea falls by the wayside, another one will occur to

This shot (RIGHT) was taken during the expedition to Sicily to take photographs for a calendar. It is one of Lichfield's own favourites although it was not included in the calendar. It was taken at dawn, around 6a.m., by natural light filtering in to the cellar of the stately home in which Lichfield and his team were shooting. The strong geometric pattern of the model's body and limbs overcomes the gloom of the cellar, and provides an almost abstract image.
50mm lens, Kodachrome 25, 1/30th sec, f2.8

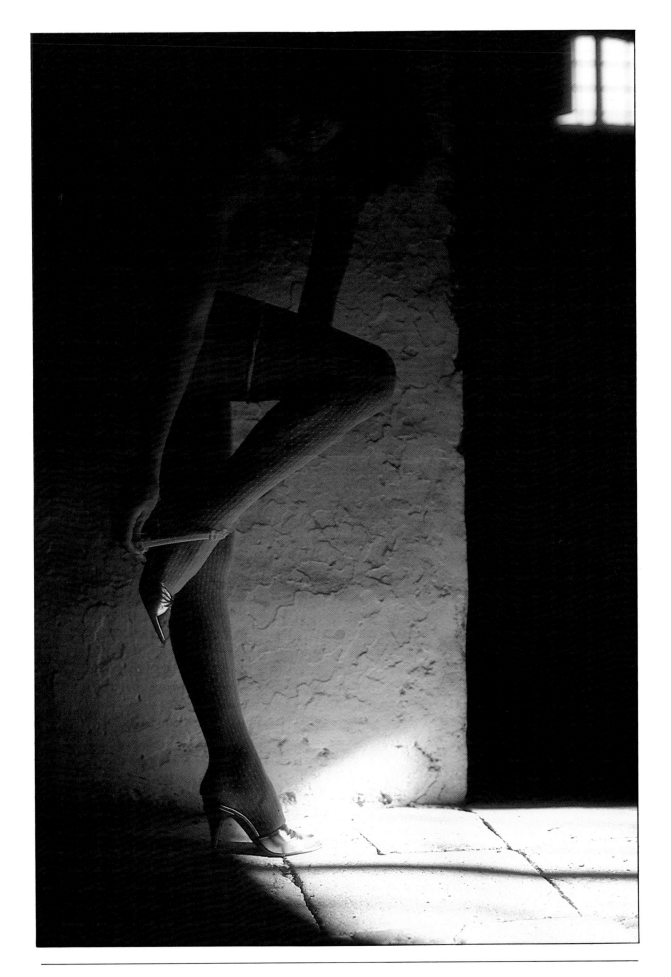

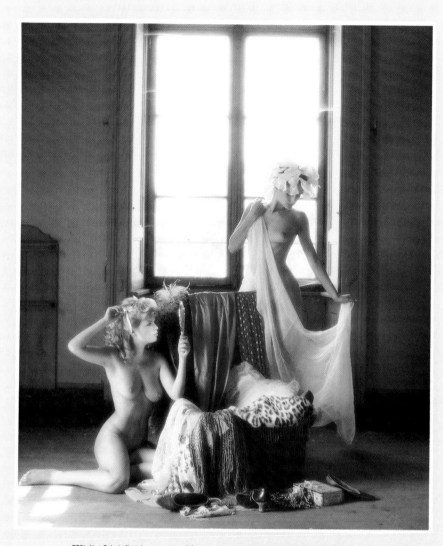

While Lichfield was working in an old French chateau, he and his team found an old chest (ABOVE). The photographer conceived the idea of setting up a scene with the two girls, as sisters, discovering a chest full of clothes and indulging in some innocent dressing-up. The stylist filled the chest with jumbled clothes and bric-a-brac, and carefully arranged the set. The girls then simply played out their 'roles'. Lichfield chose to shoot the picture against the light because he considered that this technique helped to tighten the mood of the shot. It also gave him the opportunity to allow the daylight to spill over the image, creating gentle diffusion. He used Ektachrome 200 film but pushed it to 400 in the processing. Reflectors were used to throw light back into the girls' faces.
35mm lens, Ektachrome 200, 1/60th sec, f4

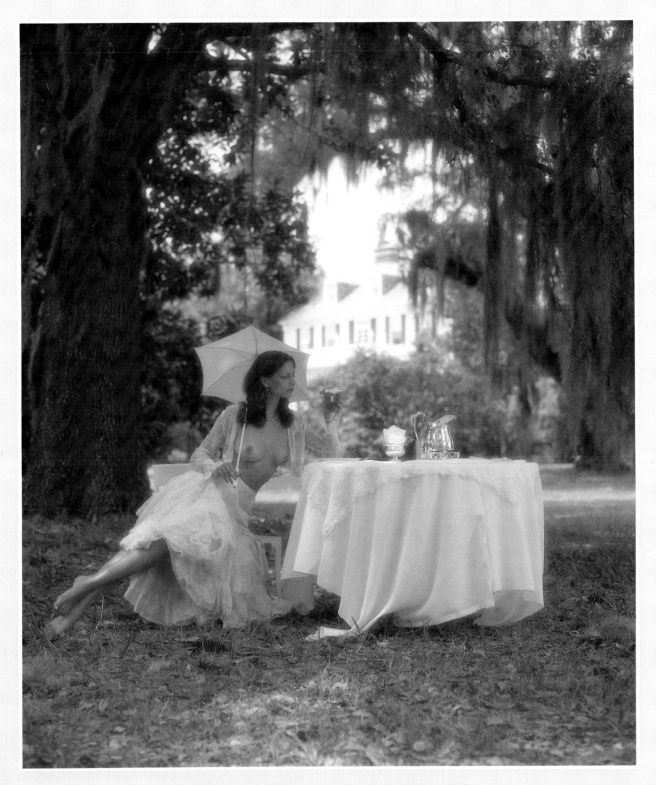

On location in the American 'Deep South', Lichfield was looking for a shot (ABOVE) which would establish the house and grounds that they were using for an entire calendar shoot. The idea was to produce a picture that set the scene and the tone for that year's calendar. The grand style of the southern planters is reflected in the house itself, the clean white table cloth, and the gentle sipping of mint julep, a drink associated with this setting. The model's naked bosom is the only aspect of the scene which is out of place and therefore draws the eye. Lichfield used a 2¼sq in camera for the shot, employing a 150mm Softar lens to give the image a diffuse feel.
150mm lens, Ektachrome 64, 1/125th sec, f8

the team while they are there. As the shoot progresses, compromises are made and advantages are capitalised on. 'Adaptability is vital for a successful shoot,' Lichfield points out.

The look of each calendar is predetermined by Lichfield and the Art Director, and they try to avoid being labelled by going for a new approach each time. It would be misleading to suggest that a particular calendar represented Lichfield's own photographic style, because the pictures are, to a large extent, a synthesis of the talents of Lichfield himself, the models, the Art Director, the make-up man and the stylist. 'You can't help acquiring a style,' says Lichfield, 'but I fight against it all the time. For example, I find that I am consistenly attracted to symmetrical shapes in pictures. If I let my heart rule my head, I'd probably produce hundreds of perfectly symmetrical compositions, which would be adequate — and dull. So I consciously avoid symmetry, unless I can convince myself that it is justified and effective.'

A clue to Lichfield's visual approach to glamour photography lies in the fact that he has no desire to use the glossy, high-tech methods that are currently popular with photographers working in the advertising field. 'I think the cold, impersonal look has been done to death,' he says. He prefers to depict his women in a warmer, more human way. This means using photographic techniques which tend to flatter the models and which produce pictures which align with accepted male notions of femininity.

On location he uses either 35mm or 2¼sq in cameras. The decision as to which format he will actually use is very often taken on the basis of film. If he wants the sharp rich tones of Kodachrome, he uses 35mm. But Ektachrome, which he uses in the 2¼sq in camera, is more suitable for soft, romantic images and it also offers the possibility of push-processing which is useful when the light levels at the time of exposure are lower than a photographer would wish.

On location, Lichfield likes to use available light as far as possible, even for interiors. He would rather use a slow shutter speed and a wide aperture than rely on electronic flash, which, he says, 'should theoretically look like daylight but never does'. Naturally reflectors are an important part of the equipment Lichfield takes on location.

'I try to avoid direct frontal lighting as much as possible,' he says. 'It makes the subject look flat. Back- or side-lighting seems to lighten the mood, and introduce depth into the shot.'

Lichfield himself is the first to give credit for the success of the calendar pictures to his dedicated team of helpers, each of whom is an expert in his or her chosen field. But ultimately it is Lichfield himself whose name is attached to the finished product. It is his eye for an attractive photograph that sets the seal on the package.

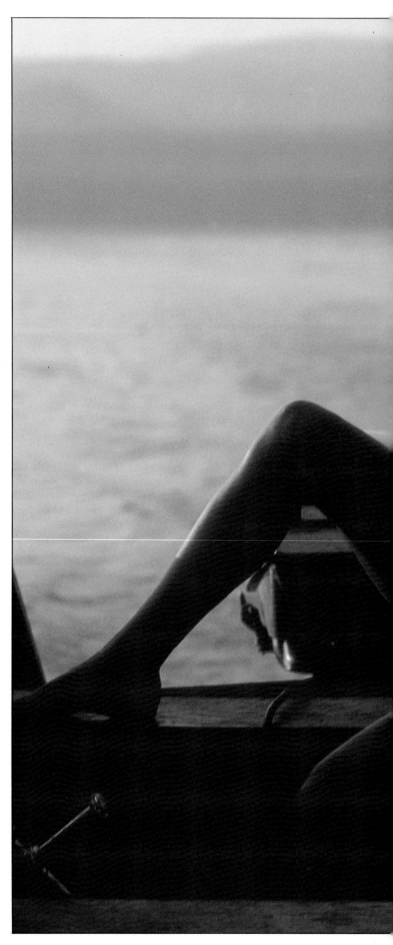

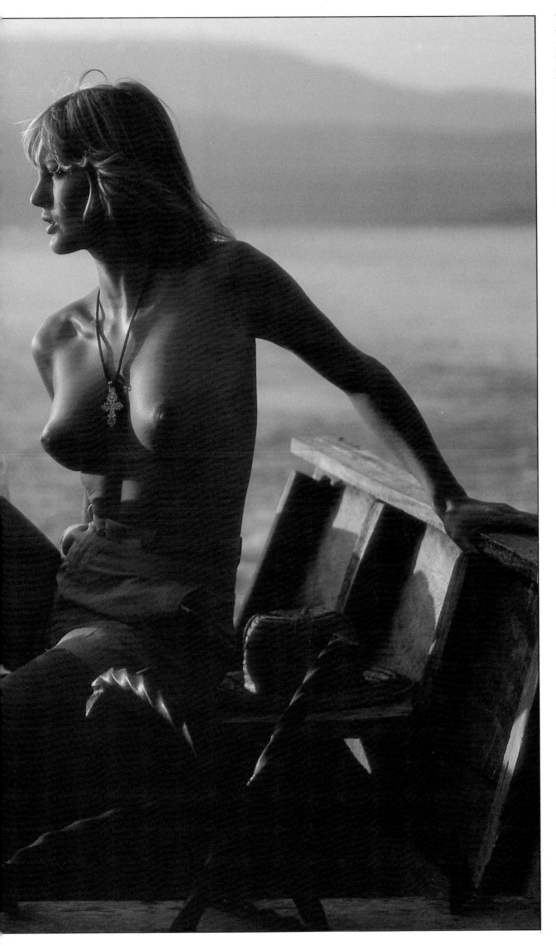

This shot was taken at dawn in the middle of Lake Baringo, for a calendar photographed entirely on location in Kenya. Lichfield was sitting at one end of the boat while the model basked in the first rays of the African dawn. The shot was backlit, and the problem was to make sure the team had completed the shot before the sun climbed too high and destroyed the golden spill of light which only comes in the early morning or late evening. *150mm lens, Ektachrome 64, 1/125th sec, f4*

"I always have a clear idea of what I am trying to achieve with a studio shot. I look for strength and purity of line, because I know that they will attract the viewer's attention. The combination of pure colour tone and bold shapes has enormous power. The fact that the composition and the colour are so important means that the model is simply another element. I'm not trying to capture character. If I wanted to do that I'd be a portrait photographer."

JOHN MASON

John Mason's approach to glamour work stems directly from his fascination with graphic design. To gain his visual effects he plays with the elements that make up a picture until he arrives at a design in which they combine together to produce a single unforgettable frame, bathed in the cold power of studio flash.

Mason's work is characterized by his use of stark bold shapes set against deeply saturated colours. If he wants a blue background, he uses a deep azure rather than a pale, weak tinge that will hardly register on the viewer. The same applies to his use of shapes. He looks for strength and purity of line, because he knows that they will attract the viewer's attention. This combination of pure colour tone and bold shapes gives his shots enormous power.

Like most creative photographers, Mason relishes the prospect of dreaming up ideas for pictures. Clients contact him and ask him to produce a picture idea that combines, for example, a car tyre, a girl and rain. Mason will then draw up a number of ideas that all contain these basic elements. The client will choose one and Mason will attempt to recreate the idea.

Working from a rough design, Mason usually starts by setting up the background. Backgrounds are very important to the overall effect he is trying to achieve, but he is careful not to let them distract the viewer's attention from the main point of the picture. He tends to go for coloured paper backgrounds, which allow him to make use of a very pure tone. He is prepared to take time to find precisely the right background paper, and will then spend more time making sure that it is evenly lit, so that it has a distinct role to play in the final image.

Gradually, Mason puts all the elements in front of the background. He uses a stylist to organise the props, but briefs her very carefully as to the sort of 'feel' he is trying to achieve. It is very important for his pictures that the props are in keeping with the overall tone of the shot, and that they are correctly lit. He is currently going through a 'high-tech' period, with a lot of gleaming chrome and shiny black.

Any clothes that are needed for the picture are hired or bought specifically for the purpose. Mason does not believe in keeping a huge wardrobe simply because he likes to treat each job as a separate entity.

In one sense, the model is simply another prop for Mason. He always has a clear idea of what he is trying to achieve with a studio shot and the fact that the composition and the colour are so important means that the model becomes just another element in the picture. He does not attempt to capture character, asserting that if he wanted to do that he would be a portrait photographer.

His choice of models is dictated to a large

Mason produces many of his photographs for the vehicle industry. This shot was taken for a truck manufacturer's calendar, so it seemed suitable to use truck components for the background. The background is made up of long strips of reflective material usually found adorning the tailgates of articulated lorries, and the strip the model is holding is simply another piece of the same material. The material is only reflective when light strikes it from almost directly behind, so Mason was forced to position his large soft light immediately to the left of the camera. The model had to hold her strip at precisely the right angle to achieve maximum reflection. She was illuminated by a small narrow beam of light from another flash head.
150mm lens, Ektachrome 64, f11

The picture (ABOVE) is another calendar shot taken for an accessories manufacturer. This time Mason used the reflective red road safety triangles which trail behind trucks. He glued them on to a thin sheet of polystyrene foam and erected it behind the model. Realizing that the whole structure was almost transparent, Mason decided to trust his luck and set up a large flat 'swimming pool' behind the background. He calculated that this would produce enough illumination to get a good exposure. As it turned out, the model came out too dark when Mason tested the shot with a Polaroid. So he set up a couple of reflectors either side of the camera to throw the red glow back onto the model. The girl's pose is a direct reference to the fact that these triangles are intended as a warning to other motorists to keep their distance from the trucks. *150mm lens, Ektachrome 64, f16*

extent by their proportions. One client commissioned him to shoot a picture to advertise motorcycle tyres. He wanted to find a girl whose arms and legs were roughly proportional to the front forks and rear shock absorbers of a motorcycle. He thought up the idea of using the model as the 'frame' of a motorcycle.

Mason relies on studio flash for his lighting. He thinks that its slightly cold, blue effect suits the nature of his pictures. He shoots a lot of Polaroids when he is setting up a shot, partly to ensure that the composition is correct, and partly to check that the light levels are going to show the right emphasis in the final picture. Most of his studio work is shot on a Hasselblad 2¼ sq in camera, either with a 150mm or 250mm lens. The film stock is generally Ektachrome 64, which is slow enough to give him the kind of colour saturation he requires.

He likes to use studio flash from strip light holders. The single flash tube that runs the length of the holder gives him a strong directional light that he can control with barn doors. He also uses a heavily diffused overall main light.

On location Mason's style of shooting is very different. The random nature of natural light makes it difficult for him to plan in advance and the careful, precise approach that characterizes his studio work goes by the board. He reverts to 35mm for sheer ease of use, and takes an 80-200mm zoom and a 24mm wide angle with him, a combination which he thinks takes care of most of the situations that arise on location. He likes to maintain a very spontaneous method for most of his location shooting. For example, he will drive around with his models, looking for a suitable location, until some combination of scenery and sunlight catches his eye. He will then proceed to set up a shot right there and then. After the constraints of studio photography he finds the unpredictability and excitement of location work a welcome change.

Mason is a great believer in reflectors and does not choose to take lights on location. He finds it is nearly always possible to set up a shot by using reflectors intelligently.

He uses Kodachrome 25 for 35mm work and checks the light levels very carefully, so as not to risk losing the colour tones that attracted him in the first place. He determines exposure settings by using a hand-held meter.

John Mason likes responding to challenges,

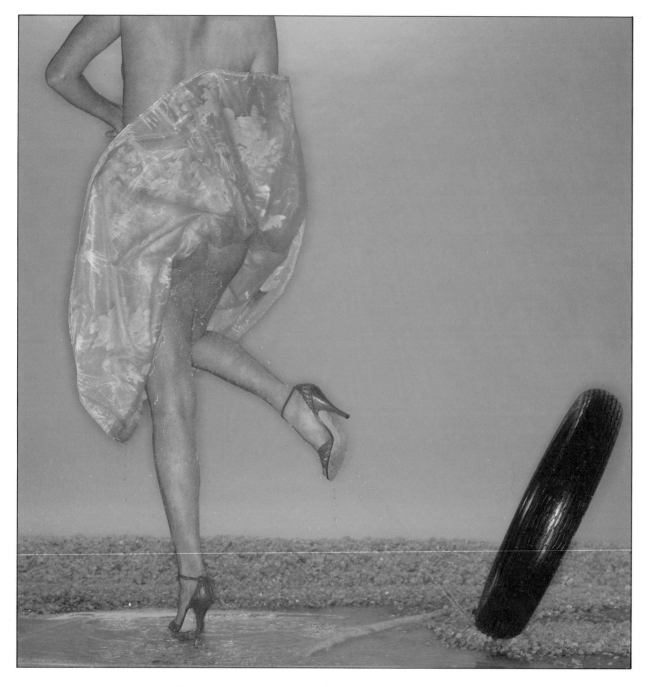

The idea of this picture (ABOVE) was to show a motorcycle tyre holding its grip even in the worst conditions. Mason brough a quantity of gravel into the studio and scattered it on the floor. An assistant sprayed water onto it to emphasize the terrible 'road conditions'. The motorcycle tyre was screwed down on to a wooden base which was then covered with gravel. (There is nothing else holding the tyre upright.) The model's dress was pinned and taped to give the appearance of having been caught by the wind. The water spraying up at the model is coming from a small hosepipe buried under the gravel. The background is lit with a large soft light covered in blue gel and the background itself is painted blue. Another ungelled flash head is illuminating the model and creating a highlight on the tyre itself.
150mm lens, Ektachrome 64, f16

whether they are in the studio or on location. In the studio, the challenge arises firstly in coming up with a graphic idea that is really arresting and interesting, and secondly in trying to make it work on film. On location the challenge exists in coping with the variables — the weather, the landscape and the light. Even if he travels abroad to increase the chances of getting consistently strong sunlight and finds when he gets there that the weather is overcast and dull, he relishes the task of overcoming the problems and still coming home with a good set of transparencies.

There are signs that Mason's clinically precise, immaculately structured studio shots are simply a phase in his career. He is starting to experiment with tungsten lighting finding it offers him the opportunity of movement in the shot. 'With high-powered studio flash, everything is frozen. With tungsten, I can get the blur of motion, and still get strong colour. It's a technique I find attractive at present.'

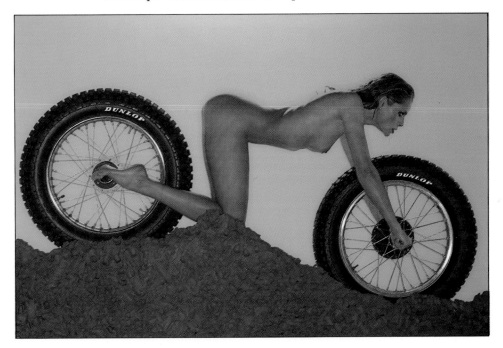

The shot (ABOVE) was taken to advertise motorcycle tyres again, this time for off-road riding. Mason had to choose the model with great care, since the pose that he had in mind would not allow for a girl whose stomach was anything less than very slim and strong. He fixed foot long spindles through the centres of the motorcycle wheels, so that the model could support herself at the back and front. Her knees are resting on a cushion hidden behind the pile of mud in the foreground, and the cushion in turn is resting on an upturned packing crate. Despite the cushion, the position was very uncomfortable for the model, and she had to rest after each take. Above the green background paper is a large soft light covered with green gel, which spills onto the model's back, throwing a green cast. She is lit from the front by another large diffused light to the left of the camera position.
150mm lens, Ektachrome 64, f16

"The photography must always take second place to the subject matter. It's the girls who sell the magazines, not the artistic merits of the photography. All the photographer can do is manipulate the elements to emphasize what the client wants emphasized."

BYRON NEWMAN

There is a wide gap between the French and English attitudes to glamour photography, according to Byron Newman, an English photographer who works mainly for French magazines. He has found that English picture buyers are simply looking for girls with no clothes on and are satisfied if they are supplied with that, whereas the French markets he works for demand more. They want pictures with style and panache. Newman explains that these magazines are up-market; they attract advertisements from top fashion houses, expensive cosmetic companies and luxury car manufacturers. The editorial content — and that includes the picture spreads — must also be pitched at the same level.

Newman has not always worked for such up-market magazines. He studied graphic design at various colleges around England before setting up as a general freelance photographer. As well as reportage work he undertook both fashion and glamour work.

Newman launched *Deluxe* magazine, an avant garde fashion magazine which carried work not only by Newman himself, but also by other photographers who wanted to throw off the restrictive limitations imposed on their work by fashion editors. When the magazine closed, Newman was invited to go to Paris to work for another fashion magazine. He spent the next few years working freelance, mostly for French publications.

Newman says that the French are prepared to pay considerably more for pictures than their English counterparts, provided that they are sure the photographer will give them what they want. In the case of a magazine such as *Lui* this means that certain requirements have to be fulfilled as their demands are very strict and the house style is clearly defined.

Newman expands upon some of those requirements. For example, they don't like electronic flash. They will only take pictures shot either by daylight or tungsten, or a mixture of both. The styling — the clothes, locations and props — cannot be anything less than immaculate. To illustrate this, Newman points out that it is not unusual to have to spend 20 minutes simply arranging the folds in a shirt. This degree of perfectionism is applied to every aspect of the shoot. 'We can spend weeks hunting for precisely the right location,' he says.

Once the details for the shoot have been finalized, Newman likes to work spontaneously. He does not pre-plan the shots, preferring to observe and then photograph moments which catch his eye. This technique ties in with the voyeuristic nature of current French glamour pictures.

Newman generally starts off with one big soft diffused light set quite far back from the scene. He then adds small tungsten lamps to raise the light levels in very specific parts of the scene. He finds that when a shot is taken on daylight film, lit by tungsten lamps, skin tones take on an attractive, warm glow. He meters entirely by using Polaroids, and therefore takes a 2¼sq in camera with him. But he does not use it for

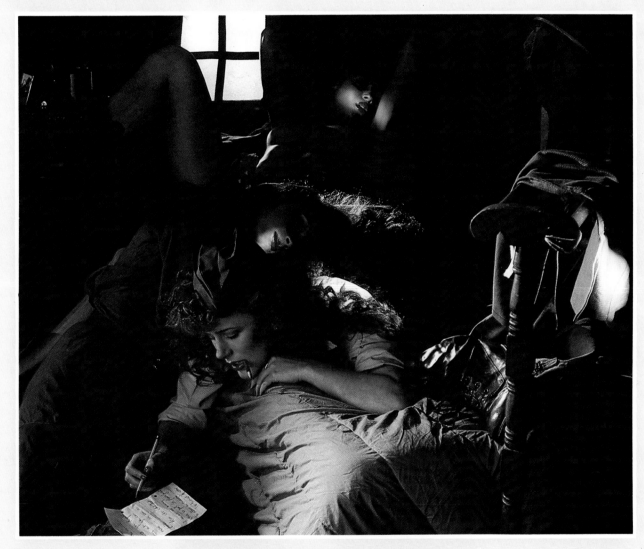

In this picture Newman was aiming to evoke a period feel in this low-key study. He deliberately set the main light far back so that it threw very little light on to the scene, just enough to make the surroundings visible. He then set up three tungsten spotlights. One was tightly masked with barn doors and beamed on to the face of the model at the back. Another, also closed down by barn doors, was carefully trained on the mouth of the middle girl. The third was set to illuminate the model in the foreground. The nature of the shot dictated that the styling had to be accurate and tasteful, and the same applied to the make-up. The models' lips, which were planned to be their most prominent feature, had to be painted with great care. The low light levels meant that Newman had to use a slow shutter speed to make sure of getting the right result.
50mm lens, Kodachrome 64, ¼ sec, f5.6

This slightly surreal photograph was taken at Heathrow Airport. Newman found a spot within the airport perimeters where the planes came in very low. He sensed that this would offer a dramatic setting for an image. The girl stood on a chair while Newman crouched so that an incoming plane was correctly positioned within the frame. He tried to use a polarising filter to darken the sky and bring up the red tone of the model's dress. However using the polarising filter reduced the already low light levels so in the end, Newman, resorted to electronic flash to light the model, and used a shutter speed of 1/30th sec to record the image of the plane on the same frame.
50mm lens, Kodachrome 64, 1/30th sec, f8

This picture was part of a series of shots taken for *Lui* magazine at an English stately home. The set was particularly carefully organized, with each chair correctly positioned, the canopy over the bed arranged so that it hung freely and clothes casually draped over the chairs to give the room the appearance of being in use. The show was lit by a main tungsten light out of sight on the right hand side of the frame. The model sat in the light path of a smaller tungsten spot just to the right of the camera position. Newman used a colour correcting filter to balance the tungsten light with the daylight coming naturally from the window.
28mm lens, Kodachrome 64, 1/60th sec, f8

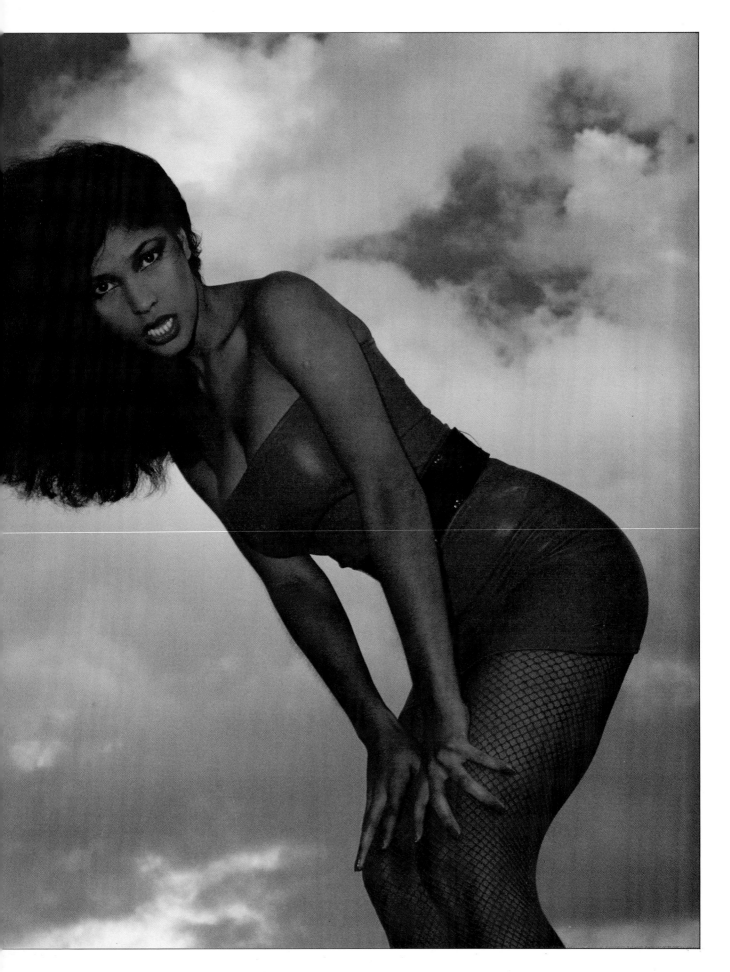

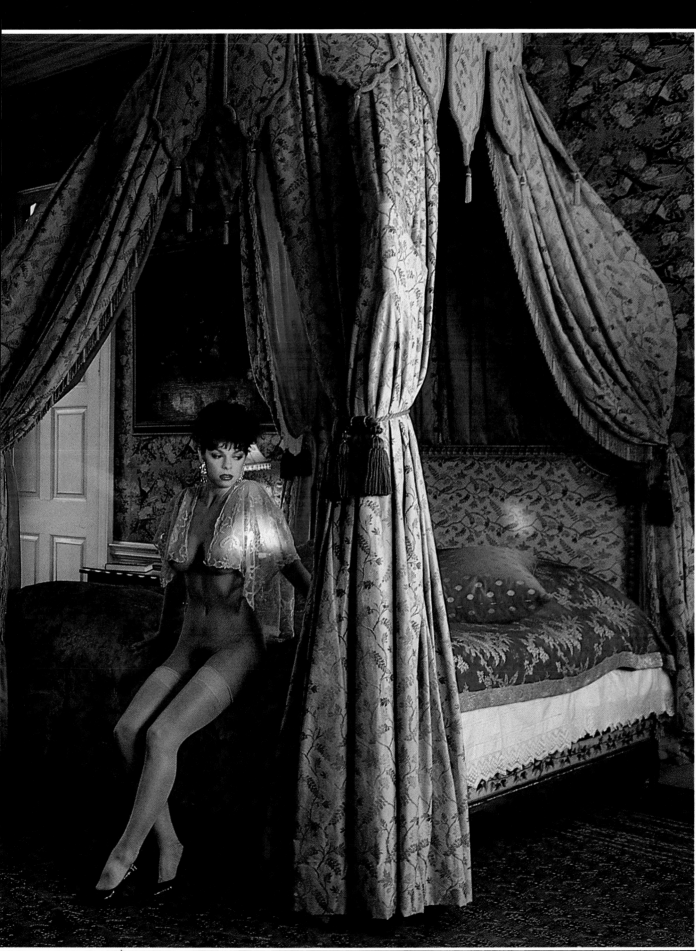

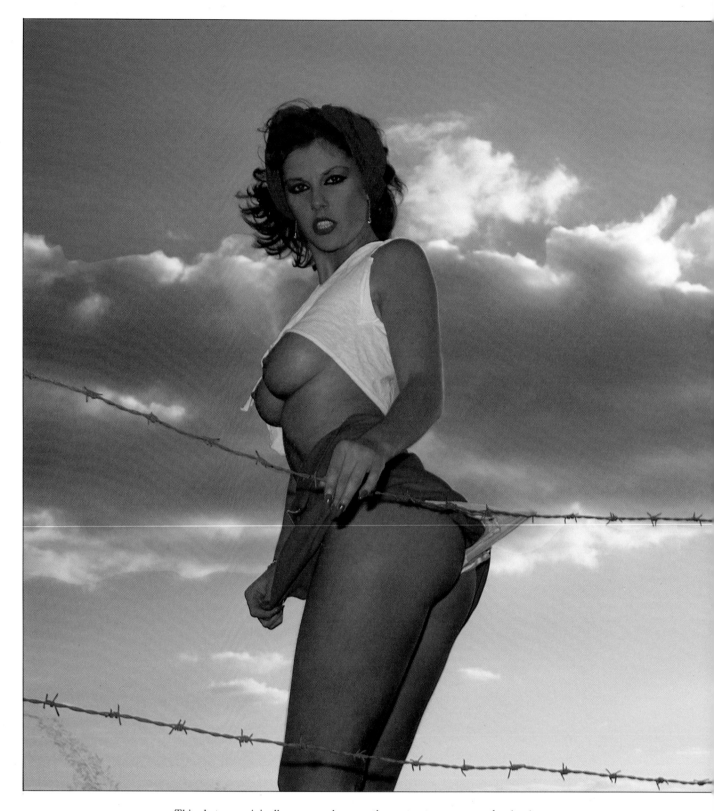

This shot was originally inspired by an illustration that Newman saw in a magazine, and typifies the quietly satirical approach that identifies many of Newman's personal pictures. It was taken on a cold clear January day in England. By choosing to photograph the model against a bright sky Newman created a problem for himself, because the contrast range was so high that the film could not accurately reproduce both the model's skin tones and the sky itself. Either the model would become a silhouette or the sky would have to be greatly over-exposed. Newman solved the problem by using fill-in flash to bring up the light level on the girl and by exposing for the sky.

50mm lens, Kodachrome 64, 1/30th sec, f8

shooting the actual pictures. He prefers to use either 35mm or 6 x 7cm, because he finds the rectangular shape of the image better suited to the type of work he produces.

The film stock is usually Kodachrome 64. This gives him an extra stop over ISO 25, and he also finds it enables him to get a slightly softer effect on the models' face. With interior work, the slow film and the relatively low power of the tungsten lamps mean that Newman usually finds himself shooting at very slow shutter speeds; this in turn means using a tripod and cable release for sharp results.

Newman has consciously tried to avoid being tagged with a particular style. He thinks it is relatively easy for a photographer to hit on a particular effect, so that after a while everyone can recognize the pictures instantly. He points out that although initially this may bring the photographer a lot of work, when he wants to change to something different, nobody wants to know. It is a trap, which many photographers have fallen into, and it is one he has tried to avoid by experimenting with different approaches. Newman does, however, think that plagiarism among photographers can have mutual benefits. He does not mean copying other people's work slavishly, but rather using techniques that they have employed on other subjects.

The eclectic nature of Newman's work stems in part from his strong desire to avoid clichés. This means that he often finds it necessary to 're-educate' his models. 'They arrive on the set and immediately go into a standard routine, which as far as I am concerned is worse than useless. It's well worth my time to give the girls an idea of what I am looking for. I don't want "the standard pose", and nor do the people who buy my pictures,' Newman says.

He likes to bring out personality in his pictures. However this does not mean that he wants his models to be themselves. Instead it means that he wants them to be actresses who can play the parts in which he has cast them. This, again, fits in with the voyeuristic approach so favoured by the French.

In the final analysis, Newman sees himself as a commercial photographer who has to please the market he serves. He is well aware of the dangers of large budgets, pointing out that they can lead to self-indulgence . According to Newman, the photography must always take second place to the subject matter.

"I always bear in mind how the catalogue or poster should look, and I keep it simple. A lot of photographers go crazy when they are commissioned to do a big shoot. They want to rent Concorde, light the runways and then pose models amongst it all. That's not my style."

UWE OMMER

Uwe Ommer is a German photographer who now works in Paris. Over the past years he has attracted a good deal of attention with his cold hard style of glamour photography. His career began when he took a job in a photo store. The store had a contract with Photokina, the mammoth photo trade fair held every other year in Cologne. Ommer entered some pictures for a competition at the fair and, to his great surprise, emerged as the winner.

Spurred on by this success and by a strong desire to avoid being drafted into the German army, Ommer packed his photo equipment and went to Paris, where he eventually got a job with a commercial photographer who specialized in producing large format photographs for the advertising market. Before long Ommer started to find outlets for his own pictures and branched out on his own.

Recognising that the most lucrative source of employment for his skills was the advertising agencies, he proceeded to learn as much as he could about their demands. He ascribes his success in this field to his ability to understand what the client wanted. 'I always bear in mind how the catalogue or poster should look, and I keep it simple. A lot of photographers go crazy when they are commissioned to do a big shoot. They want to rent Concorde, light the runways and then pose models amongst it all. That's not my style.' Ommer prefers to think up ideas which are strong in their own right, rather than relying on huge budgets. It is an approach that goes down well with his clients, but it is also one that puts pressure on him to produce first-rate ideas.

Ommer is now a highly successful photographer, constantly in transit between his Paris base and locations all over the world. When the work is on commission he hires models from agencies for simplicity and ease. But when he is working for himself he prefers to find unknown girls through his colleagues in the business. 'The problem with good professionals is simply that they are always so busy,' says Ommer. 'The time factor plays such a large part. You know they've only got an hour to spare and so there's always pressure.'

Although his success owes much to his mastery of photographic technique, Ommer

This shot was taken at dawn. The neon tube was powered by an electric generator which had been taken on location for the purpose. It was important to take the photograph at precisely the right moment because the rising sun would soon have brightened outcrops of rock behind the model and spoilt the effect of the neon light, which would have become dim in comparison to the daylight. The light thrown on to the model's body by the tube would also have been lost. Ommer metered for the rocks, which are correctly reproduced, and the effect was to lighten the sky slightly and darken the model. *50mm lens, Kodachrome 25, 1/15th sec, f2.8*

The model (ABOVE) particularly wanted some shots of her legs for her portfolio, and Thomson agreed to put something together. He cut the feet and the top off a pair of tights and asked her to wear them. He used an orange background, painted for an earlier shot, and lit it with a linear flash unit placed just out of shot beneath the model's feet. The model stood on a plank and held on to a beam in the studio roof which made it easier for her to hold her tiptoe pose. A large soft light was set up to light the front of her body, while spill from the background picked up the backs of her legs.
150mm lens, Ektachrome 64, f16

tone is usually much better than girls who have just done modelling. Secondly, they know how to move gracefully without being instructed, and thirdly, they do not look at all self-conscious when they are posing.

Much of Thomson's work is produced for advertising purposes and he claims that his real reward is seeing his pictures on a bill board. 'I'm not in the business of creating art. I'm simply fulfilling a commercial need. If I can fulfill that need successfully, then I'm satisfied,' he says.

Thomson enjoys the challenge that daylight presents to his camera. The fact that it is always changing means that he has to react swiftly in order to make the most of it, and he finds this pressure very useful for producing good work. As he points out, a professional photographer should be able to get results even in the most appalling light conditions.

Thomson manages to insure himself against bad light by having a couple of portable flashguns on location. He uses them at night as a main source of illumination or at dusk when fill-in flash offers a suitable alternative to long shutter speeds. He also uses reflectors on location. 'A gold reflector often helps to warm up a model's skin tone, while silver ones are ideal for throwing very strong light back into a picture,' says Thomson.

He uses both 35mm and 2¼sq in cameras on location; the choice usually depends on the film stock and lens he wants to use. With 35mm he can use Kodachrome 25 or 64, both stocks which he admires for their ability to produce good colour saturation.

With 2¼sq in he shoots on Ektachrome film. Unlike Kodachrome, Ektachrome stock can be 'pushed', and this, he has discovered, enables him to get warmer skin tones. 'If I underexpose the film by half a stop and then 'push-process' it by the same amount, the contrast range is increased', says Thomson. 'In addition, the colour saturation is better and although the shadows tend to block up slightly, the skin tones take on a very attractive warm hue. The highlights glow in an almost surreal way.'

As well as using long lenses, Thomson is a great believer in wide angles. If, for example, he decides the location is so impressive that he wants to include more of it in the shot, he finds the 24mm lens perfect for those 'model in a landscape' shots. He does not use zoom lenses, mainly because he suspects that they reduce the contrast on the film.

Thomson is very choosy about the models he uses, particularly if the assignment is abroad. He tries to assess them carefully before picking them. If, for example, he knows that legs will feature strongly in the shots, he will take Polaroids solely of their legs, so that he can compare them. 'It is', he remarks, 'just a question of being professional.'

He looks essentially for girls who have the right proportions. 'If a girl is well proportioned then I can exploit that potential', he says. He is also looking for girls who can contribute something to the pictures themselves. Occasionally he comes across a model who immediately understands how a certain shot can be improved by moving a couple of inches one way or the other. These are the girls that Thomson likes to work with.

He finds that dancers make very good models for a number of reasons. Firstly, their muscle

This picture was taken on location in the Maldive Islands in the Indian Ocean. The sky was grey with thunderclouds, but there were patches of blue through which the sun cast shafts of light. Thomsom waited until a shaft broke through and illuminated the sand bar on which the model was standing and the surrounding sea. Thomson, at the time, was standing in waist-deep water holding a 2¼sq in camera. His meter told him that the correct exposure would be 1/125th sec at f5.6, using Ektachrome 64 film and a 40mm wide angle lens. Following the normal Thomson procedure with Ektachrome, he stopped down to f8 and had the film push-processed by two-thirds of a stop when he got home. *40mm lens, Ektachrome 64, 1/125th sec, f8*

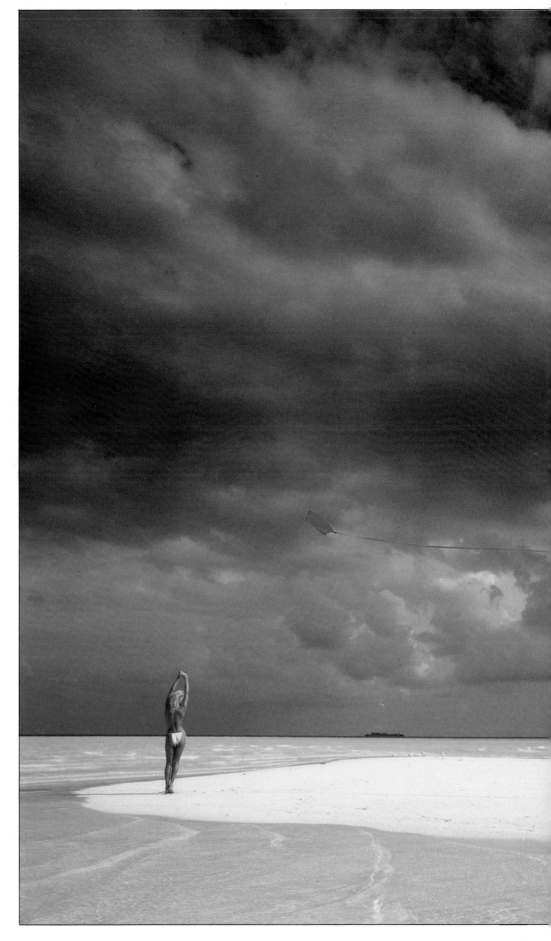

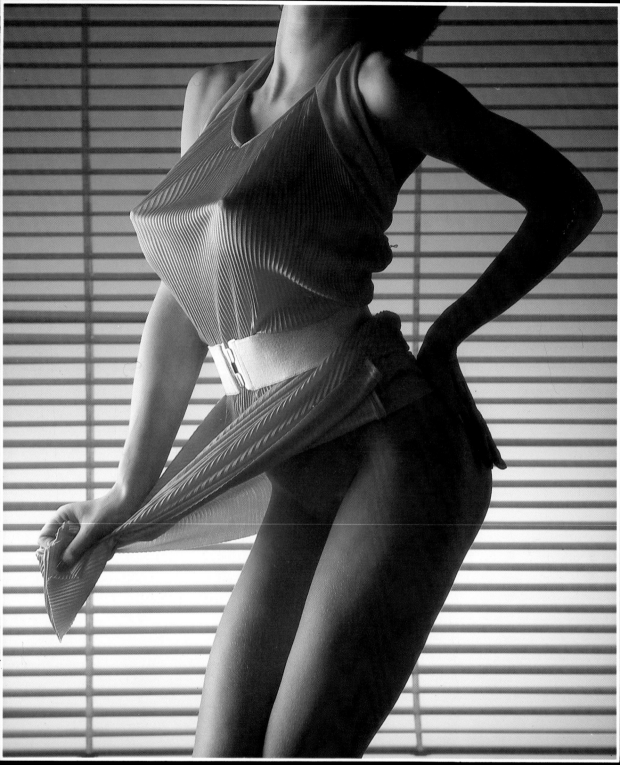

Professional glamour photography has a great deal to do with servicing male fantasies. In this case, Thomson found an enormous fake pair of breasts in a joke shop, hoping that he would be able to find a use for them in one of his pictures. The model enjoyed the whole idea, and after the shoot was over she wanted to walk out into the street wearing the false· breasts. The material of the model's dress was pleated and stretchy to fit the extra bulk and that allowed her to pull the skirt out. Compositionally, the shot is very well arranged. The angle of the breasts is matched on the right by the girl's elbow, and on the left by her hand. Her pose makes a vertical zig-zag on the film which echoes the horizontal shape. The orange screen was lit from below with linear flash, and a big soft light brought the model's figure up to the required light levels. *50mm lens, Ektachrome 64, f16*

" There is strength in simplicity and I try to keep my images as simple as possible. I love beaches, for example, because in design terms they are so neat. The sky is divided from the sea in a straight line, and the beach itself is divided from the sea by another line. Each area has its own colour, which is generally a single pure tone. Each one is rather like a perfect backdrop."

CHRIS THOMSON

Chris Thompson is one of London's most sought-after commercial photographers. While studying the subject at college he became interested in graphic design. Soon after he left college he went to work in a studio which produced the catalogue for Habitat, the London company which revolutionized domestic design in the late sixties and early seventies. He soon realized that the bold clean simple looks which were making Habitat such a success could, and should, be used in creative photography.

He spent a considerable amount of time working with designers and it taught him a great deal about the way photography worked as a visual medium. He discovered, for example, that a shot cluttered up with lots of props nearly always lacked impact in the final result. Now he tries to keep his images as simple as possible. Although the arranging of the picture itself might be extremely complicated, he goes to great lengths to ensure that what appears in the frame is straightforward.

Thomson's abhorrence of messy images is the key to his style. It influences his choice of all the elements that go to make up a picture: models, colour schemes, locations and lighting.

This approach is particularly noticeable in Thomson's studio work. He always tries to limit himself to a single key colour that is bold and attractive, finding that the addition of any other colours always seems to detract from the power of the main tone. The same applies to his use of props. He never uses more than one, unless he has to, and he makes sure that the prop harmonizes with the rest of the picture, both in colour and shape. The lighting in Thomson's studio work follows the same design concept. He does not rely on dramatic contrasts of light and shade to achieve his effects, preferring instead the clean, simple unobtrusiveness that can be created with studio flash.

The search for strength through simplicity continues on location assignments. 'I love beaches,' says Thomson, 'because in design terms they are so neat. The sky is divided from the sea by a straight line, and the beach itself is divided from the sea by another line. Each area has its own colour, which is generally a single pure tone. Each one is rather like a perfect backdrop.' When he goes abroad he often spends the first day just driving around looking for stretches of beach that are clean and isolated.

Of course, it is not always possible to shoot on beaches and Thomson's client may want him to use other specific locations. However he has developed a technique which allows him to take shots in other locations without sacrificing his personal demand for a simple design. By using a mid-telephoto lens he can isolate sections of the background and then place his model against it. He can select background details that complement the colour of the model's clothes or form a geometrical pattern behind her.

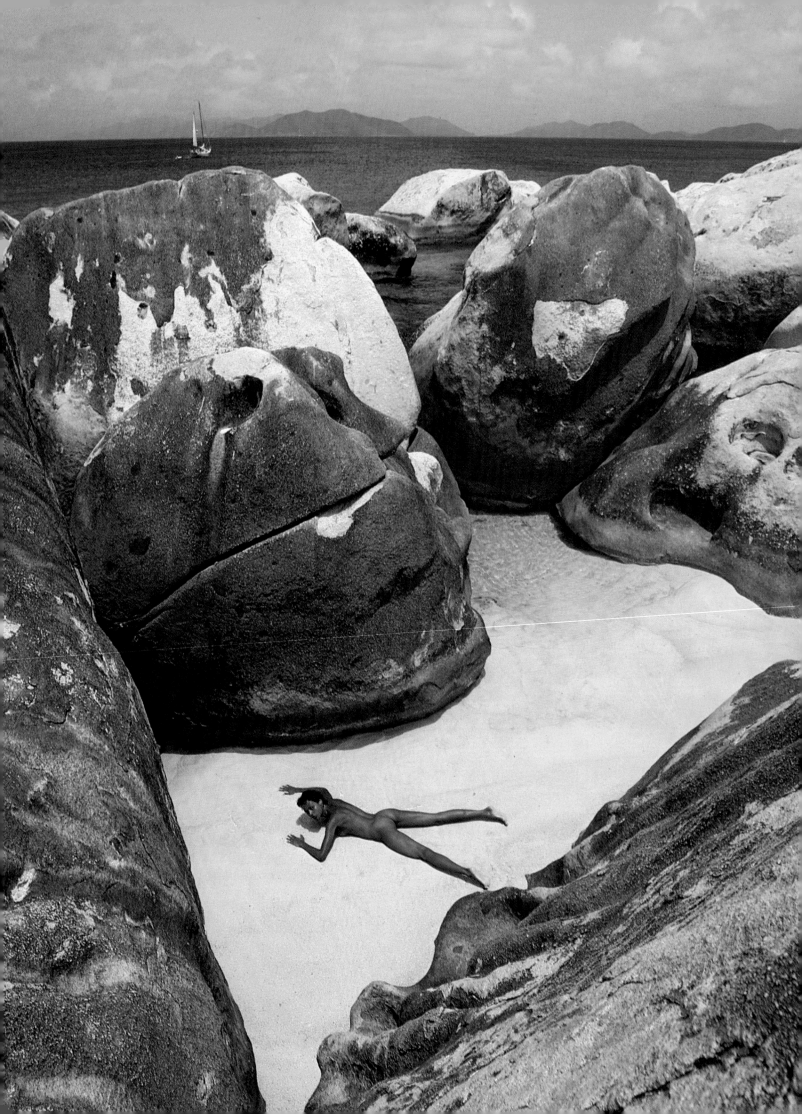

tends to belittle the importance of equipment. He uses only 35mm cameras because of their smallness and convenience. He finds the quality of film available for 35mm perfectly adequate for both his needs and those of his clients.

The key to his technique lies in his knowledge and understanding of still life photography on 5 x 4in cameras, acquired during his early days in Paris. He taught himself how to make good multiple exposures, a technique that he still employs a great deal in his current work.

On his travels throughout the world he has built up a huge collection of landscape shots, and he uses these as backgrounds for models. 'This kind of work requires a camera that has very accurate film transport. I may shoot a landscape for instance, and then copy a girl onto the frame in the studio. When taking the first shot, I mark the position of the film in the camera, so that I can put the film back in and be absolutely sure that the image area will be in precisely the same place the second time around.'

The hard edge to Ommer's studio photo-graphy comes from the use of studio flash with very little diffusion — a technique that is widely practised by still-life photographers. Since he uses 35mm exclusively he cannot resort to Polaroids for composition and lighting balance assessment, so he relies on a hand-held flash meter which gives him the correct aperture for the illumination level in use.

His liking for sharp contrasty pictures means that when he is shooting in daylight he looks for very bright, strong sunlight and, unlike most glamour photographers, is quite prepared to shoot under direct overhead sun. The technique adds drama and menace to many of his pictures.

Ommer likes to distance himself from the rat-race of professional photography as much as possible. 'Most photographers,' he says, 'are forced to accept restrictive and unimaginative assignments in order to survive. Only a few of them can choose really interesting assignments. It takes a long time to reach that sort of position, and you are probably already spoiled by the rat-race by the time you get there.'

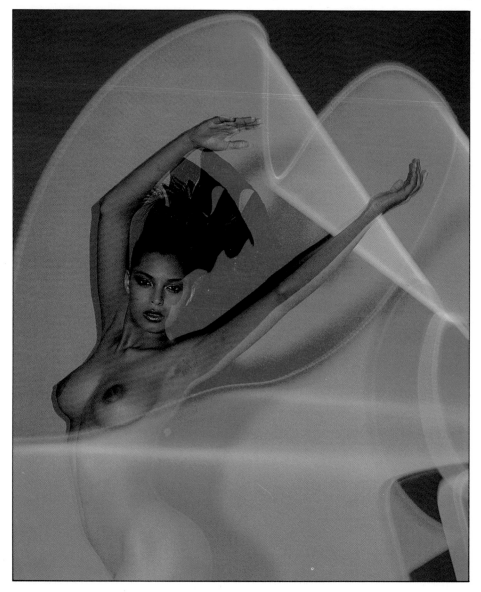

The model (LEFT) was posed against a plain backdrop and asked to stand very still, while an assistant moved the neon tube, seen on page 77, around her in a gentle, swirling motion. The assistant carefully avoided swirling the tube in front of the top half of the model's body. The model was lit by studio flash, which was left on for two or three seconds. Traces of her movement during the time exposure can be seen. The shot was taken for a calendar. *100mm lens, Kodachrome 25*
The photograph (RIGHT) is a classic example of how to use the landscape to enhance a glamour shot. The clear area among the rocks automatically draws the viewer's eye, and when he looks he finds the model. Ommer has added extra interest to the shot by including a distant view in the background with its own point of focus — the yacht. The entrance to the clearing leads the eye naturally towards the open sea and the boat. *24mm lens, Kodachrome 25, 1/250th sec, f11*

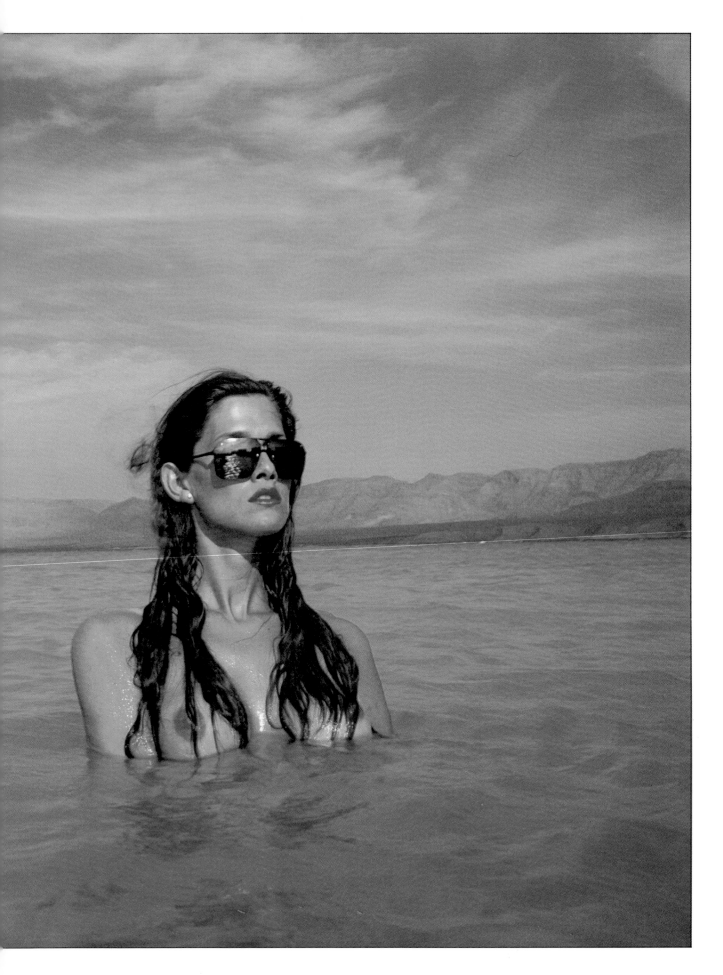

This photograph was taken in the British Virgin Islands where Ommer was shooting a series of calendar pictures. The fish in the background was, of course, fake. It was a stuffed sailfish, held in position by an assistant who was under the surface of the water. The fish gave some problems because its skin had dulled under the bright sunlight, so the team had to repaint it to make it look shiny in the shot. The wake was caused by another assistant, just out of the left hand edge of the frame, who was throwing water from a bucket.

35mm lens, Kodachrome 25, 1/125th sec, f11

This shot (ABOVE) was taken for a calendar in Palm Beach, Florida. The models were lying on top of a wooden table in a swimming pool. Their weight, and some garden gnomes attached to the feet of the table, prevented the table from floating. The models, although fairly sun-tanned, were nothing like as brown as they appear in the picture. The effect was achieved in various ways. Firstly Thomson used a polarising filter which made the blues and browns deeper. Then he underexposed by as much as two stops and had the film pushed by half a stop when it was processed. This resulted in the highlights remaining as they appeared, but the darker tones taking on deeper saturation. The girls had to be sprayed with a hosepipe to keep the water on their backs from drying.
150mm lens, Ektachrome 64, 1/125th sec, f16

"I have to think hard before I accept a hand-tinting job. The technique only suits certain subjects. The secret of its attraction is having complete control over the colour. It's almost like being a painter. The other point is that I can use my imagination to improve the image, rather than leaving a transparency as simply a record of what was in front of the camera at the time of the exposure."

JAMES WEDGE

James Wedge first enjoyed success during the sixties, not as a photographer, but as a milliner. It was a time when fashion designers were in great demand in London, and Wedge's hats were frequently used in pictures for fashion magazines.

Nowadays Wedge works behind the camera and concentrates on fashion, glamour and advertising photography. But there is one particular technique at which he excels, and which is constantly in demand by his clients — hand-tinting.

It is a technique that requires sensitivity, patience and a tremendous amount of time. The process is relatively easy to describe but the skill needed to execute it successfully can only be acquired through years of practice.

He was recently commissioned by Playboy magazine to produce a series of semi-nude pictures depicting chorus girls in a Victorian music hall setting. Playboy wanted Wedge to hand-tint the pictures. 'I have to think hard before I accept a hand-tinting job', says Wedge, 'The technique only suits certain subjects. In this case, the client wanted a period feel and this is an area in which hand-tinting can be used to good effect.'

Although Wedge has a fully-equipped studio in West London, for this commission he decided that it would be foolish to construct a set before he had investigated the possibilities of suitable locations. By chance he found a small theatre which had recently been refurbished in the original Victorian style. He decided to use it.

A great deal of time and effort was spent finding precisely the right clothes and props for the shoot as Wedge is a perfectionist in these matters.

He virtually emptied his studio of equipment, transferring three studio power packs and six flash heads to the theatre. He also took a large amount of reflectors and diffusers to ensure that

This is one of a series of photographs depicting scenes back-stage at a Victorian music hall. Wedge decided to treat the photographs to his special hand-tinting, because the soft pastel tones more accurately convey the atmosphere he wanted. Although he used a real theatre for most of the pictures, this particular shot was taken in his studio. The girl was illuminated by a large well-diffused soft light placed at floor level directly in front of her. The original photograph was taken on black and white film blown up to a 20 x 16in print. Wedge painted the colours on by hand afterwards. The delicate nature of the task means that such a job can take up to three days of patient labour. *90mm lens, Ilford HP5, f11*

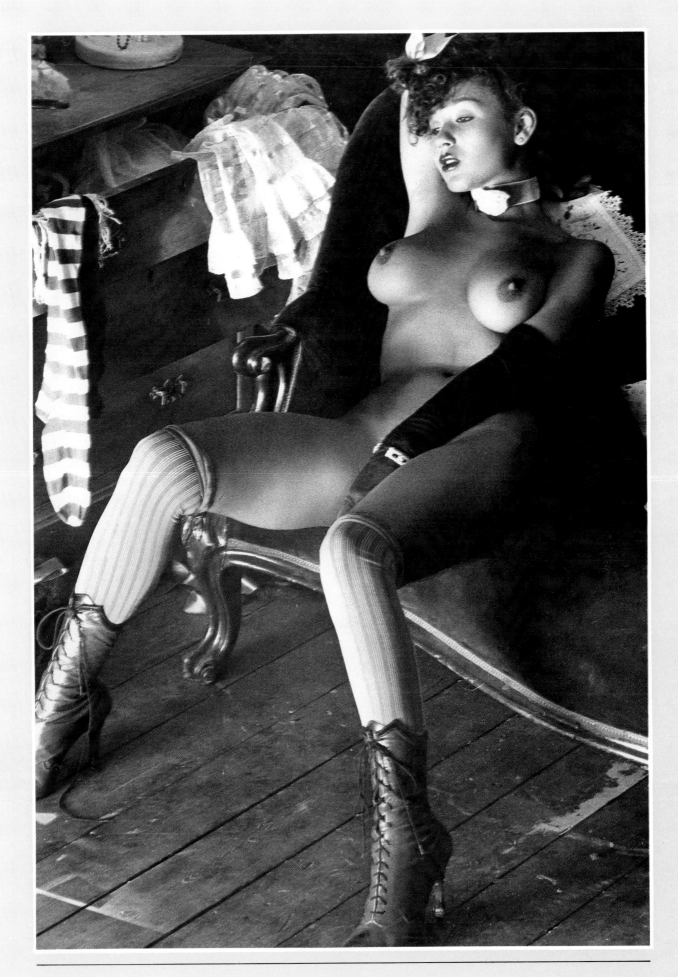

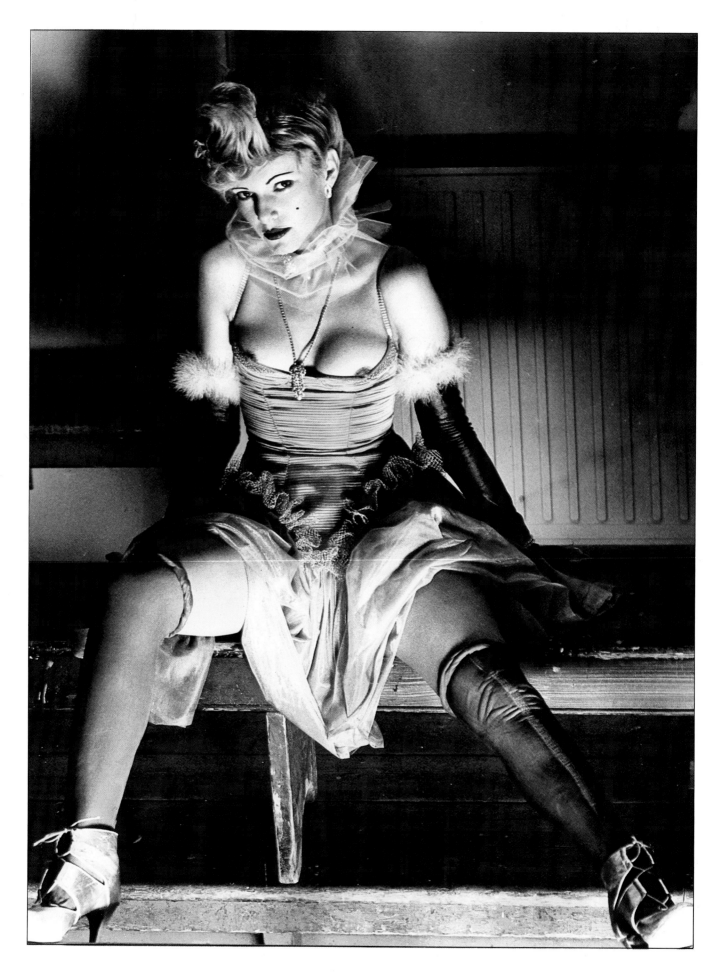

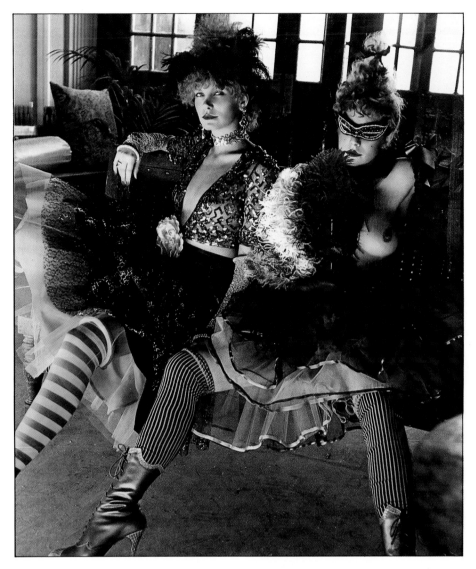

From the same set of music hall pictures, this particular shot (LEFT) was exposed in the theatre that Wedge used for most of the shoot. The model was posed on a narrow balcony which runs round the sides of the theatre while Wedge and his assistants were down on the floor of the theatre. The critical ingredient of the shot is the angle from which the light is striking the model. Wedge intended that it should look as if the model was being lit by footlights, so he rigged up a small, carefully angled flash head on a stand below her. The harsh light of the undiffused flash cast strong dramatic shadows which, gives a theatrical look to the whole picture. The cold, washed-out blue tone with which Wedge has tinted the girl's skin reinforces the impression that she is sitting in very powerful directional lighting — such as one might find in a theatre.
90mm lens, Ilford HP5, f8

The problem with this shot (ABOVE) was the mixing of tungsten, electronic flash and daylight that the location demanded. It was photographed in the foyer of the theatre, and the doors behind the models are the entrance to the building. Out of shot, above the models, is an ordinary domestic light bulb which is having a tiny, but nevertheless significant, effect on the lighting balance. Wedge wanted to use electronic flash for the main light because otherwise the shot would have looked out of step with the rest of the series. In the end, he used a fill-in flash technique. He metered normally for the daylight (and the domestic bulb) and found that he would get accurate exposure with settings of 1/15th sec at f11. He then set the powerful studio flash to give him a burst of light that would need an aperture of f11, regardless of the shutter speed. The result is perfectly balanced.
90mm lens, Ilford HP5, 1/15th sec, f11

lack of equipment would not hold up the shoot. Wedge uses a 6 x 7cm (2¼ x 3in) camera for nearly all his work. He used to use 2¼sq in, but found that clients generally required the picture to be rectangular rather than square. This meant that his shots often had to be cropped. It made sense therefore to change to a format that allowed both him and the clients to make use of the whole frame. There is also another advantage for Wedge in using the larger format. It is more suitable for hand-tinting purposes as the larger the print, the easier it is to tint.

Wedge uses either ISO 125 or ISO 400 black and white film for the original exposure. In the case of the Playboy pictures he opted for

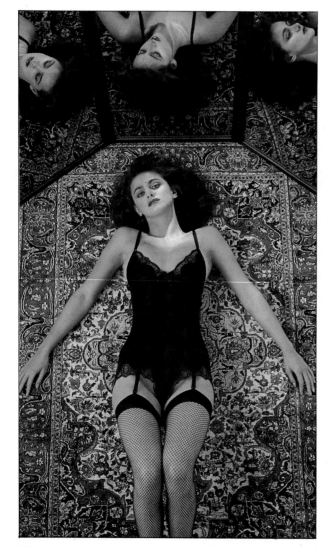

Wedge is lucky enough to have a balcony in his studio, and this shot (ABOVE) was photographed from it. The idea was simple enough — to place a screen, inlaid with mirrors, behind the figure of the girl lying on a persian rug. It was only when Wedge started to set the shot up that he realised that he would only be able to get the picture with the correct perspective if he took it from the balcony. Illumination came from two flash heads, one each side of the model, firing backwards into umbrella reflectors to give an even spread of light. *140mm lens, Ektachrome 64, f16*

ISO 400 knowing that the extra grain would help to soften the image.

Wedge tries to create a lighting set-up that reinforces the mood of the picture. For the chorus girl pictures he set out to emulate lighting conditions in a Victorian music hall, producing a soft yellowish glow with diffused shadows. He also came up with the convincing effect of lighting the girls from below as if they were illuminated by footlights. The contrast range was kept down as much as possible, so as to suggest a general aura of dimness.

Wedge processes and tints his own black and white work. He uses no special tricks, simply aiming at producing strong, clean prints. It is at this stage, after the prints are produced, that Wedge takes time to consider how he is going to proceed with tinting. He points out that he cannot just rush in to this. He has to try to imagine what the finished result will look like and think how best to achieve that effect.

Wedge is usually aware of the sort of colour scheme he wants before he takes the picture, and arranges areas of tone within the negative so that he can return to them at the tinting stage.

The actual tinting is done by means of masks. For example, Wedge decides that the model's dress should be light yellow. He masks off the entire picture with gel except the dress which he cuts carefully to shape. He then experiments with mixtures of photo dyes, water colours and ink until he finds precisely the right shade of yellow. The mixture is air-brushed carefully on to the exposed part of the print.

Cut masks on their own leave sharp edges where they finish and this is often not suitable. Wedge has various techniques for producing a gradual fall-off in colour where two areas adjoin each other. The most common is to spray the mixture carefully up to the edge of the mask and lift the mask slightly to allow some colour across the 'border'.

Patient, careful handling of the air-brush is vital. One false move could ruin an entire day's work. It is not the sort of task that can be undertaken quickly.

James Wedge has been practising the art of hand-tinting for ten years. It takes him two or three full days to finish a 20 x 16in (50.8 x 40.6cm) print. Little wonder then that he copies the end result on to transparency film as soon as he finished.

As a commercial photographer he admits he prefers to shoot straight colour pictures as it is far less time-consuming and he is able to take on many more jobs.

However the attractions of hand-tinting remain considerable for James Wedge. He enjoys having complete control over the colour and likes being able to use his imagination to improve the image, rather than leaving a transparency as simply a record of what was in front of the camera at the time of the exposure.

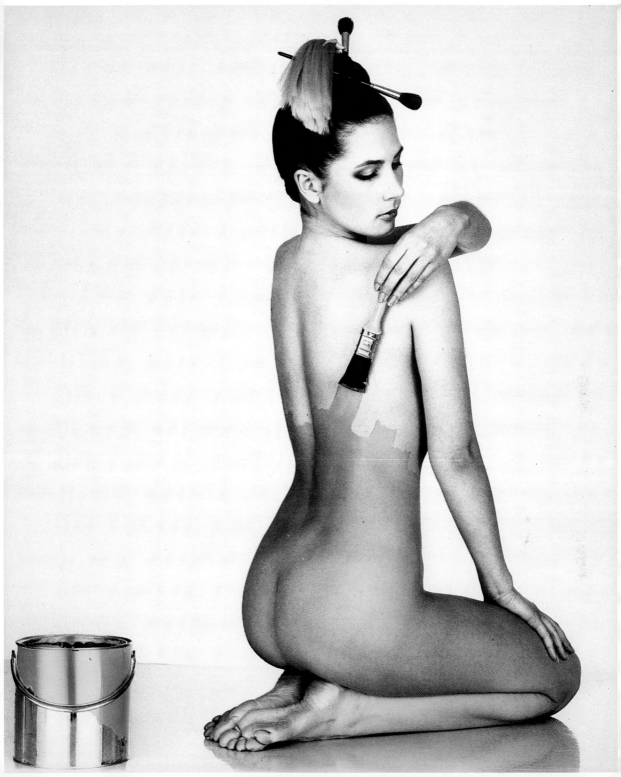

SECTION TWO
WORKING PROFESSIONALLY

Some pictures are not provided with shutter speed details; this is because professional photographers tend to leave the shutter speed out of their calculations when exposing pictures by studio flash with a leaf shutter camera. The reason for this is that leaf shutter cameras can be synchronized with the flash at any speed; it therefore makes sense to work by aperture size alone.

INTRODUCTION

IT IS OFTEN SAID that there are no rules in glamour photography which suggests, quite correctly, that great glamour photography relies on originality and innovation. This may be a good motto for the aspiring photographer, but as a piece of advice it is misleading. There are rules which can be learnt and applied and which will help the amateur photographer to get over the first hurdles, and before very long he or she will be producing competent pictures. However, competence is small comfort to the ambitious photographer. The desire to do better and more imaginative work leads the photographer to leave behind the standard approach to glamour photography and achieve effects that would not be feasible if all the conventional rules of photographic technique were followed rigidly. Rules can, after all, be broken successfully but it helps to be familiar with them in the first place.

CHOOSING A THEME

The first rule of glamour photography is 'do not touch the camera until you know precisely what you want to achieve'. You must find a starting point. It can be anything — a particular location, a particular prop, a clever lighting trick, or even a simple composition which would benefit from the inclusion of a model. The photographer charged with producing a tyre firm's calendar spotted a shop selling oversized objects like typewriters and cameras, all made from felt stuffed with paper. The ordinariness of the objects contrasted strongly with their outlandish size and texture, and the photographer decided to make them the basis of the calendar. The resulting pictures, in which models posed nude with the soft sculptures, were all thematically linked and the series worked well together.

On another occasion a photographer was commissioned to shoot a series of pictures for a company that made corrugated aluminium sheeting, not the most promising material to work with. By using clever lighting, the photographer was able to bring out the strong linear texture of the sheeting and used it to form graphically dynamic backdrops for his models.

Each scenario you think up must be related to the others and yet each one must stand up as a

Following the successful shooting of a calendar, Chris Thomson was asked to recreate one particular shot for a TV commercial. The picture below shows the shot being set up. The only light on the model comes from a single large flash head suspended above the set. The harshness of direct studio flash is toned down by the use of a diffuser screen above the model. The control unit for the flash head can be seen just behind Thomson's 2¼sq in camera.

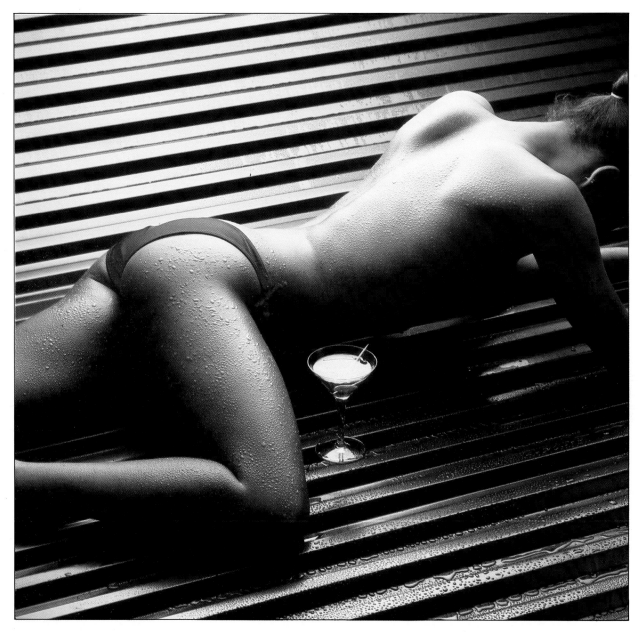

The original rough (RIGHT) for the picture above shows how the shot altered between conception and the final result. The colour of the bikini was changed, because the client felt that yellow would not stand out strongly enough for the aluminium background. However the essential design elements of the picture — the position of the model's body and shape of the glass — remained the same. The shot was part of a series taken to advertise corrugated aluminium sheeting. The picture on the previous page shows this shot being set up.
150mm lens, Ektachrome 64, 1/125th sec, f16

Ribbed Aluminium Background with water droplets.

yellow bikini

water droplets on body

Dry Martini or Vodka cocktail

strong image in its own right. Let us suppose your starting point is a brightly-coloured deck chair. An idea of the shot builds up in your mind. A nude model sits in the deck chair with a straw hat pulled down over her face. The band around the model's hat matches the stripes of the deck chair.

For the second shot you might choose a white-painted wrought iron chair such as one finds in the gardens in English country houses. A model wearing a transparent veil-like white blouse sits in the chair. She is also wearing a wide-brimmed Edwardian hat, and you choose a camera angle that shows her figure but not her face.

Immediately there are similarities between the two images — both models are sitting on chairs, both faces are hidden by hats. Equally, there are dissimilarities. The chairs, hats and locations are all different. The pictures are related but they can stand separately. You are on to a theme.

However do not rush out and hire your model just yet. All you have are the beginnings of an idea. As you dream up more variations you may find that one of your elements will work against you, the hidden face possibly. If you decide not to use that particular aspect, you will have to re-think all the pictures, and any professional photographer will tell you that change is always

easier at the planning stage rather than later on when the shooting begins.

ROUGHS

The wise photographer will draw up a series of 'roughs', sketches showing what the final pictures will look like. You do not have to be a brilliant artist to do this. You simply need to show all the elements arranged to your satisfaction. These roughs are an effective guard

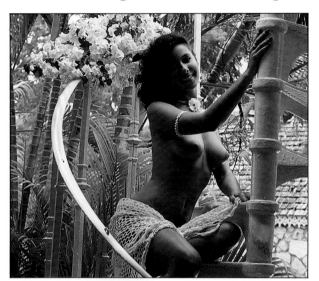

If you find an attractive location it is a good idea to shoot a series of pictures around it, trying each time to add something different to the image. The spiral staircase provides a good setting for both pictures but the addition of a few carefully chosen props radically changes the mood of the two shots. The picture (ABOVE) is essentially a straightforward glamour shot. The mood is soft and romantic. By adding a tennis racket and sun visor the photographer makes the shot sporty and active, and gives the model a specific role to play. A windmachine is positioned to blow her dress up, contributing to the outdoor feel of the shot.

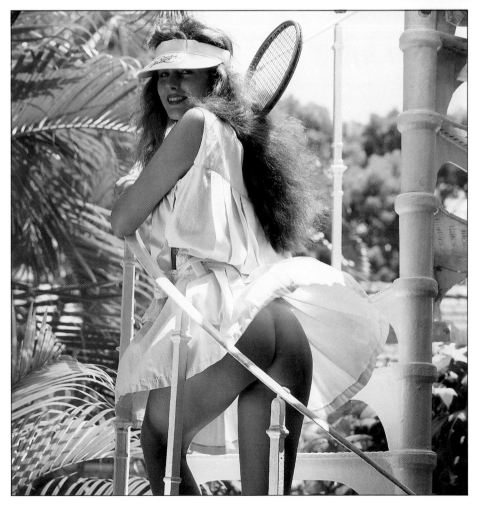

On location in Sweden, the photographer and his assistant spent much of the short day building and setting up the three silver columns, so that they would be in the correct position in the frame when the time came to photograph the models. Low evening sunlight threw a soft light across the scene, but the photographer had to work swiftly in order to complete the shot before the light levels dropped completely. The temperature also dropped fast, which explains why the photographer's gloves can be seen lying on a foreground rock. The models had to suffer for this particular picture.

FAR RIGHT Efficient planning and organization are essential if you want a shooting session to run smoothly. This means attending to a mass of detail. A check list of photographic equipment, and another itemizing everything that needs to be assembled, and listing the schedule of the shoot, can save a great deal of time and worry on the actual day.

against lax thinking. They force you to pay attention to detail. They allow you to conceive the composition of the picture and help you to choose which lens you need and plan your lighting.

Professionals rely heavily on roughs because they can save so much time in the shooting if everyone involved knows what the end result is intended to look like. Time, to a professional, is money; an extra five minutes spent in the planning stage can save you a day during the shooting.

Once you have drawn up the roughs, you are ready to start assembling the various elements that will make up the final pictures. A multitude of questions must be answered. How many models will you need? Where will you find them? Where will the pictures be shot? What equipment will you need? The answer to each of these questions will provoke more questions, and it is only when you have solved all the problems that you will be ready to shoot.

STUDIO OR LOCATION

The first thing to decide is where you want to shoot the pictures. You have the choice of a studio or a location. Your original idea may dictate which you use, but if there is a choice there are certain conditions that should be borne in mind.

100

Equipment checklist

Camera(s) Three Nikon bodies.

Lenses 28mm – 45mm zoom, 85mm, 70mm –
 210mm zoom, 50 – 300mm zoom.

Film 125 rolls of Kodachrome 25
 125 rolls of Kodachrome 64

Lighting Four tungsten lamps with stands, six
 120 watt bulbs, six 220 watt bulbs
 Gold fabric for reflectors, hand mirror
 hand-held flash gun, batteries

Camera accessories Two tripods, Filters (star, graduated
 and polarizing) cable releases, metal
 camera case, refrigerated bag for film,
 shoulder bag) powerwind, camera
 cleaning equipment, stepladder.

Shooting day checklist

Location Plage des Oiseaux, Marin,
 France.

Transport Peugeot 504 (Red)

Meeting place Hotel Splendide, Nice

Catering Picnic lunch supplied by C.B.
 (agent)

Model Lucy Charm
 Booked: 7.30 hrs to 18.30 hrs

Clothes Models own clothes, and red scarf,
 yellow bikini top, (supplied by
 Photographer)

Props Sunglasses, red airbed.

Make-up Model's own make-up.

Assistants F.M. (camera assistant)

The use of a studio allows the photographer to control all the elements. He can vary the quality or intensity of the light at will. He can make sure the model does not suffer from goose-pimples by turning up the heating. He can prevent air currents from moving the model's hair during long exposures. He can shoot at any time of the day or night. He can limit the number of people on the set and it should be relatively easy to find adequate changing and make-up facilities. Sets can be built that precisely suit the requirements of the picture.

Location shooting has merits that may outweigh the relative comfort of a studio; the first and foremost of these is authenticity. Pictures taken by studio light against artificial backgrounds look unnatural. Try building a moonlit Jamaican beach in a studio and photographing the result. However hard you try, the real thing will look better every time.

There is another, less easily quantifiable, advantage to location shooting. You are more likely to derive flashes of inspiration in natural surroundings than in the bland confines of a studio. The way a certain tree leans may form a perfect backdrop for a particular shot. Light filtered through overhanging boughs often looks better than light filtered through a vaseline-smeared lens. So, before deciding where to take your pictures, assess the pros and

cons of studios and locations, and make your plans accordingly.

CHOOSING YOUR MODEL

The next consideration is the model. Again, you have two alternatives — amateur or professional. Your choice will depend largely on your budget. A professional model can cost as much as £100 ($150) an hour, but for that amount you will have hired a girl who knows almost as much about what you are doing as you do yourself. A good model will give you the desired effect with the least prompting and she will understand the need to work quickly and efficiently. She will turn up on time, ready and willing to follow your instructions to the letter. Professional models are available through agencies in all the big cities and agencies' names can be found in the telephone book.

It is more difficult to find amateur models. One way is to ask female friends whether they would like to model for you. Another way is to approach a girl whom you think looks promising. It is quite likely that your motives will be misunderstood so this should be done as tactfully and professionally as possible. You can explain to the girl who you are and what you do, and tell her that you think she has the potential to be a good model. It may help to have some cards printed, giving your name, address and telephone number. If possible, have one of your pictures printed on the card. When you hand her the card, ask her to contact you if she is interested. This will enable her to decide in her own time, under no pressure, whether or not to take up your offer. If she does contact you, arrange to meet on neutral territory and perhaps suggest she brings a friend with her. You can then explain more fully what you have in mind.

If the girl has never modelled before, the first session should be a test. It is practically impossible to tell whether a girl is photogenic without seeing what she looks like on film. At this stage do not on any account ask her to pose in the nude unless you consider she is sufficiently confident and has some aptitude for modelling. After a few sessions she will become more relaxed in front of the camera and may start to enjoy the challenge. When you have established a mutual trust you can suggest a few semi-nude shots, but do not attempt to persuade her to pose nude against her judgement. The resulting pictures will almost certainly show her reluctance and that is not what you want. The decision to pose in the nude must come from her, not from you.

If the girl has a talent for modelling, and wants to capitalize on her start, you should do your best to help her. Give advice on how to put a portfolio of pictures together and help her to get in touch with the right people. Explain the pitfalls that exist in the modelling world and tell her about model release forms, which assign the photographer the right to use pictures as specified on the form.

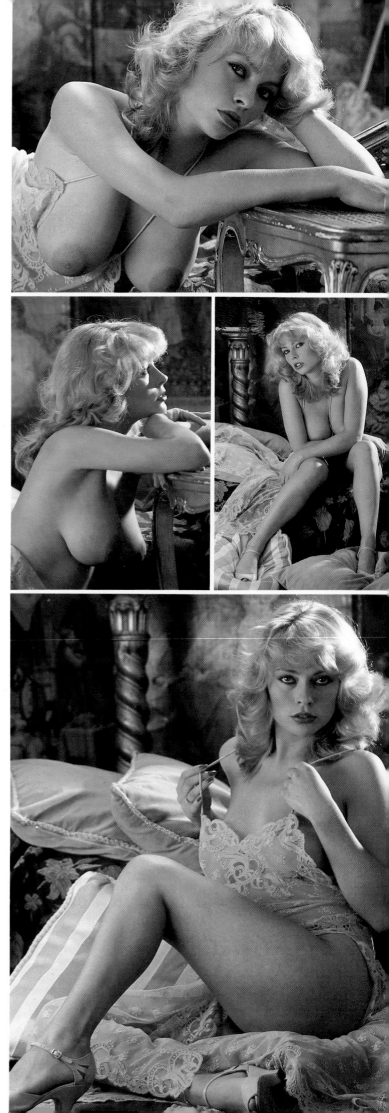

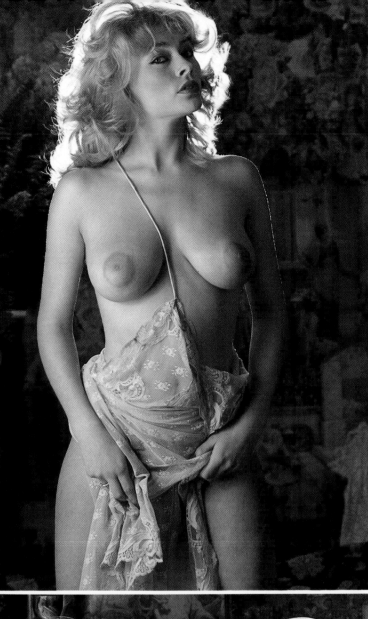

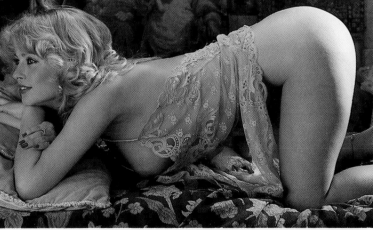

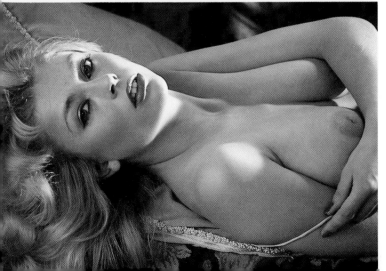

A model is able
to come up with an enormous
variety of poses (LEFT). In
these pictures a professional
model is going through a
routine so that the
photographer can take a
series of photographs showing
her figure from various
angles. The model's facial
expressions are also
important as they give a clear
impression of the range of
'looks' the girl is capable of.
The resulting photographs
will be used by the
photographer as test shots, to
enable him to assess the
model's suitability for an
assignment; sometimes the
photographer may give the
model a selection of test shots
for her own portfolio.

It is important to establish a
clear arrangement with your
model. Misunderstandings are
more likely to arise with an
amateur model who is not
protected by an agency and is
unclear about her rights.
Explain to the model about
model release forms (ABOVE).
Once the model has signed,
the photographer has
permission to use the pictures
as specified on the form.

PHOTOGRAPHIC EQUIPMENT: CAMERAS

THE 35MM SLR (single lens reflex) camera is most suitable for glamour photography. Its advantages outweigh its disadvantages many times over, particularly for location work. It is light and therefore easily portable. It is relatively cheap to buy and also cheap to run, in terms of the number of images per roll of film. Despite the low price, it is a sophisticated piece of machinery, well-engineered and capable of standing up to wear and tear.

Modern 35mm SLRs offer the photographer complete control of his exposures. A built-in light meter suggests what settings should be

Glamour photographers use all sorts of cameras and the 35mm SLR is deservedly one of the most popular. It is compact, versatile and easy to handle. It usually offers through-the-lens metering and accepts a large variety of lenses and accessories. In addition, there is a wide range of film choice for the 35mm SLR camera. However, some glamour photographers prefer to use larger format cameras, since they produce a larger negative or transparency, which in turn ensures better reproduction.

The Minolta 9000 (above) is a highly sophisticated 35mm SLR which offers autofocus allied to a comprehensive choice of exposure modes, and a large system of high quality lenses and electronic accessories. The camera is shown fitted with the Auto Winder AW-90.

Medium format cameras, such as the Bronica SQ-Am above, produce larger negatives and transparencies giving higher quality reproduction due to reduced enlargement. They also use interchangeable roll film backs (near left) and most can use a Polaroid back (far left) for instant checking of pose and lighting.

made on the aperture and shutter dials. The photographer can either use the suggested settings or choose his own, according to how he wants to vary the image.

Cameras of this kind are often provided with automatic exposure controls, which theoretically ensure that the photograph is correctly exposed. This can be extremely useful to the photographer who would rather concentrate entirely on watching the action and pressing the shutter release at precisely the right moment.

A wide range of shutter speeds is available, typically from 1 sec to 1/1000th sec. The fastest speed will 'freeze' most fast-moving subjects, including racing cars, falling rain and running water. Mid-range speeds — 1/250th sec, 1/125th sec and 1/60th sec — are the most commonly used in glamour photography, where the subject is relatively static. At these speeds the photographer can hand-hold the camera without fear of camera-shake. These speeds also allow the use of a wide range of aperture settings, giving the photographer scope to increase or decrease the band of sharp focus in the picture at will.

At speeds below 1/30th, some form of camera support must be used to prevent camera-shake. A sturdy tripod is the surest solution to this problem. Slower shutter speeds are useful because they allow moving elements in the image to blur, while anything stationery remains sharp.

All the well-known camera manufacturers make comprehensive accessories for their 35mm SLRs. These include a wide variety of lenses, flashguns, motor drives and viewing screens.

The 35mm film format has definite advantages over its rivals, not the least of which is the availability of Kodachrome 25 and 64. These two films are renowned for their pure colours and fine grain. Some publishers of glamour photography will only buy pictures if they have been taken on Kodachrome stock.

The 35mm frame is big enough to allow good print reproduction and small enough to allow the photographer to load up a 36-exposure cassette. A medium format camera such as the Hasselblad with its 2¼sq inch frame size only gives 12 exposures on normal 120 roll film. The

Rectangular film formats, such as 35mm, 6 x 7cm and 6 x 4.5cm, offer definite advantages over the square frame produced by 2¼sq in cameras. In this picture the photographer has echoed the upright stance of the model by turning the camera on its side. The inclusion of the pillars on either side of the model hold the frame together, and help to give the whole shot a feeling of vertical strength.
50mm lens, Kodachrome 25, 1/125th sec, f8

The photographer has planned the composition to make the most of the square frame (ABOVE). Every element has been perfectly positioned to achieve symmetry — even the hands of the clock have been set to echo the angle of the model's legs. The only exception is the mouse, and the viewer's attention is immediately drawn to it simply because it breaks the symmetry. If the photographer had used an upright rectangular format the composition would have looked cramped.
150mm lens, Ektrachrome 64, f16

TOP RIGHT: The horizontal rectangular frame suits the shape of the prone model, and allows the photographer to capitalize on the horizontal bands of water behind her.

The strength of the shot lies in the directional consistency.
50mm lens, Kodachrome 64, 1/125th sec, f5.6
Most roll film cameras accept 120 size roll film, however the size of the film image will vary depending upon the camera's format (RIGHT). The majority of roll film cameras give 6cm (2¼in) square pictures, but some formats give rectangular pictures — 6 x 4.5cm (2¼ x 1⅝in) and 6 x 7cm (2¼ x 3in). The advantage of these formats is that the shape of the final image is closer to that of magazine or book pages. Since this is where most of the shots are intended to be published, it helps both photographer and designer to avoid the problem of cropping.

6 x 7cm (2¼ x 3in)
6 x 6cm (2¼ x 2¼in)
6 x 4.5cm (2¼ x 1⅝in)

35mm film format offers the greatest range of film choice — everything from infra-red black and white, through to negative and reversal films up to 1600 ISO .

MEDIUM AND LARGE FORMAT CAMERAS

For sheer versatility 35mm must be the glamour photographer's first choice, but quality of reproduction is also important, particularly among professional glamour photographers who earn a living by selling their pictures to magazines or calendar companies. The fact is that the larger the original negative or transparency, the better chance the printer has of ensuring perfect reproduction. This is the reason why the 6 x 6cm (2¼sq in) format has found so much favour with professionals.

By opting for 6 x 6cm, the photographer commits himself to using a far bigger camera, and the prices of these machines are considerably more. There is just as wide a choice of lenses available as there is for 35mm, but again costs are higher. The same applies to system accessories.

These medium format cameras are better for studio work than they are for location shooting. They have interchangeable film magazines so that an assistant can change a film in one while the photographer is shooting on another.

Another point in their favour is the availability of Polaroid backs. These can be clipped to the back of the camera and instant prints can be obtained of the shot. The professional uses the Polaroid shots to assess colour balance and lighting before shooting the picture on conventional film. In this way, errors can be spotted and eliminated.

There are other disadvantages apart from cost. Besides being bulky and cumbersome, 6 x 6cm cameras produce a picture that is square. The pages of most magazines and books are rectangular. If the publisher wants to run a 6 x 6cm picture over a whole page, he will have to crop the sides of the shot. This would be unnecessary with the 35mm format. Kodachrome film is also not available in any form other than 35mm, so the medium format photographer must use relatively unstable professional film stocks.

The criticisms and praises that have been applied to 6 x 6cm cameras can also be applied to other formats. 6 x 4.5cm (2¼ x 1⅝in) give a rectangular image, but they are as bulky as the 6 x 6cm. 6 x 7cm (2¼ x 3in) cameras also produce the required rectangular picture, but are even larger, and less suitable for location work. They are however very much in favour with professionals for studio glamour.

Above that, there are view cameras, which offer 5 x 4in (12 x 9cm) or even 10 x 8in (24 x 20cm) frames. These cannot be hand-held. They are very expensive and are really the preserve of the professional. In knowledgeable hands they can produce stunning results.

There is no need to invest thousands of pounds in a medium or large format camera, if you simply intend to shoot glamour pictures. The 35mm SLR will suit your needs adequately.

PHOTOGRAPHIC EQUIPMENT: LENSES

Personal preference will usually dictate the type and number of lenses a glamour photographer will use. The Minolta Dynax 7000i is shown (ABOVE RIGHT) fitted with a versatile 35-105mm zoom lens which is an ideal substitute for the conventional 50mm standard lens. Fixed focal length lenses, such as a short telephoto 105mm, are still popular for glamour work since they have a larger maximum aperture than a comparable zoom. The rule to remember is that rules are made to be broken, and imagination is more important than hardware. Keep your lens system small for location work to reduce weight and bulk, and hence fatigue.

There is little need for the well-equipped photographer to actually move in relation to his subject, even if he wants to change the framing from wide angle to close-up. He can use a zoom lens which offers him a range of focal lengths, or he can use a set of fixed focal length lenses. The quality of the fixed lenses tends to be higher than that of zooms, but zooms are much more convenient, because the photographer does not have to physically remove the lens from the camera to change the framing. Examples of shots taken by zoom and fixed focal length lenses (RIGHT): 150mm setting on a 70-200mm zoom (1); 105mm fixed lens (2), 85mm on a 70-200mm zoom lens (3); 85mm fixed lens (4); 135mm on a 70-200mm zoom (5); 50mm fixed lens (6).

THE GLAMOUR PHOTOGRAPHER will also need a range of lenses for the camera. The 35mm camera accepts a wide variety of lenses which allows the photographer to vary the kind of shots he takes. Lenses with a focal length shorter than 35mm have a tendency to distort the image, which makes them largely unsuitable for this kind of work. The only exception is if you deliberately set out to produce a distorted shape, but generally glamour shots do not benefit from this.

35mm and 50mm lenses. A 35mm lens allows you to include the model's background which is often useful. The standard lens for a 35mm camera has a 50mm focal length. This is said to cover an angle of view approximately similar to that of the human eye. With a 50mm lens it is possible to take a full-length picture of a person from about nine feet (3 metres).

Both 35mm and 50mm lenses usually offer wide maximum apertures, f1.8 or f2, which makes them ideal for use in low light, or for dif-ferential focusing: this is a technique that allows you to select a critical band of sharp focus when operating at a wide aperture, leaving everything else to blur.

85mm and 105mm lenses are often used by glamour photographers. The design of these lenses is relatively simple and even budget-priced versions can produce sharp, rectilinear images. However the real reason for their popularity lies in the distance from which the photographer can obtain a good close-up of the model. There is nothing more off-putting, even to the professional model, than having the photographer snapping away with his lens about a foot away from her face. A long focus lens, such as the 85mm or 105mm, allows the photographer to stand well back while shooting close-ups. These lenses also offer fast maximum apertures.

135mm lenses can be useful, particularly on location where there is more space, and can essentially fulfil the same functions as the

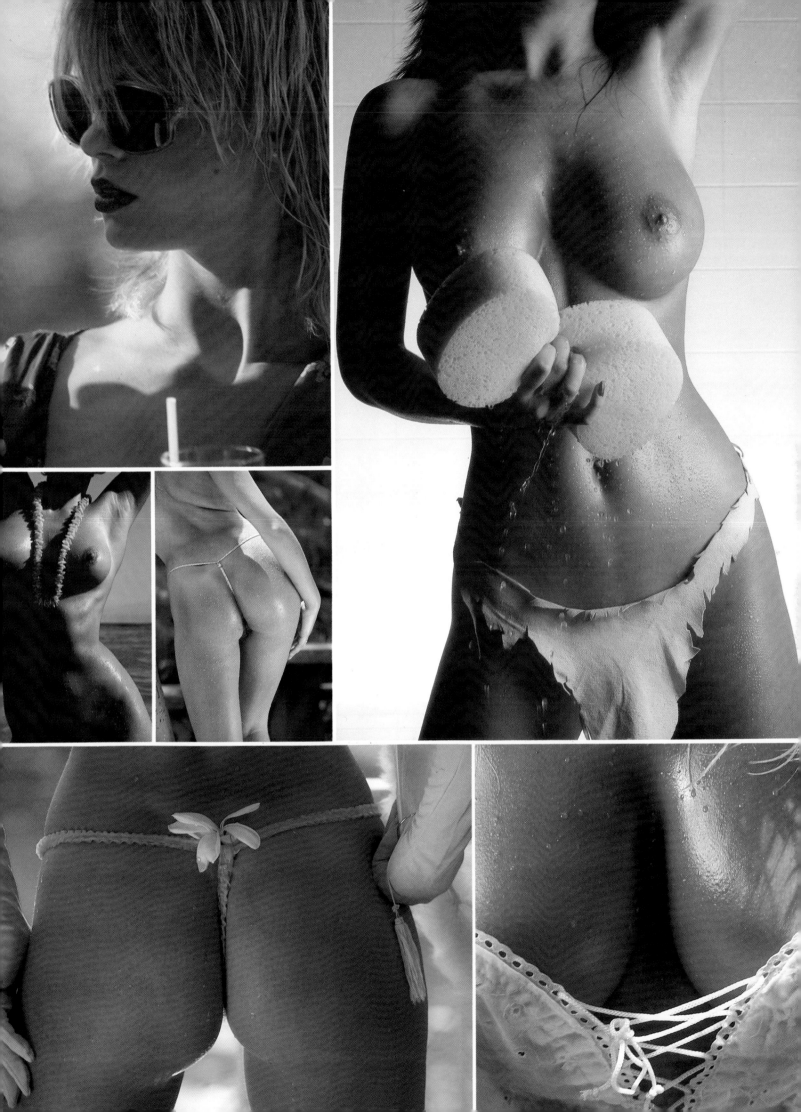

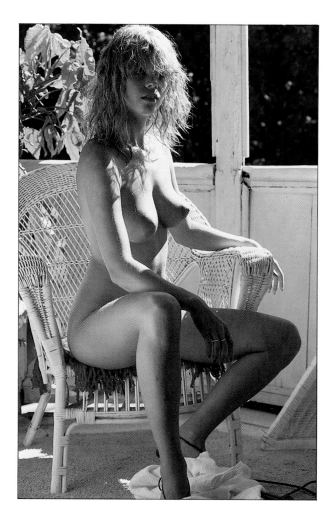

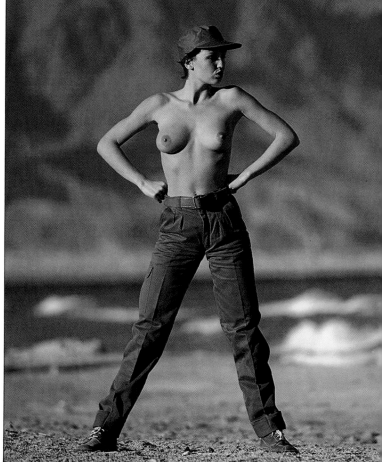

85mm and 105mm long-focus lenses. With a 135mm lens you start to see the compression of perspective that is such a noticeable trait on a true telephoto lens such as a 200mm or 300mm. This effect can be pleasing but it must not be over-used. Again you need plenty of space to achieve a harmonious effect.

The glamour photographer will have little need for lenses longer than 200mm. The working distance between model and photographer becomes so great that communication becomes impossible.

50mm is the focal length of a standard lens on a 35mm camera. With a camera-to-subject distance of about 3 metres (9 feet) it is possible to include a standing figure within the frame, provided the format is vertical rather than horizontal. The photographer has taken the picture (FAR LEFT) from about 2 meters (6 feet).
50mm lens, Kodachrome 64, 1/60th sec, f8

A 200mm lens demonstrates the compression of planes within a picture that is so characteristic of long telephoto lenses. In the picture (ABOVE) the heat haze rising off the Red Sea is emphasized considerably by the use of a telephoto lens.
200mm lens, Kodachrome 25, 1/250th sec, f3.5

ZOOM LENSES

The design of zoom lenses has changed dramatically over the last few years, and earlier criticism of them no longer applies, except in the case of very cheap units.

There are two varieties that the glamour photographer should at least investigate. The first is known as a 'mid-range' zoom and typically has a focal length of 35-70mm. These lengths may vary by 5mm each way. This lens can do the job of both the 35mm wide angle and the standard 50mm lens. The second zoom is the 70-150mm, which takes care of the longer end of the focal scale.

The advantage of a zoom is that the photographer can alter the framing of the picture with one simple hand movement. With fixed focal length lenses he needs to either change the lens or move his camera position until he finds the right position for the frame he wants.

The main drawback of a zoom is that the maximum aperture is usually smaller than one would hope to find on a fixed lens of the same focal length. The optical quality of a zoom is rarely quite as good as that of a fixed lens, but it would take a real purist to spot the difference these days. Zooms are still comparatively expensive but the more professional photographers are finding that the extra expense is recompensed by the increase in working speed.

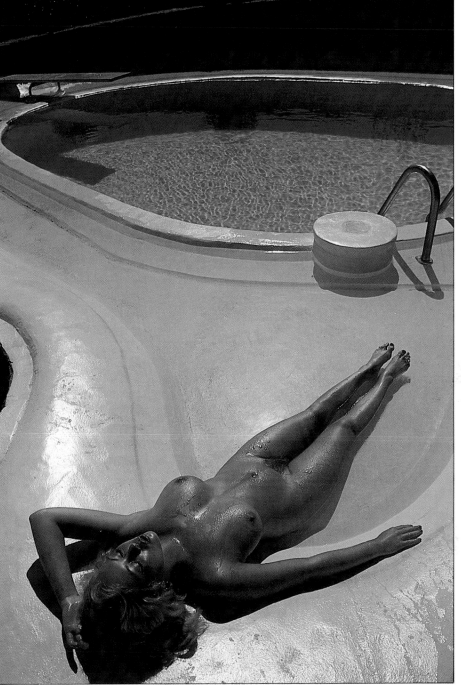

The principal advantage of using a wide angle lens is that the photographer can include far more in the frame than would be possible with a standard 50mm lens. In the picture (RIGHT) the photographer used a 24mm lens so that he could include both the complete figure of the model as well as most of the swimming pool. The danger of wide angle lenses is that proportions can become unattractively distorted. In this picture the model's legs are considerably shorter than her arms.
24mm lens, Kodachrome, 64, 1/250th sec, f8

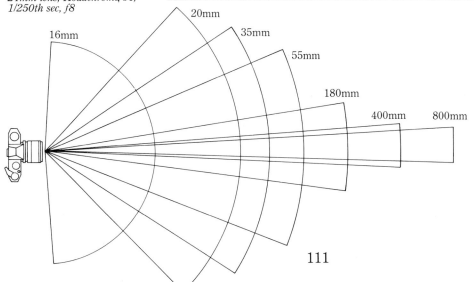

16mm
20mm
35mm
55mm
180mm
400mm
800mm

The diagram (LEFT) shows the angle of view of some of the lenses that can be used by a 35mm camera. The longer the focal length, the smaller the angle of view seen by the lens.

111

PHOTOGRAPHIC EQUIPMENT: FILM

This selection of Kodak 35mm film types (ABOVE) shows the wide variety available. The film size will be dictated by the type of camera in use. The correct colour balance will depend on whether the film is to be exposed by daylight (including electronic flash), or artificial sources. The ISO rating of the film is a measure of the film's speed of response to light. Film packaging carries an expiry date — check that you are not buying old stock.

Light can be measured by its colour temperature. The scale (RIGHT) shows colour temperature of a wide range of natural and artificial light sources. Low colour temperatures are at the red end of the scale and high ones at the blue end; noon daylight is in the middle. The colour temperature of electronic flash is approximately the same as daylight. In order for colour film to reproduce colours the way we expect them to look, the film must be balanced to match the colour temperature of the light source. Colour emulsions are therefore designed to be used with different light sources. For example, daylight film is formulated to faithfully record a colour temperature of 5500K, whereas Type B film is balanced for 3200K tungsten lighting.

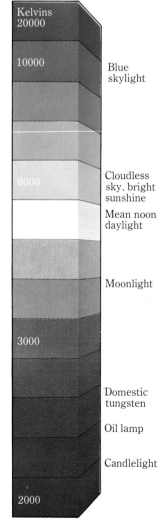

Kelvins
20000

10000 — Blue skylight

6000 — Cloudless sky, bright sunshine
Mean noon daylight

Moonlight

3000

Domestic tungsten

Oil lamp

Candlelight

2000

FOR COLOUR WORK, most professional glamour photographers prefer to use reversal film; their clients prefer it too. The main reason is that a transparency is the actual film on which the image was recorded. A print made from a negative is one step removed from the original, and is therefore a less accurate reproduction of the image in front of the camera. In addition, a print can be made from a transparency more easily than a transparency can be made from a negative.

For 35mm photography Kodachrome 25 or 64 is the usual choice. These two films are unequalled for colour purity, resolution and fineness of grain. Both the Kodachrome films are balanced for daylight. In other words they are formulated to produce accurate colour rendition in a colour temperature of 5500K, the 'colour' of daylight. As a result they can only be used when the light source is daylight or electronic flash. If the source is tungsten illumination the results will be yellowish. This can be corrected by using a blue filter, but a far better solution, if you know you are going to shoot by tungsten light, is to use film that is formulated to accurately reproduce colour at that colour temperature (3200K).

The problem with the Kodachrome emulsions is that they are relatively slow. In dimmer light conditions, it may therefore be necessary to shoot on Ektachrome stock. This is professional reversal film and is available in ASA rating up to 400. The 'professional' tag merely means that it must be kept under stable cool conditions if it is being stored for any length of time. Its high ASA rating enables you to shoot in lower light levels, but the price you pay is graininess. The resolution is less good than one finds in the Kodachrome stocks.

Black and white is less popular as a medium for glamour photography, but that has not prevented people like David Bailey from producing fine work. The distinctions between negative and reversal, daylight and tungsten do not exist for black and white film. It merely has to be chosen according to its ASA rating.

As a general rule, and this applies to both colour and black and white, the slower the film the finer the grain is. Unless your model has exceptionally fine skin it is unwise to use slow film for close-up work, because every blemish

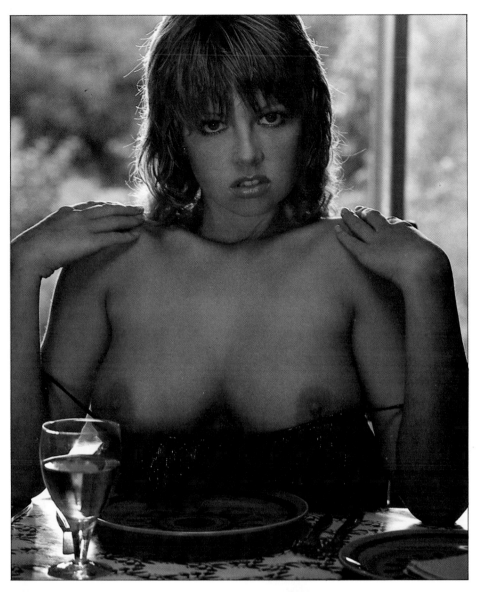

Tungsten illumination throws a particularly warm light, which only shows up if the camera is loaded with film that is balanced for daylight exposures. This combination is well suited to glamour photography because the warmer skin tones tend to complement a nude model (LEFT).
85mm lens, Kodachrome 64, 1/60th sec, f3.5
A great deal of care must be taken both with film and lighting if the model is to be photographed from close-up, unless her skin is absolutely blemish-free. The picture (BELOW), for example, shows up slight blemishes on the model's face. Slow film is finer-grained than its faster counterparts, and therefore reproduces any unevenness or mark with a clarity that can be dangerous. The grain found in faster films tends to blur such irregularities.
50mm lens, Ektachrome 64, f16

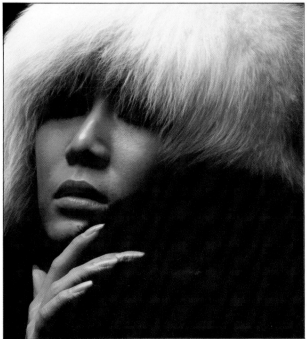

will reproduce accurately. Film rated 200 ISO is probably the best all-round black and white film for glamour work, but faster films should not be overlooked. The slight blurring of detail that accompanies the use of some 400 ISO film can appear on the print as a smooth finish, particularly suitable for glamour photographs.

Recent developments in black and white film technology have brought us high speed films nominally rated at 3200 ISO. In use, these films have shown themselves to be particularly grain-free.

If light conditions do not allow you to shoot at the aperture and shutter speed settings you want, it is possible to 'uprate' the film during processing. By prolonging development of a film which has been exposed at a higher speed rating than the manufacturer advise, you can redress the exposure balance. This can be done with both colour transparency and black and white film, but is not possible with Kodachrome films.

PHOTOGRAPHIC EQUIPMENT: ACCESSORIES

Motor drives trigger the shutter and wind on the film. Developed for fast action photography, they can be useful to the glamour photographer as they free his attention from two mechanical operations and enable him to concentrate on framing the model through the viewfinder. Most motor drives can be set to fire either single or continuous frames. With the latter setting, the camera will keep on firing as long as a finger is kept on the shutter release. With the former setting, the motor drive winds on the film automatically after exposure. As least one motor drive allow the photographer to shoot at up to 10 frames per second. Five frames per second is more common. Auto winders are basically simplified motor drives without the capacity for rapid firing. The Nikon F4 (ABOVE TOP) has a built-in power winder. SLRs without a built-in winder usually accept an accessory winder or motor drive (ABOVE BOTTOM).

CAMERA, FILM, LENS and light are the only essential requirements for any kind of photography. However the photographer's desire to overcome specific restrictions has led to a growth in accessories. The most obvious example is the flashgun. This portable, controllable instant light source enables pictures to be taken in low light levels.

The glamour photographer has little need of accessories. Most of his work is carried out in bright light conditions. Unlike the sports photographer who must capture one split-second of action, the glamour photographer can work quite happily without a 10 frame per second motor drive. Nor is it vital for him to use slow shutter speeds that demand the use of a tripod.

The fact is, however, that most professional glamour photographers use a variety of accessories, not because they have to, but because they know that at any moment the extra scope provided by an accessory may prove to be the difference between a good picture and a classic one.

The bulk film back (ABOVE) takes a roll of up to 250 exposures. It can be very useful for the glamour photographer when he is using a motor drive or power winder or if he wishes to shoot for long periods without reloading.

MOTOR DRIVES

A motor drive is particularly useful if you want to photograph a model performing some kind of action. If there is only time to take one picture during the course of the action the model will have to repeat it over and over again. She will get tired and you will get frustrated. A motor drive allowing you to fire off five or even ten frames a second will vastly increase your chances of catching the model at the right moment, against the right background, with the right expression on her face. The increased amount of film you will get through is a small price to pay under these circumstances.

One technical point on motor drives: your shooting rate will be seriously impaired unless you can set a shutter speed above 1/60th sec. The time it takes for the camera to recock its shutter and lift up the mirror, added to the exposure time, will reduce the number of frames you can expose per second.

Most motor drives have both continuous and single settings. In the first case the camera will keep on firing until either the photographer takes his finger off the shutter release, or the film runs out. In the second case only a single

ACCESSORIES

Sessions in which the model goes through a continuous sequence of poses are best captured by means of a power (auto) winder set on its 'single frame' mode (LEFT). Every time the photographer takes his finger off the shutter release button, the power winder transports the film so that the next frame is ready for exposure. This leaves the photographer free to concentrate on framing.

To make the most of an action session, a motor drive is useful. The photographer simply keeps his finger on the shutter release button continuously. After each exposure the film is automatically wound on and the shutter trips as soon as the next frame is lined up. With this technique the photographer is likely to capture a certain spontaneity (BELOW) and it certainly saves the model having to repeat an action continually. The risky part of shooting with a motor drive is that film is exposed very quickly. In some cases, a 36-exposure roll of film coupled with a motor drive will travel through the camera in as little as 7 seconds.

The desire to arrange all the elements within a composition correctly can lead photographers to adopt some strange positions. Chris Thomson (RIGHT) is seen lining up a shot for a calendar. In order to get the jetty and the model in the correct positions he had to set up a step ladder. From there he could see down into the viewfinder of the camera. Without a sturdy tripod, this particular shot would have been impossible. The light levels were low at the time of shooting and the tripod was necessary to keep the shot blur-free.

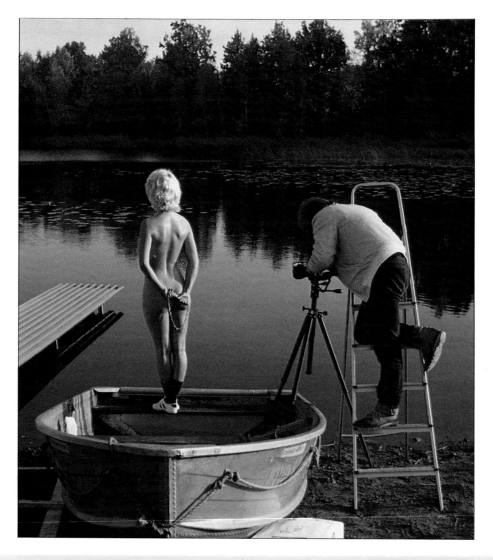

A tripod is an essential piece of equipment for a glamour photographer. Choose one of good quality, light enough to be portable, but solid enough to hold the camera and lens rigid. The standard tripod (FAR LEFT) has extendable telescoping legs and a rising centre column. For low view-points the column of some tripods can be reversed so that the camera can be mounted upside-down (LEFT).

A horizontal arm provides easy access to the camera's controls. Tripod 'feet' vary. Rubber or plastic compounds are most efficient for indoor use (LEFT). Some tripods have ribbed 'soles' to prevent them slipping on a smooth floor (MIDDLE). A spike gives a good grip for outdoor use (RIGHT).

A wide range of cable releases is available (ABOVE). Cables trigger the shutter and lessen the risk of camera shake when using a slow shutter speed, as they cut down vibration. The lead (FAR RIGHT) is electrical and can operate electrically operated shutters.

50mm lens below 1/60th sec without inducing camera shake.

The figure of 1/60th sec applies only when a 50mm lens is in use. The longer the focal length of the lens, the higher the minimum acceptable shutter speed. As a rough guide, you can say that the minimum shutter speed necessary for sharp hand-held pictures is the nearest in numerical value to the focal length of the lens. If, for example, you were using a 200mm lens you would not be able to hand-hold the camera below 1/250th sec.

There is little point in using a flimsy tripod. It might allow you an extra couple of stops of shutter speed, but you could probably achieve that by holding the camera very firmly and bracing your body against a wall. It is worth spending a little extra on a tripod to make sure you get a sturdy one. It will not wear out and it will not be superseded.

shot will be taken but the camera will wind on automatically. The nature of the shot will dictate which mode is more acceptable, but as a general rule continuous should be used if the action is either very fast or very demanding on the model. The single setting is more suitable for sequences in which the success of the shot depends upon the photographer's ability to react very fast to a single, specific instant.

TRIPODS

Without a tripod the photographer is denying himself the use of over half of his camera's shutter speed range. This is simply because most people cannot hand-hold a camera with a

REMOTE RELEASES

The normal pressure of a finger on the shutter release button tends to move the camera slightly during exposure. At higher shutter speeds this makes little difference, provided that you squeeze the release gently rather than apply sudden sharp pressure. But at slow speeds the tendency is exaggerated, and can ruin shots even when you are using a tripod. The solution to this problem lies in the cable or air release.

A cable release is a cord that attaches to the camera's shutter button. When pressure is applied by the photographer, a wire inside a fabric or plastic sleeve moves down and transfers pressure on to the camera release. The

A practical tripod head is important. Ball-and-socket heads allow rapid adjustment but are relatively difficult to position with great accuracy. Pan-and-tilt heads allow you to separate each movement — vertical, horizontal, sideways — so that individual adjustments can be made with greater precision.

Through-the-lens (TTL) metering is built into most modern SLR cameras. Some of the different types of meter displays are shown above. The matched and centred needle displays (1 and 2) have been replaced in later designs by light-emitting diode (LED) displays and liquid crystal diode (LCD) displays. In the LED display (3) the upper dot, when lit, indicates over-exposure, the middle dot average exposure and the lower dot under-exposure. The LED display (4) shows the correct aperture setting for use with the shutter speed pre-set by the photographer. The LCD (5) gives shutter speed and aperture information in digital form.

photographer's hand need not touch the camera to trigger an exposure. An air release has a similar effect, but the shutter is tripped by air pressure. The photographer squeezes a rubber bulb, the air compresses and pushes down a wire which in turn depresses the camera release.

METERS

Most modern SLRs have built-in exposure meters which measure light reflected off the area seen by the lens and, for the most part, are unaffected by anything outside that area. In the main, they are reliable and accurate.

For general photography this is satisfactory. It may not, however, be accurate enough for the specialist. The centre-weighting system — one type of TTL (through the lens) measurement — whereby the meter derives most of its information from the central portion of the field of view, tends to produce readings that take little account of shadow areas or highlights at the edges of the frame. Even in the central portion it may suggest settings that average out contrasting tones. Suppose that the centre of the field of view contains both a bright highlight and a deep shadow area. The meter will suggest an exposure value that brightens the shadow and darkens the highlight. The resulting picture will reproduce neither tone accurately.

There are several ways round this problem. You can take a close-up reading with your camera's TTL meter from the area that you want to expose correctly and then go back and take your picture according to the settings suggested by the reading. It is a time-consuming exercise, but effective. Or you can buy a camera, the Canon F1 for example, that offers 'spot' metering. This allows you to measure off as little as 12 per cent of the field of view. However there are very few cameras that offer this facility.

The best method of overcoming the problem is to use the hand-held light meter. This is a small device which can be held directly up against the subject for close measurement, or a general reading of the scene can be taken from the camera position. Its function is to provide you with accurate exposure settings for the light level in any given area. Most professionals consider the light meter to be one of the most important tools. Light, after all, is the basis of all photography.

FLASH

Instant light, in the form of a flashgun, is another useful addition to the photographer's collection of hardware. Most professionals shoot their indoor work by studio flash, but this is extremely powerful and has to be used in conjunction with mains electricity. It is not portable.

Small flashguns come into their own on

A handheld light meter is a useful piece of equipment for a glamour photographer, providing accurate measurements of light levels in specific areas. The latest meter designs have light-emitting diodes and digital read-out (1 and 2). A spot meter (2) measures the amount of light reflected from a circle of 1° and allows the photographer to take very precise readings from any part of the model or setting. The Gossen Lunasix (3) is for more general use, enabling the glamour photographer either to measure the light falling on the model or to take a reflected light reading from her skin.

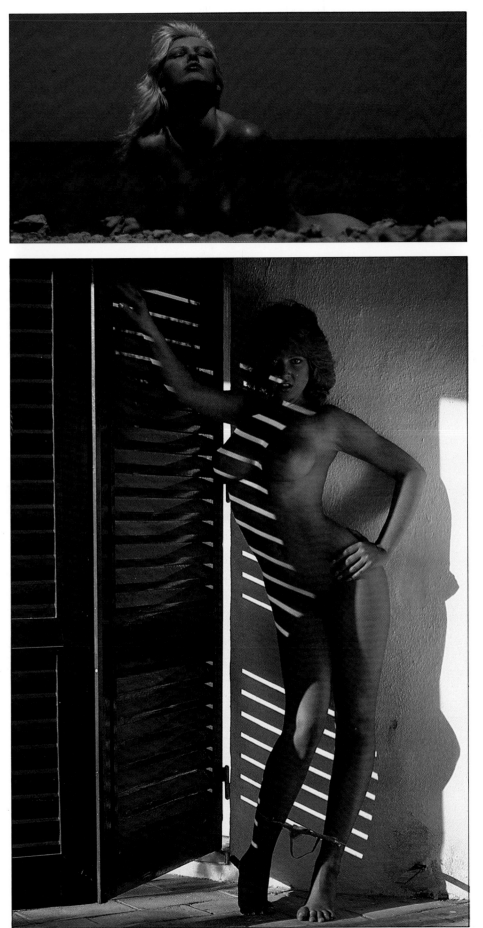

Face with fierce Mediterranean sunlight, a huge contrast ratio and an overall lack of colour, the photographer has opted to expose for the model's blonde hair, and to let the rest of the image go dark. He closed the aperture by a stop from the meter's suggested exposure value.
300mm lens, Kodachrome 24, 1/125th sec, f11

Very strong sunlight falling onto a shaded part of the scene can confuse the camera's built-in meter. The trick is to decide in advance which part of the picture you want to expose correctly, and meter directly from it. The highlights (LEFT) have simply bleached out while the rest of the model's body is correctly exposed.
50mm lens, Kodachrome 25, 1/60th sec, f5.6

The picture (ABOVE) shows a wide range of portable flash units and accessories. Portable flash units are designed to be either mounted on the camera or handheld and are the simplest way of providing instant, uncomplicated lighting on location. They enable you to work in conditions of very low light and are also useful for fill-in lighting. Direct flash can be very harsh, but the best portable units have tilting heads so that the flash can be bounced off the ceiling for a more diffused light. Some flash units also have special attachments to control diffusion. In contrast, the powerful and sophisticated electronic flash equipment (RIGHT) is not portable, and is designed exclusively for studio use.

location. The light emitting from an electronic flashgun has a colour temperature practically identical to sunny daylight. The two sources can therefore be used in tandem without strange colour casts appearing on the film. Where there is bright sunlight there is also deep shadow, and no film can encompass that sort of contrast range. The flashgun can be used to fire light into areas of shadow that would otherwise be lost on the film.

Electronic flash can also be used as a main source of illumination in outside night shots. A single powerful gun may be enough to light some set-ups, but the very directional light that it throws may look harsh and unattractive.

A better solution is to use several guns at once, spread out to give a more even illumination. To synchronize them, you can either connect each gun's lead to the camera via an adaptor, or use slave units. These are photo-electric cells which are triggered by the flashing of the camera-mounted gun and in turn trigger the other guns. Their response is instantaneous.

FILTERS

Filters fall into two groups — colour correcting filters and special effects filters. Both types have a place in the glamour photographer's collection of accessories.

Conventional filters are circular and screw directly into the thread at the front of the lens. But the most popular type of filter system now is

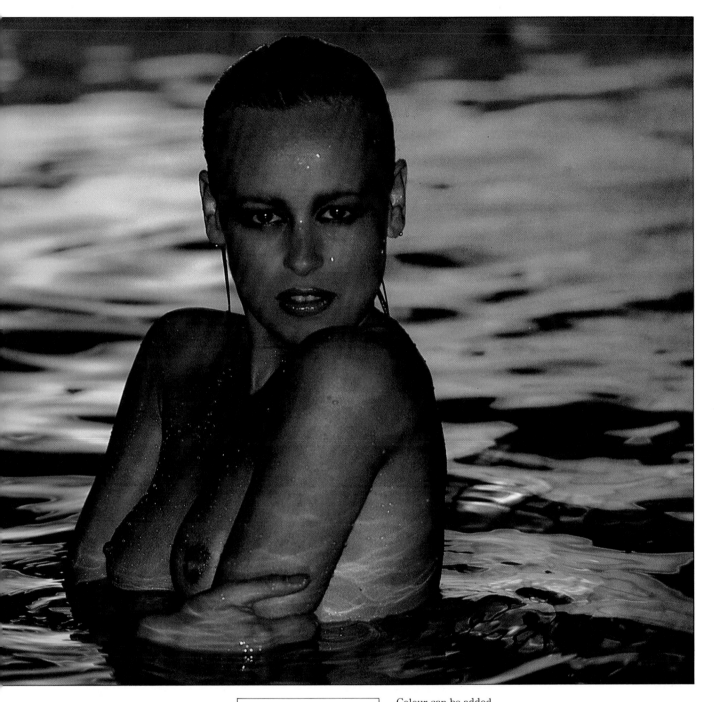

Colour can be added artificially to an electronic flash picture by placing coloured red gels over the unit's lens. In the picture above, the photographer mounted one portable flash gun in the camera's hot shoe to light the girl's face. Two other guns, one with a pink filter and one with a blue filter, were fired on to a white wall out of shot on the other side of the pool. The pink and blue reflections on the water are the effects of the latter two guns, both of which were triggered automatically by a slave unit.
80mm lens, Kodachrome 64, f16, 1/60th sec.

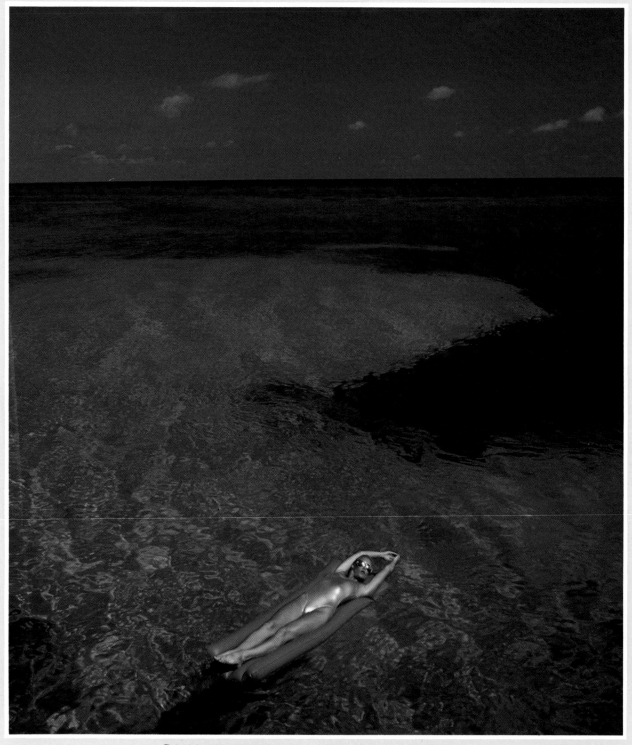

Polarizing filters (RIGHT) only allow synchronized rays to reach the film plane; they remove unwanted reflections from surrounding surfaces and darken the sky. When the polarizing filter is passing polarized light (BOTTOM) there is no effect on reflections or the sky. By revolving the filter (TOP) you will block any polarized light and the sky will darken and reflections will be reduced. A polarizing filter was used to take the picture (ABOVE). The sky is an unnaturally deep blue, and the sea has taken on a deeper shade of green. The clarity of the water has been emphasized by the removal of the reflections from the sky.

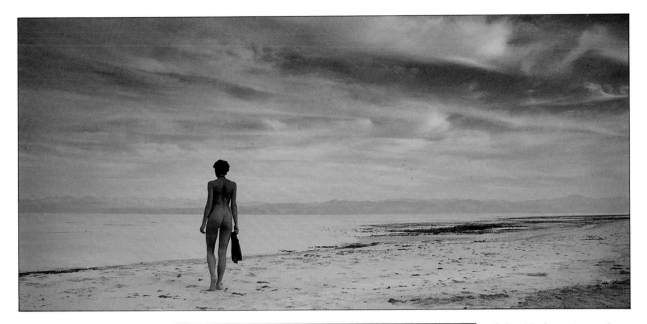

Light sky tones often beg for the use of a filter. In the picture above, a pink graduated filter has added tone to a sky that originally looked rather muddy. Graduated tobacco filters are also favourites for dealing with otherwise dull skies. *24mm, Kodachrome 64, 1/60th sec, f4*

A fine black mesh over the lens helped to diffuse the picture (LEFT). Strong backlighting played a large part, too. The photographer simply exposed for the shadows. Other alternatives are lenses made specifically to produce soft focus effects, and grease smeared over the lens. *150mm lens, Ektachrome 64, f16*

the interchangeable variety. You simply buy an adaptor and a filter holder. The adaptor screws into the lens thread and the holder screws on to the adaptor. Filters may then be bought singly as they are needed. The new system is more economic than the conventional one, because lenses have different sized screw threads and in the past you might have needed to buy three versions of one filter to suit all your lenses. With the new system you simply buy three adaptors and all your filters will fit on any lens.

All film is balanced either for daylight or for tungsten light. If you shoot daylight film in tungsten light the pictures will have an overall yellow/orange cast. This cast can be eliminated by using a colour-correcting filter — in this case, an 80B which is blue. The glamour photographer rarely runs into trouble with colour temperature, because he should be able to plan whether he is going to shoot his pictures in daylight or artificial light conditions. He can adjust his film stock accordingly.

Special effects filters are likely to be of more use. The photographer can introduce mood and atmosphere by slipping a coloured filter in front of his lens; the resulting picture will have an overall cast and will be significantly different from the original scene. The only danger here is when to use coloured filters and which colour to use. Overuse or misuse of coloured filters can destroy a picture. The questions you must ask yourself are: would the picture succeed without a filter? If so, will it be improved by the use of a filter? If the answer to those questions is yes, then try using a filter.

Graduated filters are becoming popular among professional photographers. The lower half of the filter is clear and only the top half is coloured. They are particularly useful for reducing the brightness of the sky, in cases where accurate exposure of the foreground would lead to over-exposure of the sky. Again, the colour must be chosen with care so that it adds to the impact of the picture.

True special effects filters such as starbursts and image multipliers can be striking in a picture. However the effect can tend to overpower the picture itself. You must bear in mind your list of 'impact priorities', the relative importance of each element, and make sure that the special effect fits into the shot at the correct level of impact.

LIGHTING CONDITIONS

I T IS IMPOSSIBLE to underestimate the importance of light in photography. The greek derivative of the word itself means 'drawing with light'. The photographic image is formed by the chemical reaction of silver halides to energy in the form of light. Light can be distinguished in two ways, natural and artificial. Each type has its own properties which play a significant part in creating the mood of a shot.

Natural light, also known as available or ambient light, has a tremendous range which can never be fully reproduced under artificial conditions. Even though the light from the sun comes from a single source, a vast range of effects is created by the position of the sun in the sky and the interference of atmospheric irregularities.

EARLY MORNING LIGHT

When the sun rises in the morning it casts its rays across the earth at an oblique angle. This period lasts only a short time, but it is prized amongst photographers above all other types of natural light. There are two main reasons for this. Firstly the sun's rays strike the sides of standing subjects. We are far more accustomed to seeing standing subjects lit from above, because throughout most of the rest of the day the sun is roughly overhead. The simple fact that the picture is illuminated from an unusual angle is enough to lift it out of the ordinary, even though the scene in front of the camera may be otherwise unremarkable.

Secondly, the quality of the light at this time of day is altogether different from that which occurs during the main part of the day. Instead of travelling straight down through the earth's atmosphere as sun rays do at midday, the early morning rays arrive at a slant, and their journey carries them further through the atmosphere. The result is that the light is far warmer in colour than at midday. Professional glamour photographers take every opportunity to utilize this warmth, because it suits the nature of their subject matter.

EVENING LIGHT

The same effect occurs as the sun sets, and again it only lasts a very short time. There is, however, a difference between the two times of day. The early morning light is usually clearer

Photographs of sunrise or sunset are always tricky, simply because the contrast range is so wide. If the sun is to be the part of the picture that you want to expose correctly, take a meter reading directly off it, and then bracket exposures by at least a stop either way. Remember also that sunset and sunrise happen remarkably quickly. You must plan in advance what you are after and be ready the moment the sun is in the right position.
300mm lens, Kodachrome 64, 1/15th sec, f3.5

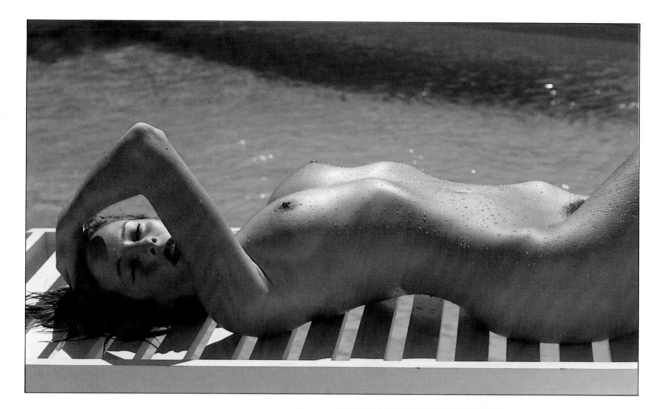

than it is in the evening, particularly near urban centres, simply because the day's activities stir up dust in the atmosphere. In addition, the land has become warmer during the course of the day and atmospheric conditions tend to produce a haze in the evening.

DIRECT OVERHEAD SUNLIGHT

As the sun climbs higher in the sky, and this is assuming that the sky is cloudless, the colour temperature of the light cools. From being a warm orange it turns to a cold blue. The shadows shrink in length but become much harsher.

Strong direct sunlight makes good photography difficult. The contrast between light and shade increases dramatically, frequently to the point where even modern films cannot accurately reproduce both ends of the tonal range simultaneously. However, the photographer can turn this to good advantage. If parts of the scene are strongly lit and others lie in deep shadow, he can elect to emphasize either part, either by carefully framing his shot or by using exposure values that allow one part to disappear into obscurity, while correctly reproducing areas he wants to keep. He can also use the strong contrast to make patterns that lead the viewer's eye back to the area of principal interest.

If strong vertical sunlight is causing the model's features to be unevenly lit, he can get around the problem by asking her to lie down. She can then be photographed from above and slightly to the side, to avoid the camera's shadow from falling within the image area; the

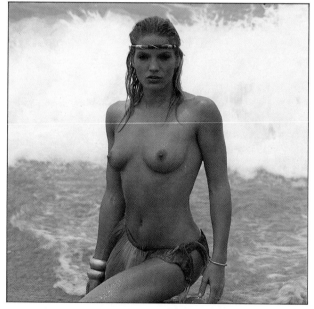

TOP Direct overhead sunlight presents the glamour photographer with problems. One solution is to make the model lie down, preferably on a light coloured surface. Her front will be lit by the direct sun, while her sides pick up light reflected from the ground. *85mm lens, Kodachrome 25, 1/250th sec, f11*

ABOVE Cloud cover at midday produces very flat lighting conditions. Both highlights and shadows merge into an overall grey. The resulting pictures lack any sparkle. *85mm lens, Kodachrome 64, 1/125th sec, f5.6*

TOP RIGHT Here the photographer has deliberately placed the model so that she is backlit by direct sunlight. A reflector covered with gold foil placed to the right of the camera throws light back up on to the front of her body. *50mm lens, Kodachrome 25, 1/125th sec, f5.6.*

RIGHT Another solution to the problem of direct overhead sunlight is to place the model in dappled shade. Exposure for shots such as this should be midway between highlight and shadow light levels. *135mm lens, Kodachrome 64, 1/125th sec, f5.6*

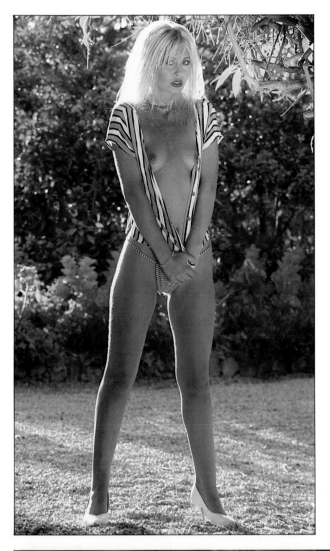

illumination will then be even.

In strongly directional sunlight it is particularly important to remember to meter carefully. You must decide what part of the image needs to be accurately reproduced and set an exposure combination that will cope with it. For example, if you are photographing a model against a background of dark blue sea and shining white sand, your camera's meter will be affected by the variation in tones and will not necessarily give you the correct exposure for the model's skin tone. Always take the precaution of taking a reading directly off the model's body. Even then you should meter both from the shadows and the highlights. The correct exposure would lie between the last two readings. In conditions of lower contrast this careful measurement would not be nearly so important, because the values for each part of the scene would be much closer together.

DIFFUSION

If the nature of the shot you are planning is rather more subtle, you would be wise to avoid direct overhead sunlight as an illumination source. Some form of diffuser, such as material, that will spread the light rays and cut down the fiercely directional intensity of the midday sun is needed.

Cloud is a natural form of diffusion and it can be very effective for the photographer; however there are drawbacks. The photographer cannot control the thickness of the cloud cover. It may be uniformly thick, in which case the contrast may be reduced to a dull average grey and these are hardly the best conditions in which to take

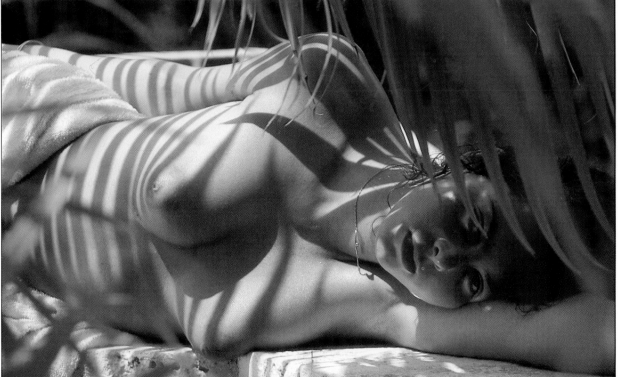

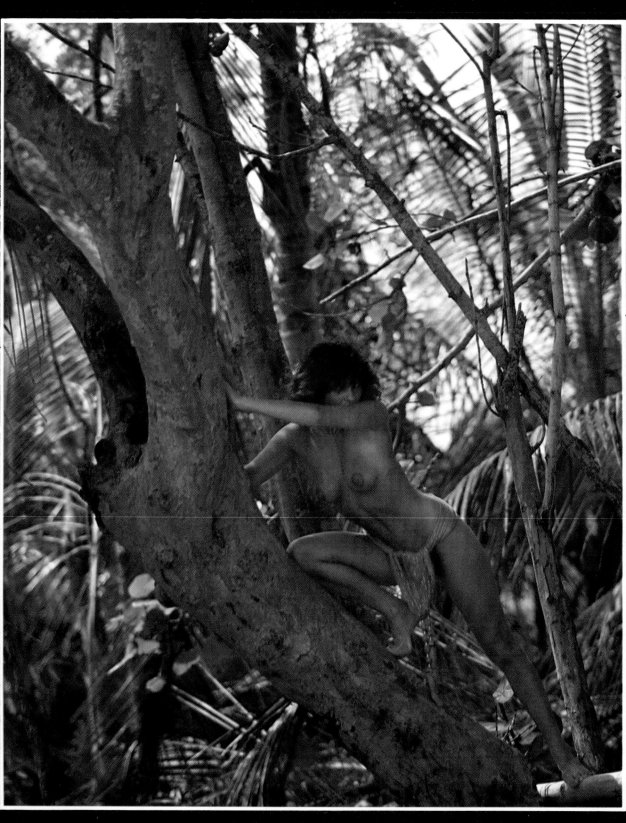

It is quite possible to shoot successful glamour pictures even when the light is flat. In the picture (ABOVE) the photographer has deliberately chosen a cluttered background and posed the model so that her arms and legs echo the asymmetrical arrangement of the foliage. A blue scarf tied around the model's body provides a vivid dash of colour which immediately attracts the viewer's attention, and the photographer succeeds in giving the composition a focal point.
85mm lens, Kodachrome 64, 1/125th sec, f5.6

photographs of beautiful women. On the other hand it may be patchy, which will mean that the light levels will be constantly changing. This will entail frequent checks with the meter to ensure that the correct exposures are being given. This will be time-consuming and tedious. You may of course be lucky with the light, even cloud cover forming the perfect diffuser. The chances of this occurring are, however, remote.

It is far more sensible to rely on a form of diffusion that you can control. Probably the simplest way of getting round the problem is to stand your model in shade. On a bright sunny day the shade is actually fairly light. It is only when you are trying to include both highlights and shadow that contrast problems are encountered. If the whole scene is photographed in the shade, the photographer is effectively setting smaller boundaries on the contrast range he is expecting the film to encompass. Incidentally, it is a fallacy to suppose that shade is simply a monotone. Areas of shade have 'highlights' and 'shadow' as well. It is just that they are less obvious and tend to be overlooked.

However finding a shady spot will restrict your choice of locations, and, more importantly, it will restrict the physical area in which you can shoot. One means of eliminating this dilemma is to shoot your pictures under a tree. Sunlight will fall through the branches and create a dappled shade. The effect of this is particularly suited to softer glamour shots.

SHOOTING INTO THE SUN

Up until now we have been talking about situations in which the photographer is trying to avoid the effects of direct sunlight. But there is no reason why he should not turn around and shoot towards the sun. The most obvious technique here is the silhouette. By standing the model between the sun and the lens, and setting the exposure for the background rather than the model's skin tone, it is perfectly simple for anyone to produce this pure form of imagery. It works particularly well with the female nude, if only because it concentrates the viewer's attention on the form of the figure. No extraneous details should be allowed to encroach into the image area or else the purity of the final product will be spoiled.

The term 'contre jour' ('against the day') can be applied to any picture in which the main source of illumination is behind the subject. A silhouette picture could therefore be described as contre jour. However the term refers more typically to shots that actually include the light source within the image area. It is a technique that is well-suited to glamour photography, provided that it is used skilfully. The central problem is that the light source itself tends to dominate the picture. Unless you are trying for a semi-silhouette effect this may not be advantageous. You have to remember that you can con-

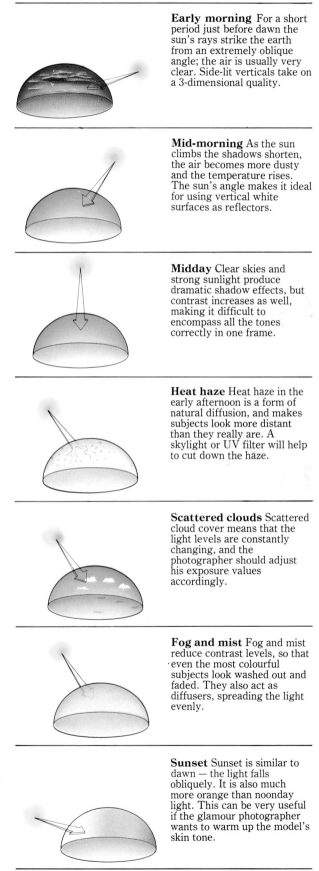

The quality of natural light changes all the time, and the glamour photographer must be able to recognize and harness the variety of effects that the movement of the sun creates.

Early morning For a short period just before dawn the sun's rays strike the earth from an extremely oblique angle; the air is usually very clear. Side-lit verticals take on a 3-dimensional quality.

Mid-morning As the sun climbs the shadows shorten, the air becomes more dusty and the temperature rises. The sun's angle makes it ideal for using vertical white surfaces as reflectors.

Midday Clear skies and strong sunlight produce dramatic shadow effects, but contrast increases as well, making it difficult to encompass all the tones correctly in one frame.

Heat haze Heat haze in the early afternoon is a form of natural diffusion, and makes subjects look more distant than they really are. A skylight or UV filter will help to cut down the haze.

Scattered clouds Scattered cloud cover means that the light levels are constantly changing, and the photographer should adjust his exposure values accordingly.

Fog and mist Fog and mist reduce contrast levels, so that even the most colourful subjects look washed out and faded. They also act as diffusers, spreading the light evenly.

Sunset Sunset is similar to dawn — the light falls obliquely. It is also much more orange than noonday light. This can be very useful if the glamour photographer wants to warm up the model's skin tone.

trol the final result by judicious use of the exposure controls on your camera. Meter whatever part of the picture you want to reproduce correctly and set the camera's exposure settings accordingly. Undoubtedly this will mean that the light source will be completely over-exposed in the picture, but it is usually of no great importance. The sun, for example, will probably become a white ball.

Finding the correct exposure for shots like this is a question of guesswork to a certain extent, and the photographer is always well-advised to bracket his exposures by at least one stop, if not two, each side of the indicated value. The point to remember is that you are trying to marshal far more light than would normally be the case, and in this situation, even the best meters will not always be accurate. By bracketing you will be giving yourself the best chance of success.

FLARE

Whenever you are shooting into a bright light, you run the risk of letting flare creep into the picture. Of course flare can, like any optical aberration, be harnessed to become another element to fit within the shot. However it is important to realize that the tell-tale streaks of scattered light that denote flare will undoubtedly form a powerful part of the image if they are allowed to reach the film plane and can possibly upset the balance of the shot. SLR users have an advantage in that they can usually see flare as it occurs and before they have taken the picture. Therefore they can estimate how much the aberration will visually affect the shot.

Flare can be combatted by using a lens hood or even a piece of card held to the side and in front of the lens so that the front element is actually in shadow.

REFLECTORS

One of the problems that constantly faces the photographer who works with natural light is

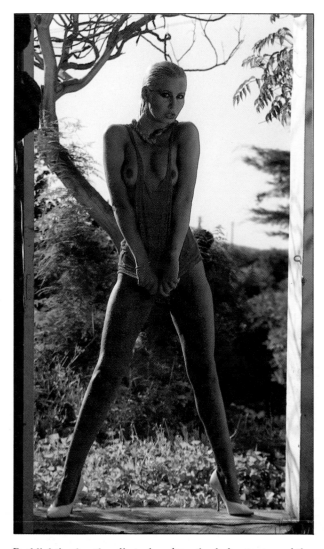

Backlighting has the effect of introducing distance between the subject and the background. If handled correctly it will rim-light the model's hair. In the case of the shot above, the model's body is also given a highlight down one side. Exposure calculations should be made from the darker tones, and the highlights should be allowed to burn out.
50mm lens, Kodachrome 64, 1/60th sec, f5.6

Lens hoods (ABOVE) are invaluable when working in intense sunlight. By shading the front element of the lens they prevent the refraction of strong light within the lens's optical system. There are various styles: 1 Built in sliding hoods, common in long focus lenses. 2-3 Detachable hoods to suit different focal lengths. 4 Rectangular hoods which only work on bayonet fittings. 5 Collapsible rubber hoods. 6 Adjustable bellow shades.

In order to include the moving image of the kite the photographer has allowed the sun to creep into the shot (RIGHT). The high shutter speed dictated that the aperture was relatively wide, and so the flare is fairly indistinct. With a smaller aperture the flare might have taken on the hexagonal shapes that are often noticeable in pictures taken into strong sunlight
24mm lens, Kodachrome 24, 1/125th sec, f5.6

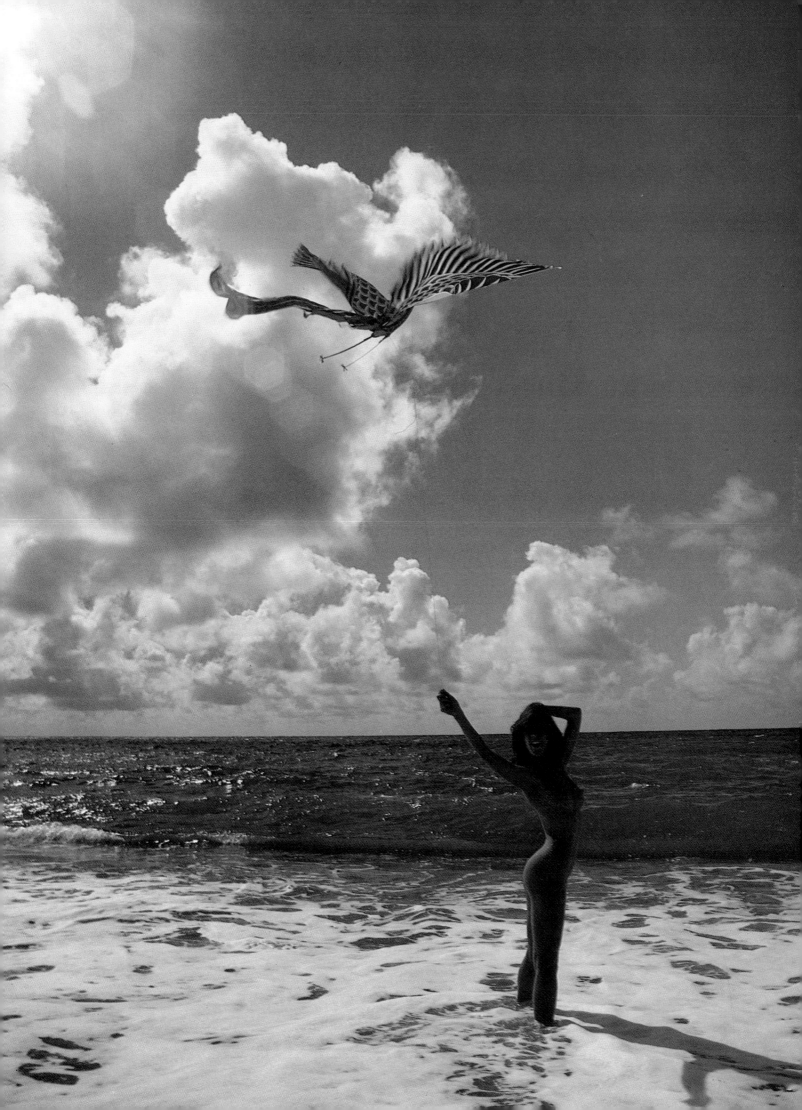

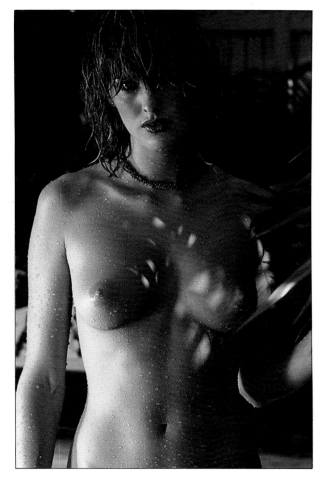

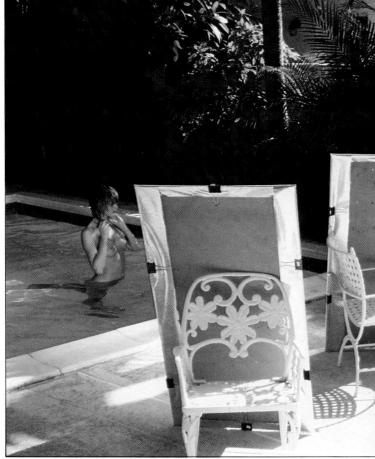

that he cannot move the light source so that it shines from an angle more suitable to his purposes. In many cases it is possible to move the model to a position that allows light to fall from a better direction. But occasionally, particularly if you are trying to pose the girl against an immovable prop, it just is not feasible.

The answer is to use reflectors. These take many forms. A white wall reflects a surprising amount of light. The sea, if the sun is at the right angle, also throws off a tremendous glare. A photographer who wanted to photograph his model amidst a forest of skyscrapers once used the light reflected from the 'mirror' windows to illuminate her.

However most of these 'reflectors' are immovable and therefore present largely the same problems as the sun. Undoubtedly the most convenient type of reflector is a plain white sheet of cardboard. It need not be too big — 3ft by 2ft should suffice for most purposes. It is easily moved and can be used to fill in shadows and reflect light into whatever shady corner you desire.

For a stronger effect some photographers use a sheet of board covered with silver foil. This material reflects 100 per cent of the light that strikes it, and can be something of a mixed blessing. Equally strong sunlight arriving from two angles simultaneously can look rather strange in a picture. It is unnatural, but it works well if you are trying to create a very bright, shiny 'high-tech' mood in the picture.

NATURAL LIGHT INDOORS

Supplies of natural light are not confined exclusively to exterior locations. It creeps indoors as well, but rarely in large quantities. The daylight that comes through windows is usually soft, subtle and muted, ideal for a glamour photographer trying for a more romantic 'feel'.

If it is very bright and sunny outside and there is a room with white walls and plenty of windows at your disposal you should try some indoor shots. The sun's rays will have bounced off the landscape, through the windows and off the walls before they fall on the model; as a result they will hardly be directional at all, and the shadows will be practically indistinguishable from the highlights.

Photographic conditions are rarely perfect, and although the quality of indoor daylight may be wonderful, the quantity will, in all probability, be insufficient. Exposure times may become so long that a tripod becomes necessary. But it is worth persevering, even though your model may have to stay still for longer than she is used to.

Do not make the mistake of posing her in a pool of direct sunlight that is coming through

132

The picture (LEFT) shows John Kelly at work on location in the West Indies. The swimming pool is in the shade and Kelly has chosen to use gold foil refelctors to bounce a warm light on the models's body. This brings the light levels up to an acceptable level and permits the use of 25ISO film and a hand-held camera. The picture (FAR LEFT) is taken during the same session. The model's skin has taken on an attractive warm, golden glow thanks to the light bounced on to her body from the gold foil reflectors.
85mm, Kodachrome 25, 1/125th sec, f8

Reflectors can be very useful to the glamour photographer. The can throw light into shady corners and fill in harsh shadows. There are many kinds of reflectors. Hand mirrors are very powerful, but their effect can sometimes be too obvious. Crumpled silver foil, pasted down onto a piece of card (ABOVE) is another strong reflector. A plain white sheet of cardboard can also be effective for softer fill-in light.

Professional photographers cannot afford to take too many chances with their pictures. If, for example, the contrast ratio is particularly high, and they are using 35mm film, they frequently 'bracket' the shots. If the meter suggests an exposure of 1/250 at f8, they will shoot one frame at that level, then another at f5.6, and another at f11. If they particularly want to use f8 for the aperture, they move the shutter speed dial a stop either way. In the examples (LEFT), the picture (TOP) was shot a stop under the suggested exposure value. The model's face has practically disappeared and the beam of light hardly shows. In the correct picture (CENTRE), the face is a little in shadow but the details are still clear. The picture (BOTTOM) is a stop over. The face details are still acceptable but the whites are very bleached out.

the window. The contrast between direct and reflected sunlight will probably produce a harsh result that spoils the effects that could be achieved by either choosing to stay with reflected light or by going outside into the direct rays.

Inevitably, there is an exception to this. Strong sunbeams falling through windows can be used. Pose your model in the ray and frame her in the viewfinder in such a way that you include both her figure and the surrounding area; set your camera to expose for the ray itself. The surrounding area will go dark in the final image and the model will appear to be caught in the sunbeam as if it were a spotlight. It is not an easy effect to achieve, and you are best advised to bracket your exposures in order to ensure that at least one of the exposures is correct.

Reflectors are useful indoors too. They can be positioned in front of windows to throw light sideways into shadier areas of the room. It is quite feasible to increase the light on your subject by a couple of stops in this way, which may mean the difference between hand-holding the camera or mounting it on a tripod.

ARTIFICIAL LIGHTING

The great advantage of shooting in the studio is that the photographer can control the lighting conditions. He does not have to worry about the

sun disappearing behind a cloud at the critical moment, or sudden gusts of wind. If he wants more light in the studio he can turn it up, or change the angle of illumination by simply moving the light stand.

There are all sorts of artificial lighting systems, but the two most commonly used by professional glamour photographers are tungsten and electronic flash. Of these two, electronic flash is becoming the most popular.

ELECTRONIC FLASH

The heart of a studio flash system is the power pack, a large capacitor feeding from the mains. Several flash heads can be plugged into the power pack, and the output of each can be varied to suit the photographer's needs.

The flashheads take many forms but the most common are single units, which are the flash equivalent of spotlights, fish fryers, flat rectangular frames that throw an even diffused light, and strip lights, long narrow frames with a flash head running the whole length. Each type has its own purpose.

The single units are used to provide directional light. For example, the photographer might want to throw light only on to a model's face, in which case he would use a single unit. The quality of light emitting from these units can be altered by the use of various attachments.

If the photographer wants to closely define the area into which the light falls, he can slip a narrow reflector over the flash tube. He can also fit barn doors, which have hinged metal wings protruding from each side. The wings can be moved so that they cut down the spread of light. He can also use a snoot, a hollow cone that fits on the front of the light. This will restrict the light to a very narrow pool.

On the other hand he may want to avoid strong directional illumination, in which case he can fit a diffuser. This may be wire mesh that fits over the reflector bowl, or an opaque disc, or even a reflector bowl fitted with a cap that cuts off direct light from the flash tube itself.

The fish fryer throws a light that is roughly comparable in quality to daylight coming through a window. The photographer uses it to provide an even spread of light over a fairly large area. Larger versions, known as 'swimming pools', are often used to provide general soft illumination over a whole scene.

Strip lights, particularly if placed either side of a background, throw an even spread of lateral light.

Arguably the most popular form of diffusion in the studio is the umbrella. A single unit is fired into the bowl of the umbrella and reflected back on to the scene. This combination provides both diffusion and direction. Silvered umbrellas produce a harsher shadow but give more light intensity than plain white ones. It is possible to

The 'fish fryer' (TOP), a large window light, provides an even spread of light over a wide area. The pivoted arm, pulley and barn doors all combine to make a very flexible light source, making the fish fryer a popular choice in photographic studios. The 'swimming pool' (ABOVE) is a larger version of the fish fryer. It provides a very broad spread of diffused light, giving flattering shadowless results.

TOP In order to give the effect of a graduated background, the photographer set up a large diffusing screen behind the model, and laid a strip flash tube behind it. The graduation effect stems from the angle at which the flash from the strip tube hit the diffusing screen at the moment of exposure. The model herself was lit by a flash head beside the camera.

RIGHT A similar technique was used as in the shot above, except that a blue background was erected behind a strip flash tube, and a wire mesh screen was placed between the model and the flash tube. The girl was illuminated by a single flash head immediately above the camera lens.

FAR RIGHT A mixture of tungsten and electronic flash was used for this picture. A single flash head was positioned behind the venetian blinds, just out of shot, firing downwards. The model was sitting on a perspex sheet beneath which were two tungsten lamps with red gel on them. Another tungsten lamp was placed behind the camera, about 10 feet back, to light her face.

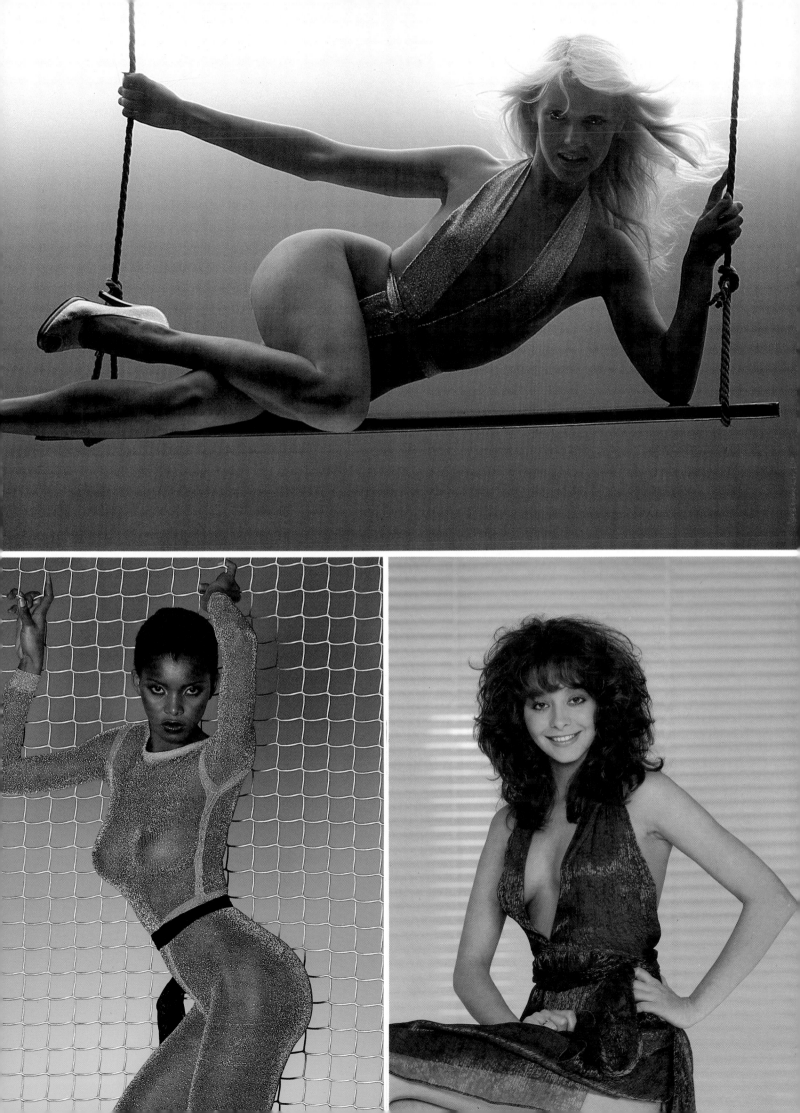

obtain an even greater diffusion effect by firing a flash straight through an umbrella.

There are many advantages of electronic flash over tungsten light. It enables the photographer to use daylight film; the studio will remain cool even if a session lasts for many hours; electronic flash heads are less prone to failure than tungsten lamps. However studio flash has one big disadvantage; it is expensive to buy. A power pack with two heads is likely to cost over £1,000.

TUNGSTEN LIGHTING

Cost is the main reason why the amateur photographer who wants to try his hand at glamour work is best advised to begin with tungsten. A three-light set-up with stands and reflectors can be purchased for less than £150 ($237), and the effects obtainable with such an arrangement should be comparable to their flash counterparts.

It is important to remember that tungsten light throws out a different colour temperature to that of daylight or flash. It is a much warmer light source and the photographer must resort either to film formulated to take account of this bias or use a blue filter to correct it.

It is also worth bearing in mind that, unless you have huge lamps such as are used for cinema photography, you will only have a limited amount of light with nothing like the intensity of flash. The demand is therefore greater for slower shutter speeds and wider apertures.

The build-up of heat in a tungsten-lit studio can be tremendous, making it practically impossible to work without mopping one's forehead every couple of minutes. This may not disturb the photographer too much, but it will be uncomfortable for the model on whom all the heat is focused. The camera will pick up beads of perspiration, her make-up will run and the results will look atrocious. So make sure that the lights are switched off whenever you have to break for any length of time. Make sure also that the studio is well-ventilated with fresh air.

Tungsten filaments are fragile things. They are apt to 'blow' if they receive even a small jolt. So be careful when you are moving the lamps. Frequent switching-on and switching-off will shorten their already relatively brief life expectancy, and they often 'blow' at the instant of being turned on. This means that if you want to keep the studio cool you do have to pay a price in blown lamps. It makes sense to have plenty of spare bulbs on hand when you are shooting.

MIXING LIGHT SOURCES

The glamour photographer can employ natural and artificial light sources at the same time. For example, when the contrast range in a scene is greater than the film can handle, it is possible to boost the darker area with the aid of a portable electronic flashgun. This will reduce the

By lighting the model with a portable flash unit held under the camera, the photographer created fierce shadows behind the girl. In the picture (RIGHT) it was done deliberately to add drama.
Usually a portable flash unit is placed in the hot shoe of a 35mm camera, although it is not the best place because light from the flash reflects back from the subject's retinas and shows up on the film as red. The easy way round this problem is to mount the flash unit on a bracket to the side of the camera.
85mm, Kodachrome 64, 1/60th sec, f11

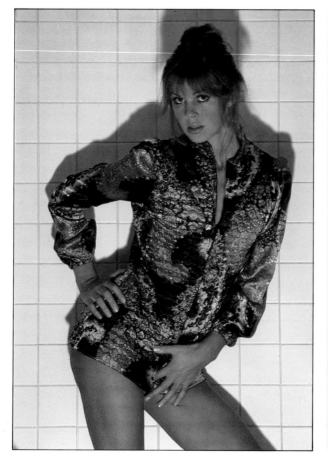

Diffusing electronic flash Two ways of diffusing and reflecting electronic flash are illustrated in the diagram (RIGHT). One basic method is to bounce light off a large white or neutral surface, such as a ceiling or wall (TOP). The sensor should, if possible, still point towards the subject so as to give the correct exposure. If the head of the flash unit cannot be moved independently of the sensor, you will need to increase the exposure. Another method is to wrap a piece of white cloth around the flash head taking care not to cover the sensor (BOTTOM).

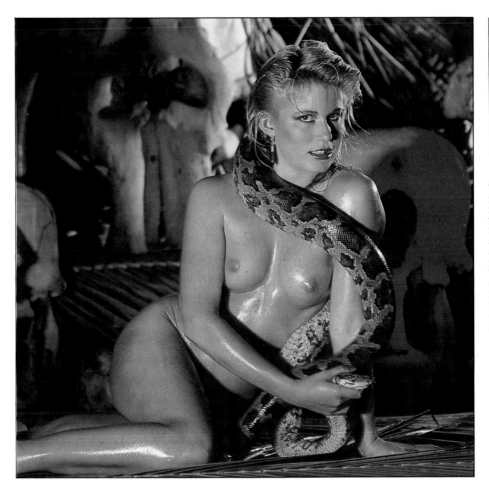

The picture (LEFT) was taken indoors in an old elephant museum in Sri Lanka. Three tungsten lamps, two from the front and one from the side, as shown in the diagram above, were used to light the model and the drugged snake. The tungsten lamps, combined with the effect of a red filter over the side lamp, provided a very warm, almost orange, glow in the picture. *50mm lens, Kodachrome 64, 1/250th sec, f2.8*

A studio umbrella on a light stand (ABOVE) is another good method of diffusing and reflecting light.

contrast range and allow the photographer to correctly expose the whole frame rather than leaving one part to either over- or under-expose.

The key to this technique lies in the fact that electronic flash is balanced for daylight. In other words, the colour temperature of the light emitted by the gun is theoretically close to that of daylight at midday. Both light sources should therefore mix without the 'join' being apparent in the final shot.

In practice this does not always occur, primarily because the colour temperature of daylight is constantly changing. In the mornings and evenings it is more orange than it is at midday. The change from warm orange to cold blue takes place so gradually that it is imperceptible to the human eye. The colour temperature of the light emitted from an electronic flashgun, on the other hand, is constant. The chances of the two being identical are fairly remote.

FILL-IN FLASH

The mixture of natural and artificial light sources is least noticeable when the picture is taken in bright direct overhead sunlight. If the photographer uses a flash gun to 'fill in' the shaded parts of the model's body, the result will look as near natural as is possible under the circumstances. This technique essentially fulfils the same function as a reflector, but offers even

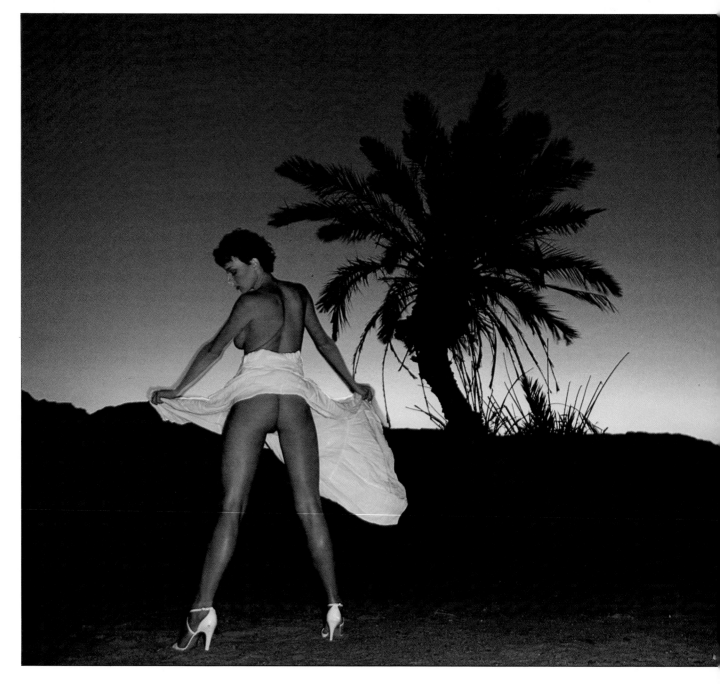

more illuminative power to the photographer.

When mixing two light sources in this way, it is important to be clear about the exposure values. By using 'fill-in' flash, you are in effect taking two pictures at once — one of the section of the scene illuminated by daylight and one of the darker parts that will be lit by the flashgun. As a general rule the flash exposure should be half that which would be required if the shot was to be lit solely by flash.

With a manual flash the lens aperture should be selected according to the power of the gun and the distance of the subject from the flash, as directed by the maker's instructions. It is usually advisable to close down the suggested aperture by one stop for fill-in shots; this takes care of the small amount of daylight that will in-

evitably creep in when the flash exposure is made.

After selecting the aperture, take a reading of the main picture area with either a hand-held meter or the one built into the camera. Simply adjust the shutter speed dial until the meter tells you that the combination of the pre-selected aperture and the shutter speed will give you a correct normal exposure.

However if your camera has a focal-plane shutter, and most SLRs are equipped with them, you must not use a shutter speed faster than the normal synchronization speed — 1/60th of a sec in most cases. In bright daylight this will normally entail the use of a small aperture, and it follows that the flashgun will have to be power-ful enough to make an impression on the darker

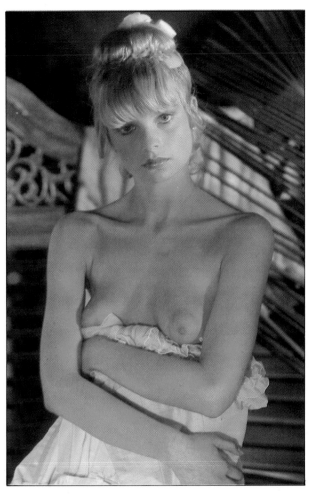

The sun had just set when the shot (LEFT) was taken, and the ambient light was not strong enough to give an exposure on the model. The photographer therefore used a portable flash to illuminate her.
24mm lens, Kodachrome 25, 1/60th sec, f2

Daylight filtered in from a window to the right and behind the model (ABOVE), but the main source of illumination were two tungsten lamps, one just beside the camera and the other to the left of the model. The orange tone came from the tungsten lamps.
150mm lens, Ektachrome 64, f16

parts of the picture, despite the smallness of the aperture. Photographers with cameras fitted with between-lens shutters can use high shutter speeds and therefore avoid the problem.

To achieve satisfactory fill-in flash with an automatic flashgun, it is necessary to 'fool' the gun's sensor. This light-sensitive cell measures the light reflected back from the subject and cuts off the flash when the level of illumination reaches a point that is adequate for the type of film in use. By setting the sensor control to a value one stop larger than the aperture in use the flashgun will then supply only half the 'correct' amount of light, and the rest will be made up from available daylight.

Fill-in flash (or synchro-sunlight, as it is sometimes known) is a fairly unpredictable tech-nique, simply because you have to assess two separate exposure levels to produce one correctly exposed image. When using the technique it is always advisable to bracket your exposures by at least one stop either side.

The light that emerges from an electronic flashgun is particularly harsh; without diffusion it is strongly directional and consequently throws jagged shadows. If the gun is mounted on the camera and the model is looking directly at it, there is a strong possibility that reflections from her eyes will give the 'red eye' effect. Many professional glamour photographers therefore avoid using electronic flash. Others, however, have created ways of working with flash, through diffusion and multiple flash set-ups, that eliminate these problems.

139

SHOOTING IN A STUDIO

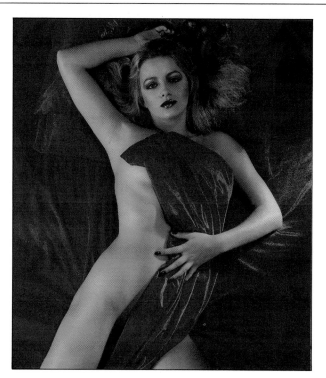

Studio conditions are particularly suited to glamour photography, simply because the photographer has complete control over light, heat, sounds, props, clothes and, perhaps most importantly, privacy. Many models prefer to work under studio conditions because they can concentrate on the task in hand without fear of outside interruption. Make-up and wardrobe facilities are available for revamping the image during the course of the shoot. In the picture (LEFT) the photographer has deliberately set out to recreate a classic Hollywood pose.
90mm lens, Ektachrome 64, f6

THE MAIN ADVANTAGE of shooting in a studio is convenience. All the technical paraphernalia required for photography is centralized in one place. Any item that is unexpectedly needed can be obtained quickly from known sources.

Naturally, this method of working holds great appeal for the professional whose costs require him to operate both speedily and efficiently. But there is a price to pay for that convenience. Studio rents can be exorbitant and sophisticated equipment is also expensive.

However this does not mean that the serious amateur photographer cannot try his luck under studio conditions. He has two alternatives. Firstly, he can hire a studio, complete with equipment and possible a model, for the length of time he requires to shoot his pictures; or, secondly, he can convert his garage or spare bedroom into a home studio.

Finding a studio that can be hired by the day or even by the hour should not be a problem in most of the larger cities. It is important that you know exactly how big the studio is and what equipment is available. These factors will un-doubtedly have a bearing on the way that you shoot your pictures. If the space is tiny, you may find that you have to resort to using a wide angle lens in order to frame your shot correctly. By doing so you will risk ugly distortions of perspective.

Studios generally have an assortment of lights that are available for use by the hirer. If you know what they have in advance, you can plan your shot to take full advantage of your rental fee. If you only possess a 35mm camera, it is worth while asking whether you can hire a 6 x 6 cm camera for the period of the shoot. It will not cost much, and if you are trying to sell the resulting pictures your potential customers will prefer the larger format.

It is likely that the studio will have a list of experienced models, who will work for a fraction of the full professional rate. As they know the studio they are more likely to feel relaxed and happy about the idea of being photographed by a stranger. This is a great advantage when you only have a limited time in which to take your photographs.

The studio is also likely to have a collection of

props and furniture, and possibly even a wardrobe of clothes, which will be available for use.

The more services that you use the more it will cost, but if you balance the cost against the saving in time and effort spent organising everything yourself, there probably is not much difference. Remember when you are dealing with a hired studio to find out exactly what is available, make notes, and take it all into account when you are planning your shoot.

By opting to take your pictures in a home studio you are committing yourself to a greater investment of your own time. A room will have to be transformed. Removable blackouts will have to be made to fit over any windows. You will have to organise some form of background

material which can be changed if the need arises. The room will have to be heated. You will have to buy lights, props and possibly clothes, as well as a comprehensive range of photographic equipment.

The advantage of a home studio, however, is that it can be used at any time, for as long as you want, at no extra cost. This means that one of the constrictions normally associated with any photographic shoot — the time factor — is removed. Provided that you can come up with an interesting idea and execute it in a technically competent manner, there is no reason why anyone should suspect it was taken in your garage or spare bedroom, rather than in a professional studio.

Every studio varies, but there are certain basic requirements which need to be fulfilled if you wish to convert a room into a studio for glamour photography. The most important thing to ensure is that you have sufficient space in which to work.

Storage space You must have a storage area so that essential equipment, such as background rolls, hardboard, polystyrene sheets and tools for building and repairing sets, is within easy reach, but can be kept out of the way when not in use.

A dressing room Your studio should have access to a room which can be used by the model as a dressing room. Within it there should be a large, well-lit mirror so that the model can apply make-up easily. There should also be hanging space for her clothes.

Seamless background roll, available in several different colours, is ideal if you want to shoot against a plain background.

Film storage freezer

Film changing room

Extractor An extractor is essential if you have sealed windows, as the build-up of heat from the camera lights will make the studio impossible to work in unless there is adequate ventilation.

Trestle table This is an essential item for building and repairing sets.

Working space There must be adequate working space in your studio. A high ceiling is a great advantage. It permits a wider range of camera positions and can be used to diffuse and reflect light. The walls should be painted with a matt, white washable finish. If there are existing windows these will need to be blacked out, either by painting over or with a light-tight roller blind.

Props Since space is at a premium it is essential that furnishings and props are chosen carefully and kept to a minimum. Pot plants, brightly coloured cushions and pieces of material are always useful to have on hand.

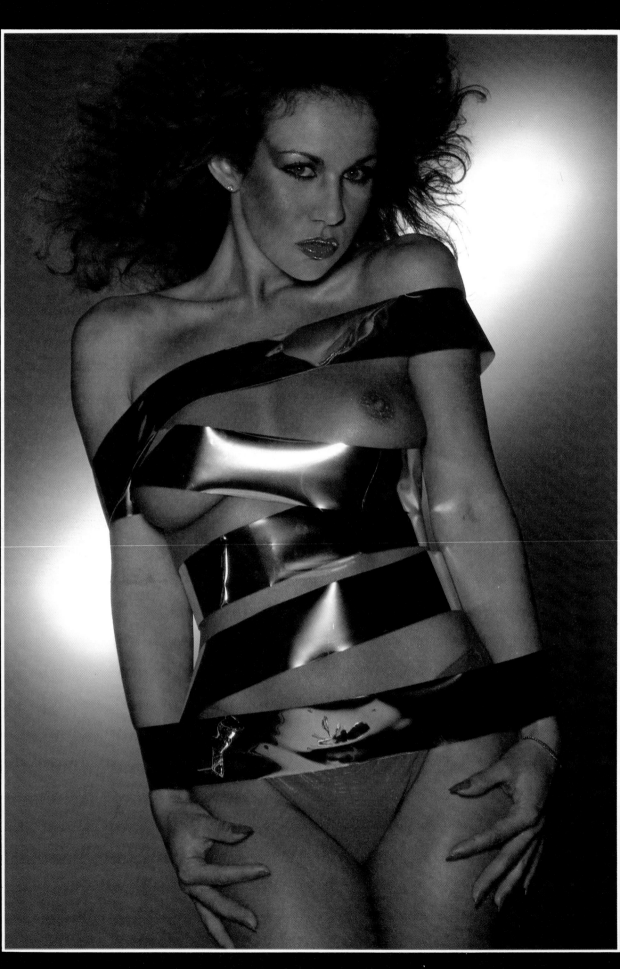

The primary advantage of studio photography is that effective pictures can be put together with little more than a few props, a model and imaginative lighting. The model (LEFT) was swathed in metallized PVC bands. A dark screen was placed behind her, and a linear strip flash tube placed close to the back of the screen. The closer a strip flash is placed to the screen the more closely the shape of a light is held.) The front of the model was lit by a single flash head placed just beside the camera.
150mm lens, Ektachrome 64, f16

The photographer had been spray-painting a venetian blind in the studio, and when he had finished he found that the paper he had laid the blind on was covered with strips of paint. He decided to use the paper as a backdrop for this particular shot (RIGHT). At first a hole was carefully torn in the paper so that only the model's face peeped through, but as the session wore on the hole became bigger. The black background was in fact the studio wall, and the model and the paper were both lit by a single flash head beside the camera.
150mm lens, Ektachrome 64, f11

To get the effect of a zig-zag of blue neon behind the model (BOTTOM RIGHT) the photographer simply covered a large rectangular soft light with black card and cut out the zig-zag shape with a pair of scissors. He then stuck blue gel over the cut-out area and placed the light upright behind the model. Another large soft light was placed just outside the left-hand edge of the frame. The pink glow came from a gelled flash head behind and to the right of the model.
150mm lens, Ektachrome 64, f16

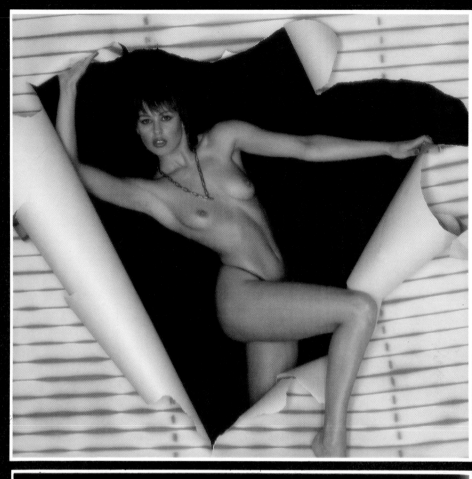

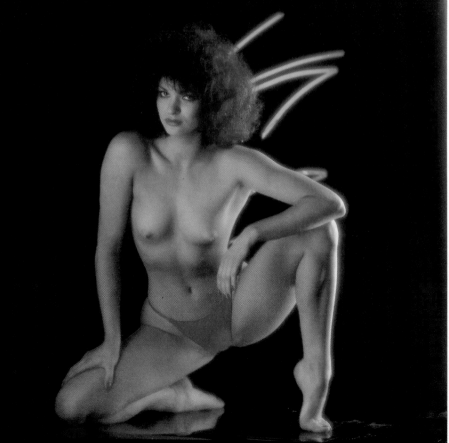

SHOOTING ON LOCATION

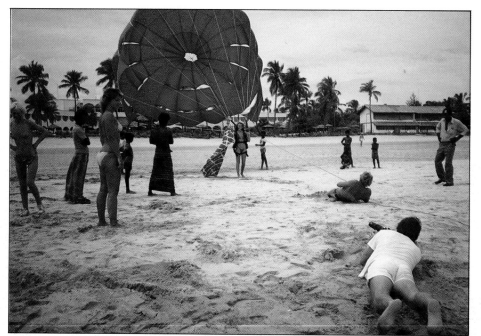

Location photography brings its own risks and rewards. The appearance of glamorous underdressed models in remote spots tends to draw crowds of local onlookers, which may impose limits on your composition (and your composure!). It may also attract the attention of the local constabulary who, by and large, do not welcome the intrusion of photographers and their models as it tends to pose a threat to the peace of the neigbourhood. It is far better to find a remote spot where you can shoot freely without risk of intrusion. To reach the location (RIGHT) the photographer and model had to swim up the river, with the camera equipment wrapped in a plastic bag. The result, in the end, made it all worthwhile.
24mm lens, Kodachrome 64, 1/30th sec, f2.8

BY CHOOSING TO shoot on location you are taking on a series of risks. If the shoot is successful you will gain all sorts of advantages that are not even available in a studio. When discussing location work, it is necessary to distinguish between exterior and interior locations. Each brings a set of obstacles that have to be overcome.

OUTDOOR LOCATIONS

The biggest problem with outdoor location work is the weather. The photographer has no control over it and there is nothing quite as capable of destroying a shoot as effectively as the wrong kind of weather. If your camera breaks down, you can use a spare. If the model falls ill, you can hire another. However, if you need sunshine and it rains, there is nothing you can do about it.

It is not surprising then that big-budget calendar or magazine shoots are nearly all conducted in places where the weather is relatively reliable. It is no accident that Hollywood, film capital of the world, is in California. The early movie moguls were well aware that California has, on average, more hours of sunshine than any other comparable part of the country. When

you are responsible for spending thousands of pounds a day, you need that guarantee of good weather.

However, there are not many photographers who can afford to fly themselves, their assistants, their models and their equipment to exotic far-off parts where there is a virtual guarantee of sunshine. The only other way that you can increase your chances of encountering the right weather conditions is by phoning the Meteorological Office before you set out. If the forecast is bad, you should contact all the people involved and call the shoot off.

Professionals do have one safeguard — 'weather cover'. This means that they arrange the shoot in two or more parts, at least some of which can be conducted indoors. If it rains, they do the indoor part and then hope that the weather clears up in time to do the rest.

When choosing an exterior location it is important to know what sort of problems might arise. For a glamour shoot you will need privacy. This means finding a spot where you are sure you are not going to be disturbed. Your final choice is likely to be somewhere isolated, and possibly, hard to reach. However, try and arrange it so that you do not have to walk any

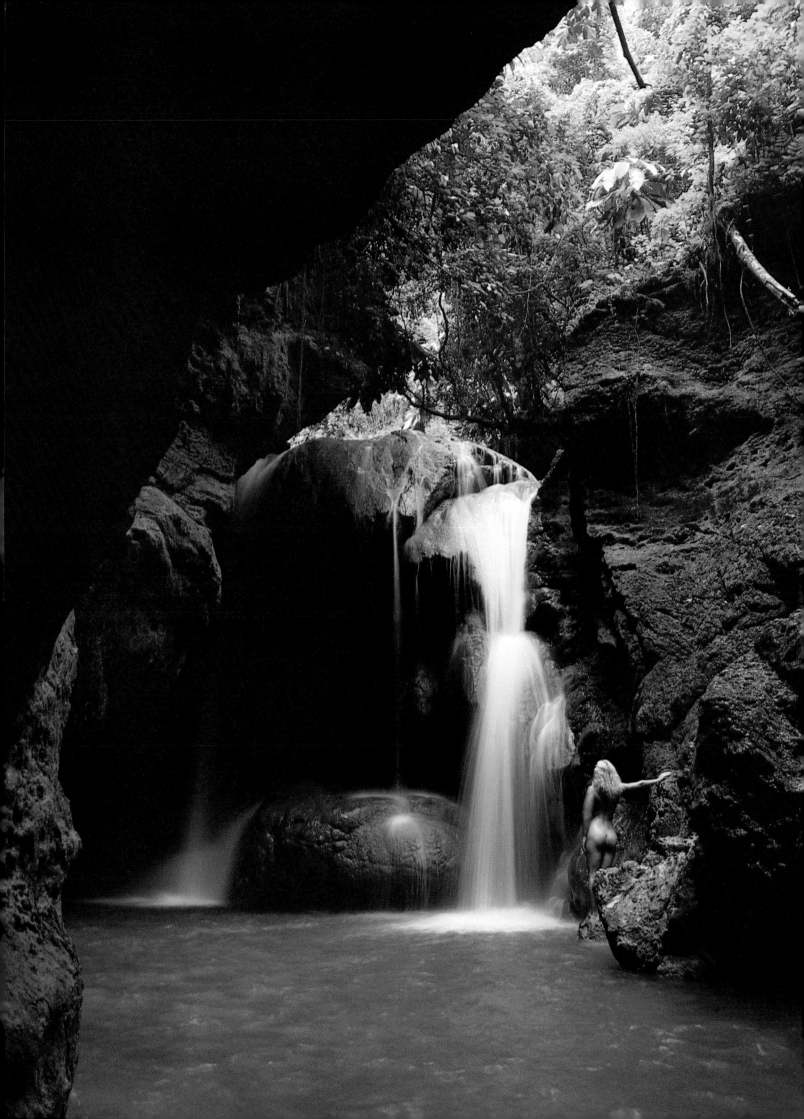

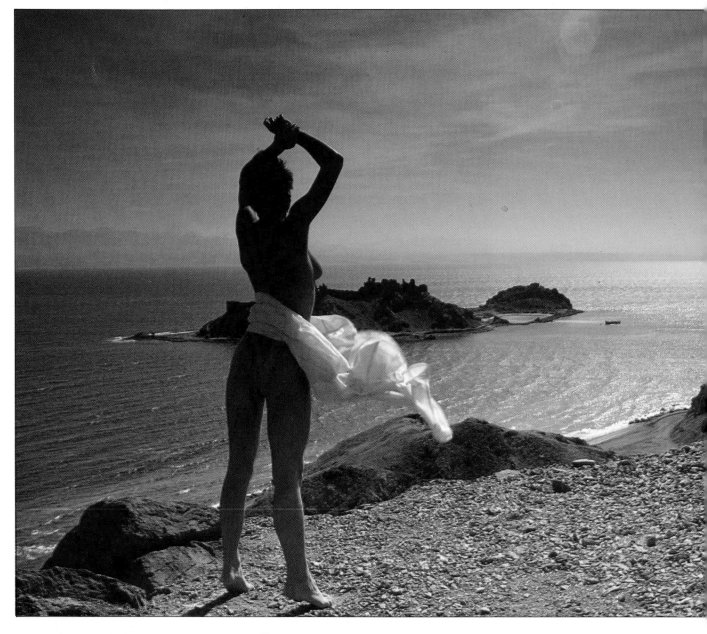

great distance from your base vehicle. You will have a lot to carry, and if you forget anything time will be wasted fetching and carrying.

When you set out on your reconnaissance, make sure that you ask the permission of whoever owns the land. A trespass charge could land you in court. When you find a potentially suitable spot study it carefully. Note the position of the trees, hedges and walls to try and envisage what it would look like in early morning or evening sunlight. Pay particular attention to the horizon line. Take photographs of the spot, so that you can refer to them when you are making your final choice. It is a good idea to note down details of possible locations on file cards, attaching any relevant pictures. The cards will form the basis of a useful location file that may save you a lot of time in the future.

Once you have selected your spot, there remains the question of transporting the people

and equipment to the appointed place. If your location is in the middle of nowhere, it would be preferable to assemble everyone and everything before you set out. If you tell the others to meet you at a pub in a village, it is extremely likely that someone will break down, or go to the wrong pub. You will have no way of contacting them and they will have no way of contacting you. The result will be frayed tempers before you even start, and that is not the right way to conduct an efficient shoot.

Good organization is essential if a shoot is going to go smoothly so make sure that everyone knows what they are required to bring with them, even if that means giving each person a typed list.

INTERIOR LOCATIONS

Interiors are generally easier to handle than exterior locations, but they do require some

Care of your camera
You should always take cleaning equipment with you on location. Sand and dust can cause serious damage if they are allowed to remain in the camera. The illustration (RIGHT) shows a basic cleaning kit: cans of compressed air (1), blower brush (2), stiff toothbrush (3), soft cleaning tissue (4), cotton buds (5).

It is important to make the most of a location. The crusader castle on the island adds an exotic atmosphere to the picture.
The photographer has chosen a strong viewpoint and shot the picture with a wide angle lens that gives an expansive vista, and therefore more location value. He has also managed to make use of the strong breeze that was blowing over the Red Sea at the time. The sky has been warmed with a yellow filter. *24mm lens, Kodachrome 64, 1/250th sec, f11*

If dust or sand has penetrated your camera you should stop using it immediately. Once particles are inside they will go deeper and do more damage if you continue turning the controls.
Treatment Remove the film. Dismantle the body as far as possible.
Use compressed air to remove particles from all delicate and inaccessible parts. Brush the remainder away with a blower brush and then wipe with a clean cloth. The exterior of a camera body is not delicate and can be treated firmly. Use a toothbrush to remove stubborn dirt from the outside crevices of the body. Slightly moistened cotton buds are also useful for reaching awkward corners on the exterior of the camera.
A small stiff brush can be used for cleaning sturdy areas inside the camera body.
The diagrams (LEFT AND BELOW LEFT) show which pieces of cleaning equipment you should use on the different parts of your camera. The key to the symbols is shown below.

Key

	compressed air
	stiff toothbrush
	blower brush
	cotton buds
	stiff brush

Shooting towards the beach

Glamour photographers like working on beaches, because there is such a variety of elements to exploit. By turning round the photographer can change the whole nature of the pictures instantly. By shooting from the sea towards the beach (RIGHT) the photographer can make use of the luxuriant greenery as a background. Light reflected off the surface of the sea can be used to bring up the exposure.

The picture below shows how the shot was taken. A portable reflector is being held by an assistant to throw side light on to the model. The photographer had to wade up to his neck in water. *85mm lens, Kodachrome 25, 1/125th sec, f16*

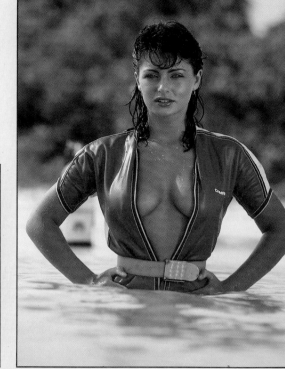

Shooting towards the sea

By shooting towards the sea from the beach the photographer gives himself the chance of using the blue or green background that it provides (RIGHT). The sky also forms another pure tone, with the horizon forming a strong light across the image. Care should be taken with sand, however; it gets everywhere. If you want the model to lie down, remember that sand will adhere to her skin, and that she will then have to go in the water to clean it off — and when she emerges wet, more sand will attach to her. The solution is to plan the shoot carefully. Sand also has a habit of getting into the cameras. It will scratch the finely polished surfaces of lenses and jam the film transport mechanisms unless particular care is taken. *85mm lens, Kodachrome 64, 1/125th sec, f8*

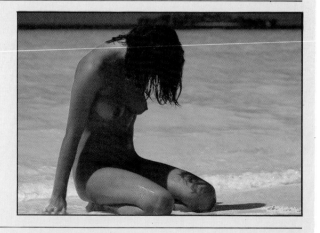

Shooting in the water

If you want to shoot from a position in the water (RIGHT), you must keep the camera dry. Salt water is one of the fastest oxidants known and the last thing you need is a rusty camera. Droplets on the lens will dry leaving a ring of salt deposit on the front element. The best solution is to use a camera with waterproof housing, or, if your budget doesn't stretch that far, to wrap your camera in a plastic bag (LEFT) with only the front of the lens peeping out. It is best to use a power winder or a motor drive to transport the film.

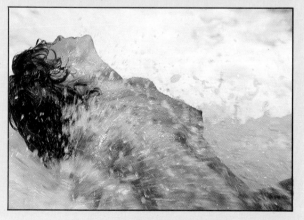

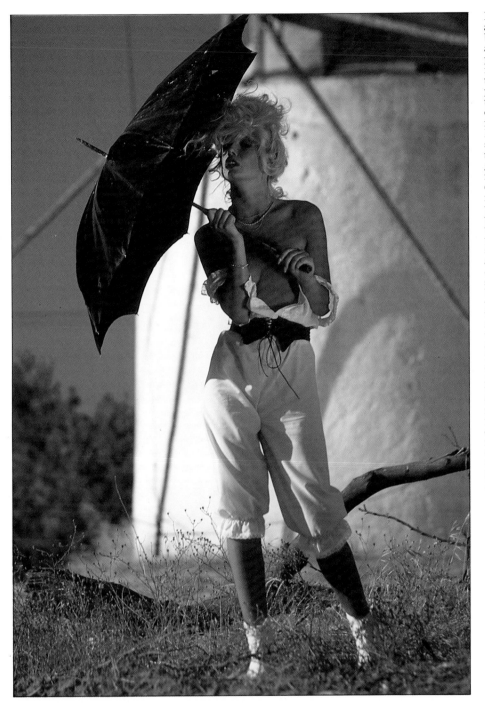

It is a mistake to assume that a picture will be good simply because it has been taken in an exotic spot. It is perfectly possible to take dull pictures in the most exciting place. At the same time, many photographers find they do their best work on location, deriving inspiration and ideas from going to different places. Extensive location research should be carried out before travelling. It is well worth going to a good library and reading any books that carry descriptions of the place. You may even find photographs that will give you an idea of the landscape. A phone call to the embassy of the country you are planning to visit should be enough to secure adequate information on the climate, times of sunrise and sunset, as well as any bureaucratic problems that you might run into, such as the need for special visas and innoculations. Use whatever 'local colour' you can find. If the location is famous for its volcanoes, for example, make certain you get some shots that feature the volcanoes. The picture (LEFT) was taken in a place renowned for its windmills, so the photographer has used one as a backdrop for his model. Note the spindly construction of the windmill is echoed in the umbrella. *50mm lens, Kodachrome 25, 1/125th sec, f11*

thorough research before the shooting can begin. The key thing to remember about location interiors is that you are likely to be shooting on someone else's property. If it is private property it is essential to brief the owner correctly before you bring down your shooting team. If it is public property, you will have to go through the 'correct channels'.

Once the photographer has found the interior he is looking for, he must ensure that the owner is aware of the nature of the project, and that the normal running of the place is interrupted to the minimum degree. At the first approach, the owner is quite likely to turn the request down. Be prepared to pay him. Owners of beautiful property need money for their upkeep, and that is the most straightforward way around the problem. Offer what you think is a reasonable sum and be prepared to haggle.

Point out the advantages of cash payment and reassure the owner that the property will not be damaged in any way and that it will be left in precisely the condition it was found.

Explain which rooms you want to use and for how long. Your team will feel much happier if there are no strangers around when the shooting is taking place, so do your best to persuade the owner to leave the whole shoot alone while it is actually in progress. To do this successfully, you must be tactful and reassuring.

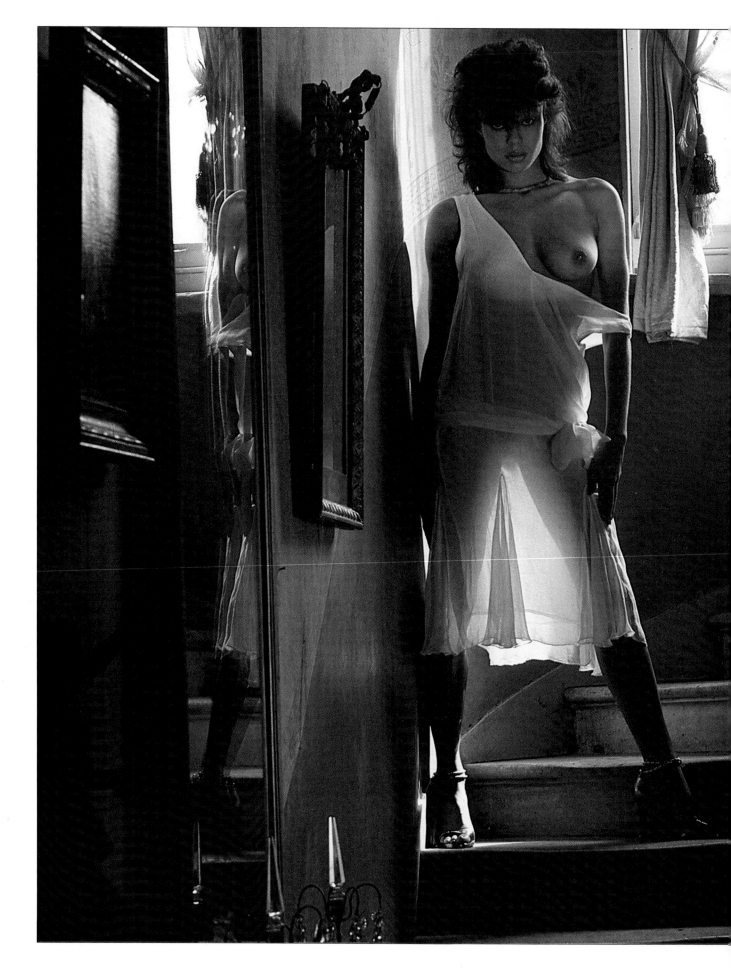

With interior locations it is best that the model has some relation to her surroundings. This means that the picture attains the illusion of a narrative. The relationship between the model and the location should be one either of contrast or harmony. For example, the picture (LEFT), shot by Bryon Newman, shows a model whose clothes are in disarray posing in an environment that emanates good taste, orderliness and refined behaviour: the staircase of a stately home. The contrast add a freshness to the image, and a sense of intrigue to the picture, thereby provoking the viewer's curiousity. *28mm lens, Kodachrome 64, 1/8th sec, f8*

Even if the owner does not charge you for the use of the property, you must explain to him that you will have to use electricity. You will also need the use of a changing room, tea-making facilities, a toilet, and somewhere to park.

When you are researching locations, make certain that all the necessary facilities are available. Make a list of what you need before you start and methodically check off the items as you go. As well as the basic facilities listed in the last paragraph, note whether the sun shines through any of the windows during the day. Take some pictures of the location while you are there; it will help you to assess the property's possibilities when making your final choice.

There may be special requirements for the particular pictures you want to shoot. If, for example, you need to include hot food in the picture, you will need a kitchen that is not being used by anyone else. On one occasion a photographer wanted to set up a banquet scene. He found a marvellous room in a run-down country house. On the appointed day he turned up with half a dozen models and a team of assistants. The girls who were to prepare the food went in search of the kitchen, but to their horror found only a delapidated stone sink with no running water. It was an expensive oversight on the photographer's part.

Unoccupied properties have their advantages. You are almost certain to have the run of the place with no outside interruptions and you can generally change the fixtures and fittings as much as you like. But do check carefully that you have brought all that you need. You probably will not find any electricity, for example. That means you will have to hire a small generator to power your lights. You will also probably need to have a base somewhere else, such as a nearby pub or hotel. Another point to remember is that the local police should be alerted that you will be working in the unoccupied property, otherwise they are quite likely to come and investigate what is going on.

James Wedge, the London-based photographer, recalls an occasion when he took over a derelict house to shoot some fashion pictures for the Sunday Times. The art director wanted the house to look as though it was on fire, so the props man set up dry ice canisters and red flashing lights inside the house to simulate smoke and fire. The idea was that the models would then lean out of the windows and Wedge could photograph them. All went well, until two fire engines came screaming round the corner. Apparently someone had reported the 'fire'. The firemen were not amused.

If your pictures are intended to have a 'period' flavour you must pay particular attention to detail. It only takes one electric light-switch in the background to spoil a shot that is supposed to be set in the eighteenth century. Radiators, light fittings and out-of-

period furniture crop up too frequently in what are supposed to be 'period' interiors. They may sound obvious but the number of times that details like this are overlooked while the shoot is in progress is surprising.

The best way to avoid all these traps for the unwary is to plan the shoot meticulously. When you are hunting for your location, take your 'rough' along and compare it minutely with any likely places. Consider whether you will have to change your concept of the picture to accommodate the demands of the location, and then check that these changes do not have repercussions that will adversely affect the final result.

Once you know that the picture can be shot there, turn your attention to the wider aspects of the project. Will you and your team be able to work comfortably and efficiently at the location? Are all the necessary facilities available nearby? If something goes wrong, will it be easy to contact people who can help? Are there shops nearby which will be open in case you have to make some last-minute purchases. Is everyone who might be even remotely affected by your presence aware of what is going on? If the answer is no to any of these questions, think twice before setting off to shoot. Bad organization only adds to the many problems which can arise while shooting on location. The best defence is to check everything very carefully before starting.

IMPROVIZED LOCATIONS

The photographer who cannot afford to travel to exotic and far-off places can still discover beautiful and unusual locations nearer home. He can also, with the imaginative use of props, costumes and light, transform commonplace surroundings into a good setting for a picture.

One London professional was commissioned by the tourist board of a Caribbean island to shoot a poster showing a girl posing on a tropical beach with a windsurfer in the background, but their budget did not cover the expense of a shoot taking place in any tropical country.

Having given the project some thought, the photographer decided that he had no need to go further than the South Coast of England to take an effective shot. The picture was composed with the girl occupying half of the frame, her head tilted back as if she was catching the sun's rays; a potted plant was strategically placed so that its fronds extended beyond the model; the windsurfer was asked to sail around in a particular area in the background.

The photographer shot the picture into the sun so that flare obscured much of the upper part of the frame. This made it look as though the picture had been taken under strong tropical sunlight. A polarizing filter was used to make the sea a richer blue which contrasted nicely with the bright red of the windsurfer's sails.

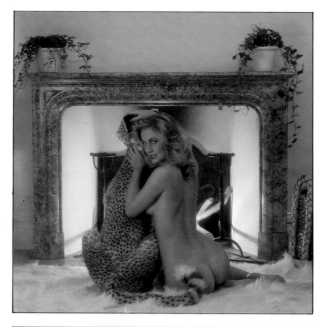

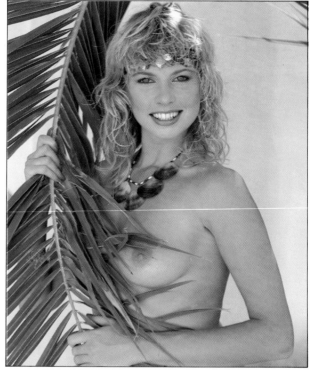

You don't have to travel miles to get a location 'feel' in a picture. If time is short and your budget is tight, you can make do by using props to suggest foreign places, or grand interiors. The girl sitting in front of the fireplace (TOP) is really sitting in a studio; the fireplace is propped against the wall; the plants have come from a nearby shop; the rug has simply been laid out on the studio floor.
90mm lens, Ektachrome 64, f16
Palm fronds (ABOVE) are probably the easiest way of suggesting that the picture has been shot in a tropical climate; they are easy to buy in big cities. To reinforce the feeling of the tropics the model is wearing an exotic looking necklace. The photographer has also ensured that the background is obscure, so that there are no tell-tale details to give the game away.
85mm, Kodachrome 25, 1/60th sec, f4
The photographer's angle of view in the picture (TOP RIGHT) has helped to keep out stray background details; leopard skin accessories add an exotic feel to the shot.
35mm lens, Kodachrome 64, 1/125th sec, f5.6

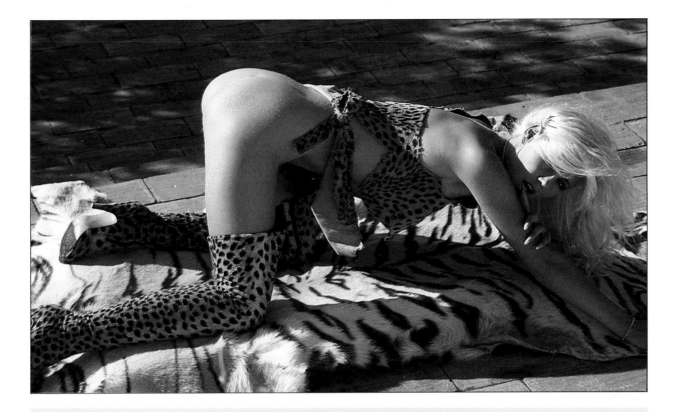

Back and front projection

The popularity of transparency film among professional photographers has given rise to a couple of other methods of avoiding travelling to expensive foreign locations. Both are dependent on the use of a projected slide.

Back projection originates from Hollywood's early days. When it was too difficult to film a conversation between two people in the back of a taxi travelling along a main road, the director would film the background seen out of the taxi's rear window on location. He would then have a mock-up of the taxi built in the studio. The background film was projected on to a screen behind the 'taxi' and the actors would speak their lines while the background film rolled. The film crew would rock the 'taxi' to simulate motion.

The principle is the same for still photography. A screen is erected behind the model and a transparency is projected on to it from behind. Provided that the edges of the screen are not in the shot, it looks as though the model is actually part of the background scene.

The theory is relatively straightforward. In practice, it is quite hard to achieve a credible effect with back projection. The first

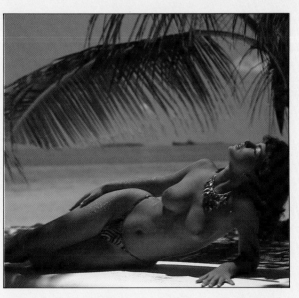

difficulty is perspective. The relative sizes of the model and the background must be true to life. This can be achieved by using the correct lens. A wide angle lens, for example, will tend to make the model look nearer the camera. A telephoto has the opposite effect.

The other difficulty with back projection involves lighting. The model must be lit in such a way that it appears that she is lit by the same source as the background scene. This sometimes demands that the light source is at the front,

and this in turn means that her shadow will fall on to the screen itself. Light falling on the screen will also cancel out the projected image and the effect will be ruined.

There is yet another problem. You need a suitable slide to project. If you do not have one of your own, you may have to hire one from a photo library, and then if you want to sell the resulting double image, you may encounter problems with copyright. The same difficulty can of course apply to the other method of faking a location

— using front projection.

This technique has only been developed in recent years and it requires more complex equipment than back projection. It does however provide a way of avoiding some of the problems inherent in back projection.

A front projector is designed to throw the image of a transparency on to a semi-silvered mirror, which is positioned precisely on the camera/subject axis. The camera can 'see' not only the image on the mirror, but also the model, and behind her, a large, highly reflective screen. The precise positioning of the projector ensures that the model's shadow falls directly behind her and is therefore invisible.

With front projection you can use studio lights from any angle, because the tiny beads that form the surface of the screen reflect light back directly along its original path. The drawback is that both the projectors and the screens required for front projection are expensive, making it a fairly exclusive technique.

COMPOSITION

EVERY PHOTOGRAPH CONSISTS of a variety of elements. The skill of a photographer lies in his ability to manipulate these elements to produce a fresh and striking image. In order to do this successfully the photographer must be able to recognize the visual potential of the various factors at his disposal and acquire an understanding of how to make use of them.

COMPOSING THE IMAGE

Every successful picture has a point of maximum interest, a point to which every other element in the picture is of secondary importance. When planning a shot, this focal point must be decided at an early stage. The rest of the picture can then be designed around it, so that each element contributes harmoniously to emphasize the centre of interest.

To achieve this effect, it is essential that the photographer is aware of the 'impact value' of each element. In glamour photography a human figure attracts greater attention than an inanimate object. A face takes precedence over a body. Of all the facial features, it is the eyes that first catch the viewer's attention.

Moving away from the human body, shape and colour are the prime attractors of attention. A vivid red ball takes visual precedence over a pastel coloured one. Stark, well-defined shapes stand out strongly, while amorphous, irregular patterns make less demand on the viewer.

Sometimes, of course, the photographer may wish to produce a soft, misty effect and allow gentle, blurred images to become the centre of interest in the picture. This effect can be achieved by diffusing the light as it enters the lens. The soft edges created by this technique help to give the shot a romantic feel.

There are various ways of achieving this sort of diffusion. Some photographers smear a little vaseline on the lens; others tape a piece of nylon stocking over the front element; it is even possible to buy a special lens that is designed to blur the image. However all these techniques have drawbacks. It is hard to remove the vaseline after use; it is difficult to ensure that the nylon gauze is evenly stretched; the special lenses are expensive. The cheapest, most convenient way of diffusing a shot is to buy a soft filter that screws on to the front element of the lens. These filters are cheap, durable and effective.

VIEWPOINT

One of the features of a good photographer is an ability to present an unremarkable subject in a fresh and arresting way. When you consider that we are accustomed to seeing the world from a height of five to six foot above the ground, it is not difficult to realize that by raising or lowering the camera a viewpoint will be produced that is out of the ordinary. This fact applies to all forms of photography, and glamour is no exception.

An example of this is the aerial photograph. However well you know the front, back and sides of your own house, it is unlikely that you have seen it from above. The change in viewpoint helps to make a picture of the house interesting and different by showing a new dimension.

It should also be noted that changing the viewpoint affects the subject's impact value. A low viewpoint, with camera at floor level pointing up towards the model, will make her

The art of successful composition lies in the photographer's ability to visualize the precise shape of the image on film. Every line of a photograph tends to attract the eye, and so it is important that the lines lead to the point of maximum interest. The photograph (RIGHT) was taken on 2¼sq in film; the camera has been positioned so that the centre of interest lies straight down the centre of the shot. The model's long hair hanging down contributes to the symmetry of the shot. Note that there is nothing in the background to distract the viewer from the pure lines of the model's body.
150mm lens, Ektachrome 64, f16

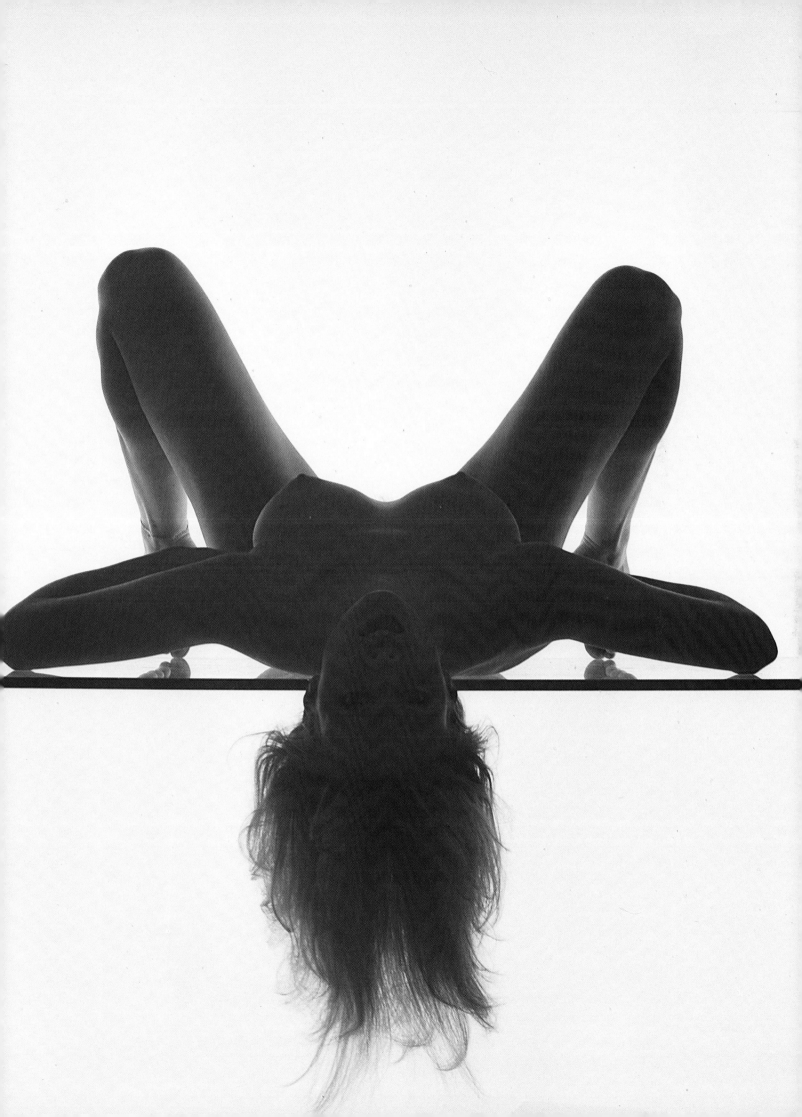

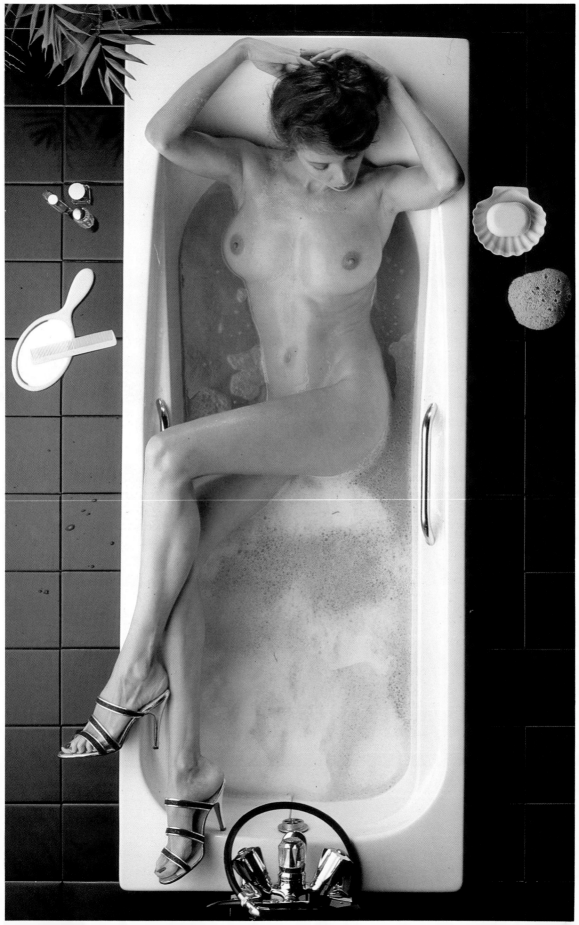

dominating and overwhelming. A high viewpoint, looking down on the subject, will tend to reduce the importance of the picture's main subject.

BACKGROUNDS AND FOREGROUNDS

It is essential that the photographer pays attention to what is behind and in front of the model, if she is to stand out as the focal point of the picture.

Backgrounds can be used to add atmosphere to a picture, or they can be an integral part of the composition. Conversely, they can be largely eliminated or at least toned down. The choice of a low viewpoint when photographing a model on location will often give you a background of sky, a single tone that will set off the model without attracting attention to itself. If you are forced to shoot the model against a fussy background, you can tone down the distraction by using a wide aperture on the camera and bringing your

model as near to the camera as possible. The background will then be thrown out of focus and reduced to a blur.

Foregrounds can also be used to enhance a picture, but they require more care on the part of the photographer. The danger is that anything positioned between the camera and the model will tend to distract attention away from the main point of interest. Provided you remember that foreground details must lead the viewer's eye back to the model, you can use them to good effect. Branches, for example, can form a frame around the model's face. Differential focusing can also be used to keep the model sharp between blurred foreground and background.

USING LOCATIONS

Successful glamour photography depends largely on the photographer creating a sense of harmony between the model and her surroundings. If a single discordant element creeps

An unexpected viewpoint can boost the appeal of a picture enormously. We are accustomed to seeing the world from a height of five to six foot. When we see a view from any other angle it strikes us as novel. The bird's eye angle of view (LEFT) has produced order in a picture which would have been messy, had it been shot from head height. The composition

has improved immeasurably. The high viewpoint also brings about a change in the psychological effect of our perception. Because we are above the model, there is a sense of voyeurism. The subject is defenceless and vulnerable.
40mm lens, Ektachrome 64, f16

In contrast, the picture (ABOVE) is taken from a low viewpoint. The model is looking down at the camera with a menacing air.
135mm lens, Kodachrome 64, 1/125th sec, f5.6

In the picture (RIGHT) the model's arms form a natural frame, while the toy water pistol protrudes from the frame as it to guard the contents within it.
50mm wide angle lens, Ektachrome 64, f16

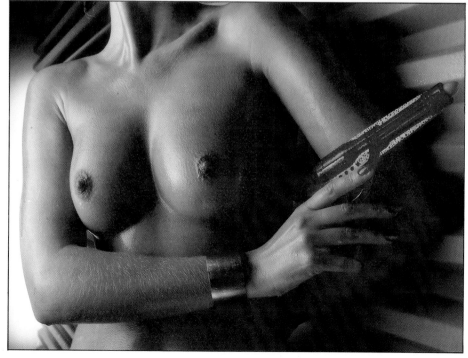

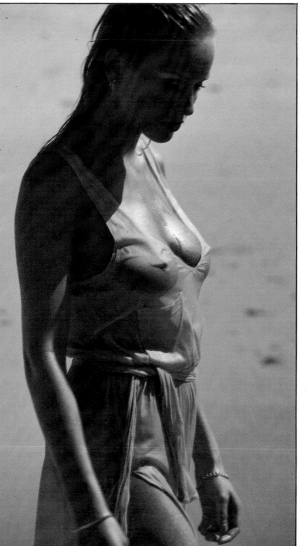

It is widely accepted that a scantily dressed model is far more attractive than one with no clothes on at all. In the picture (LEFT) the photographer has dressed the model in skimpy clothes and then asked her to make the clothes wet, thereby producing a clingy effect that is much in demand by buyers of calendar pictures.
85mm lens, Kodachrome 25, 1/125th sec, f5.6
A sense of harmony must be maintained if a composition is to work well on film. The scarecrow model (FAR LEFT) perfectly suits her rustic surroundings. The fact that she is standing in a prominent position on a hill adds to the credibility of the picture. Note also that she is posed a third of the way across the frame, a position that allows her to be the main point of interest while still leaving a clear view of the beautiful landscape. There are two strong horizontals in the shot — the skyline and the model's outstretched arms. The eye is naturally drawn to the area defined by those horizontals, and is therefore led to the model's torso.
24mm lens, Kodachrome 64, 1/125th sec, f8

into the composition, the overall effect of the picture is significantly reduced.

It is not surprising that many photographers choose to shoot glamour pictures by the seaside, in the sun. A nude or semi-nude model posed on a beach fits in easily and happily with her surroundings and a harmonious effect is created. A similar impression would not be achieved if a scantily-clad model was posed on an ice-floe.

Beaches have other properties that make them ideal for glamour photography. They offer the photographer plenty of room in which to work. He can set up all his equipment and still shoot out to sea, along the beach, or towards the land. The sky, the sea and the sand are single tone elements, and he can rely on his model being the dominant interest in the picture if he limits himself to including only one background tone.

He can also exploit the natural abundance of textures found in a beach setting. The combination of smooth skin and sand, for example, can help to provide a vital element in the composition of a picture.

Water offers the photographer all sorts of possibilities for pictures. It can be used simply as a visual backdrop. It can vary or improve the tonal qualities of a shot thanks to its chameleon-like capacity to change colour according to the state of the sky. It can also help to create and change the atmosphere of a picture. The glamour photographer can effectively use a calm sea to complement a romantic picture. Alternatively, choppy waves suit a lively picture of a laughing model in bright sunshine playing in the sea.

The sensual quality of water has equally attracted photographers. An expanse of tanned smooth skin, dotted with droplets of water is a cliche, but it is an effective one.

Landscapes, if carefully selected and composed, can also form a suitable background for glamour photography. For example, the gentle undulations in a landscape set off the soft curves of a female body and the element of harmony is provided in the picture.

Again, it is important that the model fits naturally into her surroundings. The

Clothes and props can make or break a picture. For glamour photography, it is useful to have access to a good supply of flamboyant and wierd clothes. Theatrical and dance outfitters are good sources. Props can easily be gathered, either by some diligant browing for cheap jewellery and knick-knacks in high street shops, or by rummaging around in second-hand shops. Most photographers always keep an eye out for items that might come in handy for a shot. More expensive items of clothing can often be borrowed from boutiques, on the understanding that the photographer supplies some pictures in return. The colour content of any clothes or props that are used will affect the look of the picture and may have to be chosen with the background colour in mind.

The four pictures on this page illustrate how props and clothes can be used effectively. The blue of the model's shorts (BELOW RIGHT) is a close match to the shutters behind her, while her pink bow tie stands out in contrast. The red telephone (BELOW FAR RIGHT) was borrowed from the neighbouring photographer's studio, because it stood out from the blue-painted aluminium sheeting in the background. The model's transparent 'coat' is simply a cheap cape. Even an ordinary household item such as venetian blinds (ABOVE RIGHT) can be put to good effect. The fishnet body stocking (ABOVE FAR RIGHT) was bought from a dance shop, as was the taffeta dress. The shoes came from a jumble sale.

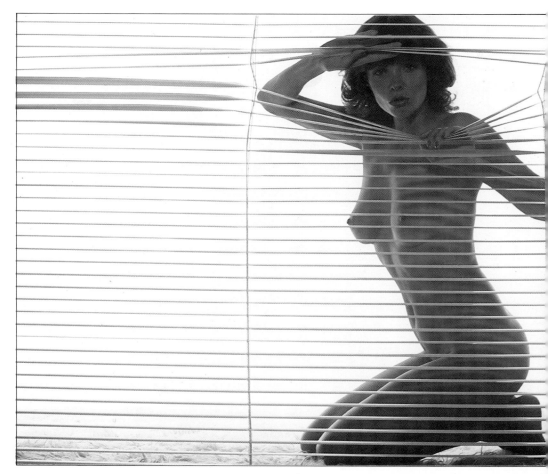

photographer must look for shapes and colours that harmonize, or contrast, in order to give the picture the correct emphasis, and leave the model as the centrepiece.

CLOTHES AND PROPS

Asking a completely nude model to 'pose' is a photographer's recipe for disaster. Some direction from the photographer is essential. Clothes and props can also help considerably. Even if you intend to take nude pictures it is usually better to start off with some shots of the model fully dressed. The beginning of the session will go more smoothly if she is relaxed. Once you both get into the swing of things she will feel happier about undressing.

Modelling is said to be similar to silent acting. Clothes will help the model to enter into the mood of the shot. If, for example, you want your model to play a vampish part it will be easier for her if she has an appropriate costume to wear. Similarly, if you want her to look sullen and aggressive, ask her to dress in leather or suede. It is worth remembering that female models are often far more aware than men of the effect that clothes can have. Provided that you have given your model an idea of the sort of effect you want to achieve, the chances are that she will know how to implement the look.

Professional models keep extensive wardrobes of clothes and you should try to go through the wardrobe with your model before the session. You will often find that the clothes themselves give you ideas for pictures. Alternatively, if the model does not possess the sort of clothes you need for the session, you could try asking a local boutique if they will lend you some clothes for the shoot, on the understanding that they receive a set of pictures in return.

Clothes and jewellery can direct the viewer's attention to areas you wish to emphasize. For example, a pretty necklace can help to make a fine neck the focal point of the picture. Clothes, such as blouses and scarves, can mask parts of the body and soften the blatancy of a nude shot, providing possibilities of tantalizing and erotic pictures.

Props fulfil much the same role as clothes. A good prop can set the tone for an entire session. The model will be much happier if she has something to react to. She will be able to improvize around the prop and you can allow her imagination to do some of the work for you.

Bear in mind that anything included in the shot should have a value of its own. If you are choosing a prop, make sure it suits the tone of the picture, and that it adds something — colour, shape, spectacle — to the end result.

ABSTRACT SHAPES

Photography is a graphic medium and therefore many tricks employed by designers can be used to add zest to an image.

161

If, for example, there are any lines included in the picture area, the photographer should ask himself whether they are adding to, or subtracting from, the impact of the image. As a general rule, lines should lead the viewer's attention towards the centre of interest. It is usually possible to alter the camera angle to make sure that they do.

It is sometimes possible to create a 'frame within a frame', such as a model glimpsed through a window or in a mirror. By including the frame itself the image has two frames, each one bringing the viewer further in towards the focal point of the picture.

The bolder the lines in the picture the more care must be taken to ensure that they contribute to the effect you are trying to create. This applies also to strong areas of tone or shape. Unless the photographer is aware of the dynamics of his image, it is quite possible to find that an essentially irrelevant area of the picture takes precedence over the principal subject.

Just as bold shapes and colour can enhance a shot, so can the use of texture. To bring out texture, the photographer must ensure that the material in question is lit strongly from the side.

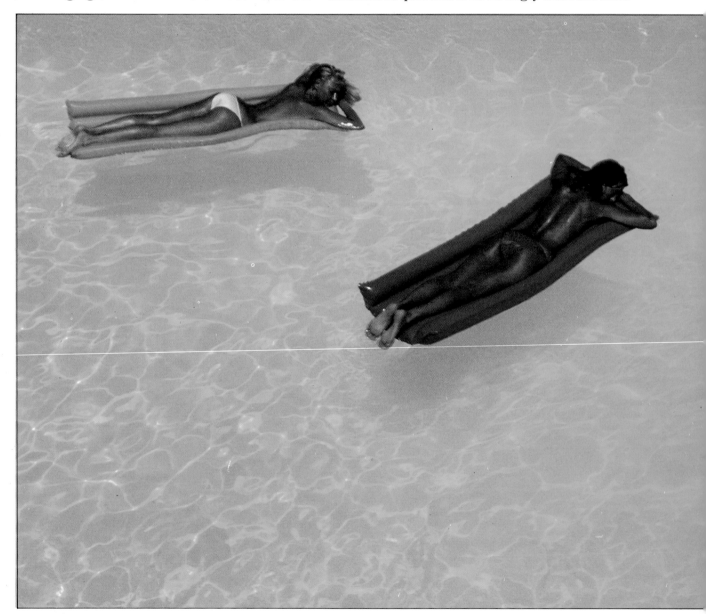

ABOVE Strong images are created through the use of bold colours and striking patterns, regardless of the actual subject matter. This apparently casual picture was in fact carefully staged. The colours of the sunbeds and the models' bikinis were selected specially to contrast with each other. The girls were asked to lie in a particular position so that their forms all matched. A high viewpoint was chosen so that the photographer could eliminate the sides of the swimming pool to leave only the pure blue of the pool itself as a backdrop.
85mm lens, Kodachrome 64, 1/250th sec, f5.6
TOP RIGHT By placing the

A rough texture, such as stone, contrasts well with smooth skin, emphasising the tactile qualities of both.

These graphic devices work particularly well with abstract glamour. By photographing only a portion of the model's body, the photographer can depersonalize the image and reduce it to abstract shapes. This often introduces an element of mystery into the picture. By removing the image from our everyday concept of the nude the photographer can produce an exciting and challenging shot for the viewer.

This approach has particular advantages for the hobby photographer, particularly if he is using an amateur model. Since he need not show the model's face she is likely to be more at ease during the shoot, knowing that there is little chance of anyone connecting her with the image.

The reduction to a series of shapes also means that the photographer can play tricks with the priorities of the image. As there is no human face to demand the viewer's attention, and the body becomes simply another abstract, the photographer can invest other elements in the picture with a greater degree of importance.

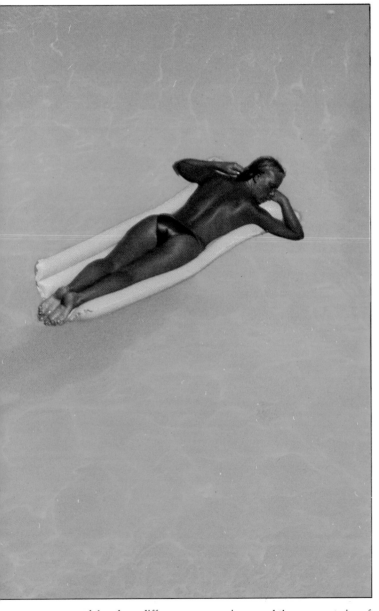

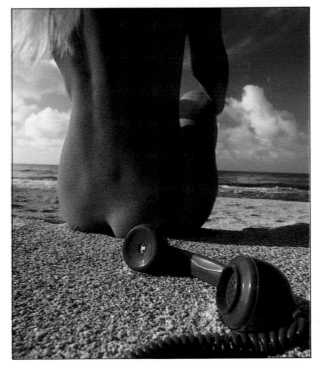

model under a diffuser screen and selecting a high viewpoint the photographer found a way of showing only the shape of her body.
90mm lens, Ektachrome 64, f16
FAR RIGHT This picture is a simple study in shapes. Use of the wide angle lens produced an elongated effect which increased the apparent size of the telephone in relation to the model.
18mm lens, Kodachrome 64, 1/250th sec, f11

THE MODEL

IN THE FINAL ANALYSIS glamour photography is not about cameras and lighting and film — it is about capturing the essence of female beauty. It is a visual attempt to define what makes a woman attractive. The photographer throws up images that may, or may not, capture a certain characteristic, mood, or look that strikes a chord in the viewer. Since beauty is purely subjective it is likely that only a few pictures will really create an impact on any one viewer, which perhaps partly explains why the demand for pictures of attractive women continues unabated.

MODEL/PHOTOGRAPHER RELATIONSHIP

To present female beauty successfully is not simply a question of finding a girl who has fashionable vital statistics, is the right age and has the right haircut or style. The elusive element springs from the model's personality. If a girl is naturally quiet and withdrawn, the photographer should work to make the picture show this aspect of her character. By the same token, a lively and effervescent girl should be photographed in a situation that allows her to be herself. Newcomers to glamour photography often overlook this vital fact and find that the session is stilted and awkward as a result. The tension between the photographer and the model will almost always show in the final shots.

Professional photographers talk about 'establishing a rapport' with a model. This sounds hazy and ill-defined, but it is probably the most crucial element in any glamour session. What they are really saying is that they take the trouble to get to know the model's personality and are not simply preoccupied with her surface appearance. This, of course, takes time, which explains why so many professionals only use a small number of girls. The better the relationship you can establish with a model the more likely it is that she will be relaxed and that the camera will pick up that indefinable quality that turns an ordinary picture into a special one.

The rapport which a photographer can establish with a model is helpful whether he is taking fashion pictures or portraits; it is even more important if the session is to be either nude or semi-nude. Nakedness promotes a feeling of

This casual, relaxed shot was
not planned. It was taken at
the end of the day and acts as
a happy momento of a
successful day's shooting.

defencelessness and vulnerability and it is up to the photographer to make the model feel relaxed and comfortable in front of the camera. There are certain practical considerations which should be dealt with by the photographer. The immediate environment should be private and there should be no chance of intrusion by strangers. It must also be comfortably warm. If the shoot is indoors, music often helps to provide a relaxing atmosphere.

One of the most effective ways of distracting the model's mind from the unaccustomed role of appearing naked in front of other people is to construct the shot so that she has something positive to do as a part of it. She is soon likely to stop feeling self-conscious about her nudity if she is able to concentrate on something else. It is at this point that props and the nature of the setting come into their own. If the photographer gives the model a book, for example, she can experiment with different ways of holding it. The task will use her acting skills which are a necessary part of good modelling. It is much better if the photographer merely gives the model a starting point and lets her develop her own approach, but she must know the effect the photographer is trying to achieve. This means he will have to give the model some basic direction. However once she knows what is

At the beginning of a session a series of test shots is a good idea. The results are often surprisingly good (BELOW). The shots can help the model to relax and provide a good basis for a working relationship. They also give the photographer valuable information about the model's good and bad points.

Study your model carefully before you start shooting. Note her strengths and weaknesses so that you can show off her good attributes and disguise her faults. Listed below are some of the points to consider when assessing a model.

Height For nude photography height is unimportant, but the body should be well proportioned.

Hair Healthy, shining hair is very important.

Skin A clear skin is very desirable, although blemishes can, of course, be disguised with careful make-up.

Face A profile shot might suit your model's face better than a face-on one.

Neck If your model has a long, thin neck, make the most of it. It can look very elegant in a picture.

Bust Size is very much a matter of taste — firmness is generally more important than the size of the breasts.

Waist A small waist is pleasing, but not essential. The waist should be in proportion to the hips and shoulders.

Hands If your model has long, fine hands make the most of them. Watch out for noticeable veins in the hands.

Hips Wait for pressure from underclothes to disappear.

Long Legs These are a great advantage in glamour photography. However if your model has short legs you can adjust the viewpoint to compensate — short legs will look longer from a low viewpoint.

required, the photographer should leave her to work it out herself. Giving her strings of contradictory instructions will not only confuse her, it will also tend to suppress her own initiative.

ASSESSING A MODEL

There are other aspects of a photographer's relationship with his model which are also important if a session is to be successful. As a craftsman, the photographer must be able to assess a model's body and face critically. There is no such thing as the perfect shape. Every figure has 'merits' and 'faults' but is it up to the photographer to draw out the model's best attributes.

A model's hair can be dressed in any number of styles, given time. If, for example, you are planning a period picture, it might be appropriate to have the model's hair in ringlets. There is no point in telling her this five minutes before the shoot is scheduled to begin. However if you let her know in plenty of time she will be able to do something about it. You should also remember, when assessing a potential model, that a hairstyle that does not 'belong' in the shot can be eliminated either by framing closely on the girl's face, or by asking her to wear a wig.

Unless you plan to shoot an 'abstract' nude that does not include the model's face, you must pay attention to the model's head. No-one has yet produced a formula that will tell you whether a model will be photogenic or not but the general rule is that strong, well-defined bone structure will produce the best results on film. Soft, round faces can look homely. Sharp, pinched faces can look hard. The ideal lies somewhere between the two, but it is probably wiser to err on the thin side.

There is a simple photographic reason for this. The bone structure of a face defines its different areas sharply. By throwing light on to it from different angles each area is illuminated in turn. It is therefore possible for the photographer to build up a clear view of where the contrasting tones of light and dark will fall in the final picture. However you light a round face, the contrast will blur gradually from light to dark, and there will be none of the definition lines that delineate the bone structure.

Study the girl's face carefully and look for blemishes. They may be scars, wrinkles, birthmarks, even a crooked nose. All these things can be disguised by careful lighting, but it always helps to know with what you are dealing. One area that is often overlooked is the teeth. Make sure that the gap between the front teeth is not too wide. It may sound petty, but a black gap in a set of gleaming white teeth is very noticeable.

What constitutes a 'good' figure is a matter of fashion. The painter Rubens evidently thought that plump curves and full breasts added another dimension to a model's level of attrac-

tiveness. Nowadays fashion has swung the other way and slenderness holds sway. However, it is preferable to avoid the gaunt skeletal look, because it will probably induce the wrong sensation in the viewer and will simply not look sexy. Equally, avoid a model who is carrying excess poundage. One successful London glamour photographer always recruits his models from the ranks of dance choruses. He maintains that they are exceptionally fit, their muscle tone is perfect without a hint of sag or droop, and they are accustomed to very hard work. This is a good description of a successful glamour model, especially if you realize that a girl's figure is probably at its best for modelling purposes in the late teens.

POSING

The traditional image of the photographer posing his model in carefully staged attitudes is misleading. There was a time when the photographer instructed his models to stand in a certain way and remain absolutely still until the picture was taken. That was in the days of slow film, when the shutter had to remain open for anything up to a minute. Any movement would have recorded as a blur and the effect would have been ruined.

Fast film emulsions have virtually put an end to static posing. The model can move around and, provided the photographer uses a shutter speed of 1/500 of a second, the pictures should be reasonably sharp.

This is just as well because there is little models loathe more than striking and holding a frozen pose. It is almost impossible to keep a happy expression looking natural after spending an hour or so with a fixed smile on the face. A spontaneous look of delight is worth a hundred frozen smiles.

This is not to say that the photographer should not be fully aware of the effects of certain body postures or that he should not ask the model to adopt them at times.

The first and most important rule of glamour posture is to make sure that the model looks proud of her figure. If she is standing, she should try to keep her back straight, her chest out and stomach held in. The last thing you want is a model who is hunched up, as though she does not really want to be in the picture at all. The shoulders are also important. The model should keep them back if her arms are in front and forward if her arms are behind. Rules, as was said earlier, are made to be broken, but only if you are sure that the effect is pleasing.

The least attractive angle from which to photograph a model is square on. This always looks posed and 'stagey'. Always try to position your model at an oblique angle to the camera. This will help to show off her figure and adds a touch of dynamism to the picture.

The same is true of movement. A picture in

which the model looks as though she is doing something always has more impact than a simply static representation. A good way of achieving this is to ask the model to change her position very slightly between exposures. The onus is then on the photographer to work quickly enough to keep up with the rhythm of her movements. This method entails shooting a great deal of film, much of which is unusable because the model is blurred or blinking, but it will almost certainly produce one or two shots which have punch and impact.

The art of making a model look attractive depends to a huge extent on the photographer's ability to pinpoint what it is about the girl that makes her appealing. One model may have devastating eyes, while another's strong point may be long legs. It is no good exposing hundreds of pictures of a particular model because she is 'good-looking'. You must have a firm idea about the reasons for her appeal and pin-point this in your shots.

It is then possible to assess how to make the most of the model's attributes. It would be idiotic to ask a girl with beautiful eyes to wear a pair of sunglasses. But the correct emphasis may be achieved by getting her to look directly at the camera while holding a pair of sunglasses

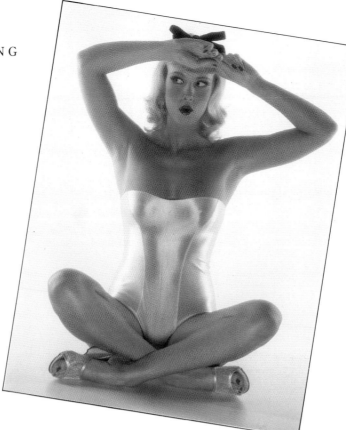

Who could guess that the model's dress (ABOVE) is being kept together by pieces of sticky tape and a bulldog clip? During a break between shots, the model studies polaroids of herself (LEFT) and considers how she can improve her pose. This pose is based on an airbrush illustration by Vargas (BELOW). A great deal of care and concentration is needed on the part of the model and the photographer to get a recreation right. In this shot, it is remarkably successful.

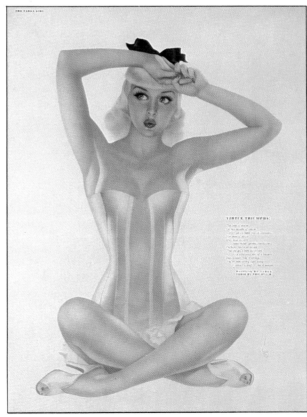

as though she has just raised them up to get a better look at the camera. The viewer will think that the model has been interested enough in him to raise her sunglasses. There is also the suggestion that the revelation of these beautiful eyes is a rare occurrence, as they are usually masked by the sunglasses.

A more obvious example is the long-limbed model. It would be quite possible to photograph her sitting behind a table, sipping a drink. The shot might be perfectly exposed, exquisitely composed and visually altogether stunning. But the photographer would be failing to make the most of his opportunities, simply because he has masked the model's most outstanding feature. Far better, for example, to have her standing full-length against a balcony with the setting sun behind her as she sips her drink.

Choose the clothes that you want the model to wear with great care. Make sure that they suit her skin or hair colouring and that they harmonize or contrast with any background colours you intend to keep in the shot. Hats can be useful, particularly if you are shooting in strong sunlight. Chosen with care they can add a great deal to the style of the shot, although avoid any hats that are too formal; many professionals prefer caps or possibly men's hats.

Make-up It is in the photographer's interest to make sure that the model has time and space in which to prepare herself for a photographic session. If she feels confident about her own appearance she will inevitably feel more relaxed when the camera is turned on her. Make-up is an important aspect in glamour work. There are two main reasons for this. Firstly, the power of studio lights or bright sunshine is practically guaranteed to show up any blemish on a model's skin. High resolution film will show any variation in skin colouring. Make-up can be used to mask such unwanted details. The second reason is more complex. In glamour work the model is trying to attain a peak of perfection in her looks. Even if she was incomparably beautiful she would probably still need to use cosmetics, not because the make-up is necessarily needed to add the last detail of perfection, but because it enables the model, posing as the ultimately desirable woman, to achieve the status of a perfect image, rather than merely of flesh and blood. It is very important that the photographer recognizes this and gives the model the opportunity to build this image up before she steps in front of the lens.

General Rules The model should start by cleaning all traces of old make-up off her face using a cleansing cream. Skin freshener should be applied to remove the grease left by the cleansing cream. Once the skin has been thoroughly cleaned, the model should apply a layer of moisturising lotion and leave it to soak in for five minutes or so. She should then apply foundation. The colour of the foundation should be chosen carefully to harmonize with the model's overall skin colouring.

There is a great tendency among amateur models to use a thick foundation. Unless the model has an uneven complexion, it is much better to start off with a thin layer of foundation. It will look far more natural in close-up shots. The overall effect of the foundation is to make the model's face look smooth and evenly toned. The foundation should tail off on the model's neck, and she should take great care to make sure that there is no 'tide-mark' at the point where the foundation meets natural skin. Blusher can be used to highlight areas such as the cheek-bones.

Lips Lip colouring helps you to achieve the effect you have in mind. For example, if you want the girl to look sexy, try a deep glossy red and ask her to make her lips look as full as possible. If, on the other hand, you want the fresh innocent look, a light pink may be appropriate. Lips can be reshaped with the clever application of lipstick and lipliner. The illustrations show how to correct a wide (1), a full (2), a thin (3) mouth.

Eyebrows The eyebrows play an important part in characterizing the face. Care should therefore be taken to ensure that they are correctly plucked and shaped. They can be tidied up by brushing the hair in one direction, and, if necessary, an eyebrow pencil can be used to fill in the shape.

The skillful application of make-up can effectively alter a model's looks. In the picture above, the combination of heavy, vampish eye make-up, an exotic hair-do and dark blusher on the cheeks helped to transform the girl who walked in through the photographer's doorway. The addition of a cricket helmet and stocking legs on her arms also contributed to the dramatic effect.

170

Body make-up is frequently used in glamour photography; it has two functions — to decorate and to disguise. As decoration it may take the form of exotic designs painted onto the model's body, giving a tattoo-like effect. As a disguise, it can be used to cover birthmarks and blemishes that would otherwise spoil the effect the photographer is trying to achieve. If you wish to create an extreme effect and make it look as if the model's body is completely painted it is still essential to leave a strip down the spine of the back clear so that the pores can breathe properly. In the picture (ABOVE) a type of spray-on body make-up was used to achieve this silver, metallic effect. The model has also tinted her hair. The photographer wanted to give the effect of a metallic sculpture.

The picture (ABOVE) shows a basic selection of cosmetics and make-up equipment. It includes: lipliner, lip gloss, lipsticks, eyeliners, eyeshadows, blusher, mascara, eyedrops, face powder, foundation, eye make-up remover, toner and cleanser. A selection of different sized brushes is also useful. Although models do have their own make-up equipment, it is worth keeping an emergency stock in case they forget or run out of something.

POST PRODUCTION

A light box and magnifying glass are essential for viewing transparencies. Another good method is to use a screen projector and project the transparencies onto a screen. This enlarges them without losing their best qualities. There is a large variety of slide projectors available, but as with cameras, you get what you pay for. Leitz and Rollei are top quality brands and while the Pradovit 153 IR (BELOW LEFT) is for 35mm slides; the Rollei (BELOW RIGHT) projects medium format transparencies.

ONCE THE SHOOTING SESSION is over, the films must be sent for processing. Professional photographers tend to use a laboratory that they know and trust for all their processing work. The fact that the lab has given them consistently good results in the past helps them over the anxious period between shooting and receiving the processed images.

If you are in any doubt about the exposure levels on a particular film you can ask the laboratory to perform a clip-test. This involves cutting a frame or two off the beginning of the film and processing them normally. If they show consistent under-exposure, the rest of the film can be processed for slightly longer than normal, and the slight deviation can be rectified.

It is worth bearing in mind that the stated ASA rating of any film is nominal. Manufacturers' quality control allows a variation of a third of a stop. Professional photographers usually buy their film in bulk and make sure that each roll is from the same batch. They then expose a roll and have it processed carefully. A consistent variation of the exposure index shows them that the film is either over- or under-rated. The variation can be allowed for whenever film from that batch is in use.

If you have rated the film over or under its nominal ASA speed while shooting, perhaps to overcome low light levels, you must tell the laboratory. They can then 'push' or 'pull' the film to compensate for the difference.

If you have used reversal film it is preferable to have the roll returned to you as strips, rather than framed. There will undoubtedly be a certain amount of wastage, particularly if you have bracketed your exposures, and there is no point having useless pictures mounted.

Kodachrome is different. In the UK it can only be processed by Kodak. It cannot be 'pushed' or 'pulled' and it is always returned as mounted slides.

PRESENTATION

Transparencies are best viewed on a light-box, a case with a sheet of opaque diffuser plastic over the top that contains two or more daylight-corrected fluorescent tube lights. The sheets of film can be placed on the top and then viewed through a magnifying glass.

If you do not have access to a light-box, you can always suspend a sheet of plain paper over the bowl of a desk lamp and examine your slides against that. If you intend to sell the pictures you must undertake a rigorous editing function. Anything that is out of focus, incorrectly

exposed, badly composed or visually unexciting should be thrown out. If you do not do this you will waste the time of your prospective purchaser, forcing him to sort through them instead.

The images that pass your qualifying test should be mounted and filed in plastic sleeves. Avoid using glass mounts because if you have to send them through the post they may get broken. There is every chance that the slivers of glass will irreparably damage transparencies and the recipient will have the unpleasant task of removing the broken glass. Glassless plastic mounts are the answer. If the pictures are filed in sleeves the transparency surfaces should not come to any harm and they will be easy to view.

It is very difficult to accurately assess the value of a set of pictures. The standard contract between photographer and picture buyer allows £250 for the loss of a picture, but that figure is related neither to the cost of producing the shot nor to any payment that may arise from it. The fact is that pictures do go missing from time to time. Of course it makes sense to get as much recompense as possible, but there is little point in upsetting good buyers for the loss of one shot. If they have used your work in the past they will probably use it again and their business is almost certainly worth more than one picture. If you are sending pictures by mail, you can safeguard yourself by registering the package or sending it by recorded delivery.

Professionals often have their best pictures duplicated. They retain the originals and send out the duplicates. If a buyer likes the shots, the photographer can supply the originals. That way he only risks losing pictures when he has already made a sale. The drawback is that duplicating is time-consuming and fairly expensive.

An alternative method of presentation is to have 10 x 8ins prints made from your slides. Recent advances in colour chemistry, such as Cibachrome and Agfaspeed processes, have brought this technique within the range of the amateur. You can take the time to produce excellent prints from the slides and use the prints as a showcase of your work. The originals can then remain safely in your files.

If you are trying to sell your pictures on a speculative basis, remember that the prospective buyer is a busy person who is unlikely to want to look through hundreds of transparencies. Never show him or her more than about 25 shots. If they are impressive, the buyer will ask to see more, and then you can find out what sort of pictures are required and fit your submission to meet the buyer's needs.

Picture libraries usually require a minimum submission of about 500 transparencies from a new photographer. The reason is simple — a photographer who can supply 500 above-average shots has a more consistent track record than someone who can only supply 50.

Transparencies that you hope to sell should be captioned carefully, both for identification and to protect copyright (ABOVE). If you wish to sell your work it is important that you present your pictures attractively. There are various methods of mounting transparencies (RIGHT): a portfolio with a ringbinder system (1) and black card window mounts (2) are both good solutions. Any published work should also be neatly displayed (3). Some of your best shots could be made into laminated prints (4); these are of high quality and can look very good, but they are expensive.

INDEX

ACKNOWLEDGEMENTS

In section two the pictures are by:

Chris Thomson: 97, 98, 100, 106 (t), 109 (cl) and (tr), 110/111 (c) and (r), 113 (b), 115, 116, 121, 122, 123, 131, 135 (t) and (l), 136, 138, 142, 143, 145, 146, 152 (t), 155, 156, 158, 160/161 (tl), (tr) and (br), 162, 163, 168/169 (r) and (l), 170, 171

John Kelly: 99, 102/103, 105, 107, 109 (tl), (c), (bl) and (br), 110 (l), 113 (t), 119, 124/125, 126, 127, 128, 130, 132/133, 135 (r), 137, 139, 140, 144, 148, 149, 152 (b), 153, 157, 159, 160 (bl), 164/165, 166, 167, 173

Byron Newman: 150/151

Alberto Vargas: 169 (b)

Key: (t) top, (l) left, (r) right, (b) bottom, (c) centre

Pictures by David Hamilton (pages 41 and 42) and Jan Cobb (pages 31 and 32/33 supplied by *The Image Bank of Photography*. Pictures by Beverley Goodway (pages 35, 36, 37, 38 and 39) supplied by *Colour Library International Limited*. Pictures by Byron Newman (pages 150 and 72) reproduced by kind permission of *Lui* magazine. Pictures on title page (2/3) by Lucien Clergue (large picture) and Chris Thomson (small picture).

CLASSIC *Glamour* PHOTOGRAPHY

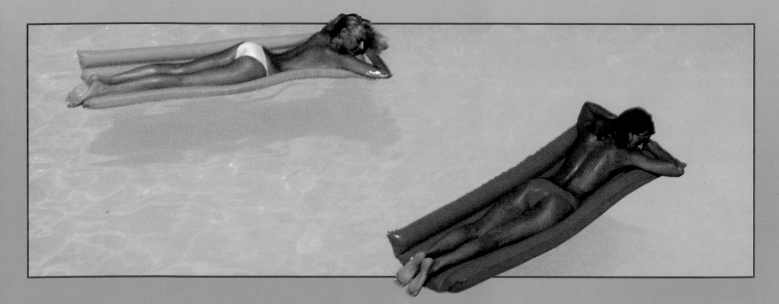

The featured photographers include:

MICHAEL BOYS
BOB CARLOS CLARKE
PATRICK LICHFIELD
LUCIEN CLERGUE
BEVERLEY GOODWAY
UWE OMMER
CHRIS THOMSON
JAN COBB
JOHN MASON
CHEYCO LEIDMANN
BYRON
DAVID HAMILTON
JOHN KELLY
JAMES WEDGE

Front cover photograph by John Kelly

Back cover photograph by Michael Boys

Jacket design by Bob Fillie

8¾ × 11⅝ (23 × 32 cm).
160 color plates. 16 color diagrams.
27 black-and-white illustrations.
176 pages. Index.

AMPHOTO
An imprint of Watson-Guptill Publications
1515 Broadway, New York, NY 10036

ISBN 0-8174-3672-3

$22.50
U.S.A.

90000
9 780817 436728